The complete paintings of

Caravaggio

Michael Kitson

Harry N. Abrams, Inc. *Publishers* New York

**Classics of the
World's Great Art**

Editor
Paolo Lecaldano

International Advisory Board
Gian Alberto dell' Acqua
André Chastel
Douglas Cooper
Lorenz Eitner
Enrique Lafuente Ferrari
Bruno Molajoli
Carlo L. Ragghianti
Xavier de Salas
David Talbot Rice
Jacques Thuillier
Rudolf Wittkower

*This series of books is
published in Italy by Rizzoli
Editore, in France by
Flammarion, in the United
Kingdom by Weidenfeld and
Nicolson, in the United States
by Harry N. Abrams, Inc.,
in Spain by Editorial Noguer,
and in Switzerland by
Kunstkreis*

Library of Congress Catalog
Card No. 69-16899
© Copyright in Italy by
Rizzoli Editore, 1967
Printed and bound in Italy

This book depends for its choice oi
illustrations and for much of its docu-
mentary material on the Italian edition
by Angela Ottino della Chiesa. The
analyses, attributions and chronology
of the works, however, are those of the
present author.

Table of contents

Photographic sources Colour plates : Aschieri, Milan ; Emmer, Milan ; Meyer, Vienna ; National Gallery, London ; Nimatallah, Milan ; Scala, Florence.
Black and white illustrations : Alinari, Florence ; Archivio Rizzoli, Milan ; Fogg Museum of Art, Cambridge, Mass ; Kunsthistorisches Museum, Vienna ; Istituto Centrale di Restauro, Rome ; Soprintendenza alle Gallerie, Florence ; Staatliche Museen, Berlin.

Introduction

The name of Caravaggio has passed down the centuries as that of an *enfant terrible*, a prophet of realism and the creator of an aesthetic revolution. He has been alternately villain and hero, sometimes both at once. To his contemporaries he was a phenomenon, whom they feared, admired and did not quite understand. To the next generation he was a gifted painter but a dangerous influence who had undermined the established laws of art. The eighteenth and early nineteenth centuries largely lost interest in him. To Ruskin he was the 'black slave' of painting. In our own time, however, his reputation has risen higher than ever before. He has been called the first modern painter; he has been set up as the original anti-academic and anti-idealist artist, the arch-rebel who first bravely sacrificed beauty for the sake of truth.

Our age likes rebels, so long as they are safely dead. Yet there is a danger that Caravaggio's real quality as an artist may get lost between, on the one hand, the romance attaching to his name and, on the other, the minute speculations that have been heaped by scholars, often with little or no evidence, round the attribution and exact dating of his works. Caravaggio's *is* a compelling personality and his personality is relevant to his art. To the scholar his work does present baffling problems. But the key questions are: what did Caravaggio succeed in achieving as a painter? Why is he one of the handful of great Italian painters of the seventeenth century?

The second question is of a type that is never easy to answer. The first is harder to answer than might be suspected, if only because Caravaggio himself left a conspicuous but incomplete clue to it. In evidence given during an action against him for libel in 1603 he asserted: 'a good artist is one who knows how to paint well and how to imitate natural objects well.' Contemporary critics amplified this (perhaps drawing on other, unrecorded statements by Caravaggio), reporting him as holding that all painting was worthless unless it was closely copied from nature. They alleged that he worked directly on the canvas without making preparatory drawings, that he painted in a shuttered studio by the light of a single lantern suspended from the ceiling (in order to produce the dark shadows penetrated by shafts of light that characterise his work) and that in his opinion 'it required as much skill to paint a good picture of flowers as one of figures.' Later in the century it was added that he despised the art of the past.

No doubt some of these reports were over simplified or exaggerated. (That Caravaggio despised the art of the past is unlikely since, during the lawsuit mentioned above, he praised contemporary artists who were devoted to the past, although his own use of it was different from and less reverential than theirs.) Still, even if we assume that much of what was said about Caravaggio was true, we are still left with a one-sided account of his art. The reports suggest that his aim was one of uncompromising realism, and it is true that realism is an important component of his style; textures, surface details and psychological reactions are depicted with a rigorous clarity not seen in painting before. At the same time there is much in his work that cannot be explained as realistic and to which neither Caravaggio himself nor his early critics left any real clue.

What remains unexplained is the role of imagination in Caravaggio's art. He was not a Chardin or Cézanne, able to find in categories of painting, such as still life, portraiture and landscape, in which the artist could work with the motive continuously in front of him, the stimulus necessary to express his vision; on the contrary. While it is true that he was crucially involved with still life at an early stage of his career, he was an indifferent portrait painter and

barely touched landscape even as a background to his figure compositions. Essentially he was an artist in the great tradition of Italian figure painting. He painted altarpieces and easel pictures, the latter with both religious and secular subjects, as his Renaissance predecessors had done (although he did not attempt frescoes). This was in keeping with the tastes and the conditions of patronage of his time. To create such works it was necessary to be able to reconstruct long past or legendary events. The painter had to conceive compositions which could not be copied from groups of models posed in the studio (X-rays show that Caravaggio had trouble with composition and frequently changed his mind on the canvas). Such paintings, if they were to succeed, had to stir the emotions of the spectator. In short, a leap from the imitation of nature into the realms of imagination and invention was necessary. No doubt Caravaggio would not have denied any of this. Yet he appears to have had no articulate theory or settled procedure concerning these matters and positively to have rejected past traditions of posing and composition – in which he was particularly original. Only with regard to lighting (another very original feature) do the early critics have much to say, although they do not analyse it and only one of them, Giulio Mancini, noticed that it was not realistic.

We are thus faced at the outset with a paradox; not the last in discussing Caravaggio. We are well informed about what is fundamental but also in a sense peripheral to his art – his realistic treatment of accessories and details. But regarding the questions that matter when we look at his paintings – how Caravaggio dealt with action, composition and lighting and what emotional content his work is meant to convey – we are left without aid from contemporary sources. To resolve these questions we have only his paintings on which to rely; perhaps even Caravaggio himself, if one asked him, would have been unable to give a clear answer.

It is probably true, though some modern authorities have denied it, that Caravaggio was trained as a still-life painter. If true, this is significant, for still life is an art in which it is possible for the painter to execute each brushstroke with the object placed in front of him, and Caravaggio's later stress on the importance of working from nature and his emphasis on the difficulty of painting flowers may have been derived from his training in Lombardy. His early works, mainly half-length figures of boys with fruit,

flowers, carafes or musical instruments, seem to have been developed out of the paintings of still lives and heads which hack artists sold cheaply in the Roman streets, and it was with such artists that Caravaggio first associated in Rome. Yet the earliest examples of such works that we know (Pl. 1 and 1–4) already show remarkable individuality. They are technically very skilled in some parts – the still life; and very amateurish in other parts – the anatomy of the figure. At the same time they display complete personal assurance. The influences Caravaggio drew upon, chiefly in north Italian painting, have been so adroitly concealed that it is impossible to specify exactly which artists he used.

From the start he exhibits a limpid manner, a seeming candour. The figures and objects in his small early canvases are seen against warm neutral grounds under a diffused, often silvery light. The poses are precisely held yet tentative, the outlines are delicate and economical, the forms unaccentuated and soft, the colours luminous and clear. The painting is smooth, compact and terse without any display of expressive 'handling', (this is also true of most of Caravaggio's later work). The intense whites and velvety blacks are positive colours, not neutral light and shade. Bloom lies on the fruit, the wood-grain is visible on the surface of a table or lute, the music on the sheets is legible. Following upon more than a century of sophisticated representation in Italian painting, upon a tradition in which all the resources of perspective, foreshortening and anatomical knowledge had been exploited, in which subjects and compositions had become ever more complex, this is elemental painting. Yet, though simple, these early works of Caravaggio are not naive in the way that primitive paintings are naive. Without wishing to load them with too much significance, we may detect in them a new combination of contrasting qualities. In both manner and matter they are at once innocent and knowing, direct and secretive, tentative and poised. In mood they have something of the melancholic preciosity of late sixteenth-century Italian madrigals or Elizabethan love lyrics. Stylistically they retain strong traces of Mannerism, although this is partly disguised by their correspondingly Mannerist subject matter, so that we read their style as a function, rather than as a quality in itself.

It has been said that some or even almost all of these figures are idealized portraits of the painter. This is clearly wrong since the earliest of them was

executed when Caravaggio was nineteen or twenty, whereas the boys represented are barely adolescent and we know what Caravaggio looked like – swarthy, heavy-featured and with a beard (Pl. XXXI and 40) – at 26. Yet it is not hard to see how the mistake arose. The early paintings have the silvered, slightly withdrawn and atmospheric look of images seen in a seventeenth-century mirror, while the expressions in the eyes have more than a hint of Narcissism. It is perhaps true, as Longhi has suggested, that Caravaggio used a mirror, sometimes tilted (Pl. XIII), to aid his invention, as if to 'try out' reality in a readymade rectangular frame; but this is not to say that he habitually depicted his own features. The self-regarding gaze of the figures also has a non-autobiographical explanation. These are surely erotically appealing boys painted by an artist of homosexual inclinations for patrons of similar tastes. His last and most extravagant work in this vein – *Victorious Love* (46), painted about 1602 – is blatantly designed with this in view.

It is curious and interesting that Caravaggio followed up this early series of boys, sometimes thinly disguised as Bacchus – less often he depicted girls disguised as saints (Pls. XIII, XV) – with two further series of partly naked single figures in his middle and later years (he died when only 37). The first of these later series represents the young St John the Baptist and runs from about 1598 to 1606. The second, beginning about 1602–04 and ending in 1608, only two years before the artist's death, represents St Jerome writing with a skull beside him as a reminder of death. Adolescence, early manhood, old age: there is a progressive increase in seriousness and a change from the secular to the religious in these three groups. However, from 1598 onwards, single figures were only a sideline for Caravaggio; his main tasks were now great altarpieces and other subject paintings.

The transition from Caravaggio's early to his mature style took place fairly rapidly, probably about 1597–99, and thereafter his development followed a more gradual evolution. *The Sacrifice of Isaac* (Pl. X), *Judith beheading Holofernes* (26) and – assuming it is by Caravaggio – *Narcissus* (Pl. XII) typify this transitional phase. Three new interests appear in these works for the first time in Caravaggio's art: action, the expression of emotion, and the modelling of forms in relief, with which we may associate the most obvious development of all – the adoption of very dark shadows surrounding and partly cutting into forms illuminated by a harsh beam of light. Each of these interests, though new for Caravaggio, was a traditional preoccupation of Italian artists. It will be convenient to treat each in turn, showing how he developed them during his career and exploited them in profoundly original ways.

Action: in his mature and late periods Caravaggio chose dramatic, often violent, events. Renaissance artists had done something similar. They had introduced, as a standard feature of the painter's repertory, the depiction of a moment of revelation or decision in human affairs, or the sudden intervention of the supernatural, with spectators looking on in wonder or fear. What Caravaggio did was to intensify and sharpen these crises. He placed them in spare but real settings, stripped them of nobility and decorative attractiveness and forced them upon the observer's attention by locating the figures in the front plane of the picture and closing off the background with a wall of darkness. *The Calling of St Matthew* (Pl. XXIV) takes place at a gamblers' table in the shadowed courtyard of a Roman palace. St Peter is crucified (Pl. XXXVI) alone on a blackened hillside, uncomforted by visions of heaven; even his executioners, their faces hidden, are merely doing a job, indifferent to their victim's fate. David contemplates the severed head of Goliath (Pl. XLVII) not in triumph but in disgust.

This last painting, like many others by Caravaggio, is struck diagonally across by the highlight on a sword-blade. The sword seems to play an almost autobiographical role in Caravaggio's iconography, connecting his life and his art. He is recorded as sometimes walking the streets with a page carrying a drawn sword in front of him and he was often involved in fights, one of which (in 1606) ended in a murder and his subsequent flight from Rome. In his paintings the sword holds the eye, mesmerized, at the focus of the action. Now it is a duelling rapier, red-tipped (Pl. XV), now a scimitar (26), now a heavy executioner's blade (Pls. XXV, XLVII, LVI). In the most horrifying example – *The Beheading of John the Baptist* (Pl. LVI) – the two-handed weapon lies on the ground while the observer's eye is focused on the knife drawn by the executioner to sever the head.

In Caravaggio's art there is much action but little movement, as unfriendly seventeenth-century critics pointed out. In his last paintings there is scarcely even

an attempt at suggesting movement. Yet this limitation may be regarded nowadays as a merit, in so far as it removes a distraction for the eye, a quality potentially softening the harshness of the subject. Caravaggio's poised stillness is strange and curiously compelling. It is impossible to deduce the positions of his figures before and after the event depicted. In a technical sense this was an awkwardness and sprang from his lack of training in conventional drawing. As his critics would have put it, he was unable to translate an action or figure group into a conception. His imagination conjured up these things ready-made and placed them 'there' in front of him. His compositions have no rhythms, only lines of force. The contours of his figures are taut; along the frontier where light and shadow meet there is tension, as if each were trying to crowd out the other. A composition by Caravaggio is new because it has no formula to fall back upon. Because the action is not released in movement, the effect is one of fierce concentration.

The expression of emotion: with this as with other traditional preoccupations which Caravaggio treated in new ways, he may have remembered a saying, perhaps still current in Milan when he was a boy and recently revived there by the critic, Lomazzo, of the greatest artist to work for long in that city, Leonardo da Vinci: 'that figure is most admirable which best expresses the passions of the mind.' Caravaggio's first attempts at violent expression and gesture occur in the early *Boy bitten by a Lizard* (4) and *The Card-Sharpers* (15) but it was only from the late 1590s onwards that the rendering of pain, disgust, wonder, horror, grief and fear became a constant feature of his art. In their more exaggerated forms (Pls. x, xix) these expressions seem to us overdone but the intensity with which they are painted saves them from caricature. Action in Caravaggio is reinforced by the urgency of human reaction. Hands point and gesticulate, faces peer closely at what is going on, no-one in Caravaggio's paintings remains stoically unmoved. The most poignant gestures are hands covering faces in grief (Pls. xxxix, lvi, lix). In his latest works Caravaggio seems to revert to a method of rendering emotion older than Leonardo's, and *The Beheading of John the Baptist*, *The Burial of St Lucy* (Pl. lix) and *The Raising of Lazarus* (Pl. lx) remind us – surely it can only be coincidence? – of the late, expressionist bronze reliefs of Donatello.

The modelling of forms in relief: the doctrine that it was the artist's duty to represent forms in three-dimensional relief by means of shadows may also have reached Caravaggio indirectly from Leonardo. Beginning with *The Sacrifice of Isaac* and *Judith and Holofernes*, darkness rapidly closes in on Caravaggio's forms and, by *The Calling* and *Martyrdom of St Matthew* (Pls. xxiv–xxxiii) of 1599–1600, the *tenebroso* manner for which he became famous had been fully developed. His use of shadows was much harsher and more extreme than Leonardo's; nevertheless it may have originated in the same purpose, namely that of making the illuminated parts look as rounded as possible. However, it goes further than this. It becomes an end in itself, not merely a means to an end. Contrary to what some seventeenth-century critics (though not Mancini, who was more perceptive) implied, the effect is not 'true to nature'. It was said that Caravaggio painted in a shuttered room with a single light suspended from the ceiling. Whether or not this is true, the result lacks the half-shadows, reflected lights and sensation of dimly perceived space that an actual lantern would create, and in Rembrandt's art does create. In Caravaggio's paintings the light, often entering from one side, isolates parts of the forms in livid brilliance in an almost arbitrary fashion. Other parts are lost in the shadow that fills the background, although these parts are not quite united with it, as on close inspection their edges can just be seen. This shadow is thick, impenetrable, airless; 'absence, darkness, death; things which are not' (to quote John Donne's *Nocturnal upon S. Lucies day*); it is space-denying, not space-creating. By the way it bites into the illuminated forms it helps to clarify the composition. In the late works, from *The Madonna of the Serpent* (59) of 1605 onwards, the darkness occupies an increasing area of the picture. In *The Burial of St Lucy* and *The Raising of Lazarus* (87, 88) it occupies the whole upper half of the canvas, leaving the figures as if at the bottom of a well. (Curiously, in a few of these works, especially the Messina *Adoration of the Shepherds*, 89, Caravaggio begins to create depth once more and to provide a defined, though simple setting, as if he were already pointing the way towards the Caravaggism of his followers.)

This darkness, and the lit, fragmented forms to which it acts as a foil, is far too positive to be a merely realistic device. Its effect is highly dramatic. It creates mood. It forces attention on the few forms

which break through it. In every picture our eye is attracted by a small number of incidental details: the grain of the wood in St Peter's cross, the soles of the peasants' feet in *The Madonna di Loreto* (Pl. XLIII), the skull apparently dropped from the awakening Lazarus's trailing hand. Illuminated forms generally have a hard edge, which Caravaggio, when preparing the composition, incised into the ground with a semi-sharp instrument: he did not use drawings. Caravaggio's use of light and shadow is profoundly original in its effect, even though it may have originated in a traditional purpose. Other artists had used light and shadow as a means of creating a continuum throughout the picture. With Caravaggio they are divisive rather than unifying forces, although they may form a coherent abstract pattern on the picture suface.

Emotionally and formally Caravaggio's art is shot through with the ignoble. Unlike Renaissance art, it is not elevating. In noticing this the seventeenth-century critics were right, although they seem to us to have drawn the wrong conclusions from it. They accused Caravaggio of neglecting ideal beauty, respect for which they considered the foundation of good painting. To us this characteristic of his seems, if not a positive virtue, a distinguishing mark. Caravaggio shows us a side of the subject he is depicting that had not been represented in art before, a side that appears to us nearer to 'the truth'. His art has no heroes, no idealised Christs or saints, and sacred events are shown taking place in squalid surroundings (works that are partial exceptions to this rule, such as *The Entombment*, Pl. XL, or *The Madonna of the Rosary*, Pl. LI, seem for this very reason anachronistic, although they were once much praised). Caravaggio was perhaps the first artist in history to disregard the notion, invented in the fifteenth century, that the object of a work of art was to be beautiful.

Caravaggio's unheroic presentation of religious subjects nevertheless leaves a certain ambiguity in the mind. In contrast to Rubens or Bernini, we do not know the nature of his religious beliefs. That his paintings did not always accord with Counter-Reformation attitudes is suggested by the refusal of some of his altarpieces by the clergy of the churches for which they were painted, although they were evidently rejected more because they were indecent in treatment than unorthodox in content. There is surely very little truth in the suggestions that have been made recently that Caravaggio was a sub-conscious Protestant or, more plausibly, that he was a follower of the 'popular' sixteenth-century saint, St Philip Neri. Like St Philip Neri he seems, it is true, to show scant respect for the saints and clergy as intermediaries between the individual soul and God, but his art was not popular in the sense of appealing to the tastes of the people. On the contrary, the patrons who most appreciated him were sophisticated aristocrats, *monsignori* and cardinals. Nevertheless, his art can be called religious, if not devotional, in one sense: it is an intensely serious treatment of the subject in hand. Nothing in Caravaggio is done for effect or for decorative purposes. His paintings are moving in human terms, and therefore those that are religious in subject matter are moving in religious terms also.

No other seventeenth-century Italian painter expressed this type of feeling with such concentrated art and with such grandeur. Caravaggio's followers either sweetened or coarsened his style. They sacrificed either his harshness or his poetry; they could not combine both. Later baroque painters, though superficially more skilled than he, could rarely match his ability to rivet our attention with every figure on the canvas, at least on a large scale. The temperature of Italian painting falls after 1630. Caravaggio belonged to a more serious and a more experimental age. But even among his equals – Annibale Caracci, at moments Guido Reni and Guercino – he stands out as a painter of strange and fierce originality.

MICHAEL KITSON

9

An outline of the artist's critical history

It is often believed that, despite his great importance, Caravaggio was neglected by contemporary and slightly later critics, and that those few who did discuss his life and art distorted his image. This is a mistake. The whole seventeenth century, beginning in the artist's lifetime, showed uninterrupted interest in the dramatic figure of Michelangelo Merisi da Caravaggio. That it should have dealt with him by exalting or demeaning him as a 'naturalist' and an enemy of the accepted canons of ideal beauty is not surprising in view of the universal tendency to belittle – or at least to patronize by over-simplifying – the achievement of artists who disregard established taste. Because of this, Caravaggio was considered inferior not only to such major painters as Poussin, Annibale Carracci and Guido Reni but also, at any rate by Roman critics, to secondary figures like Domenichino, Lanfranco, Albani and Pietro da Cortona and even occasionally to quite minor ones like the Cavaliere d'Arpino and Baglione. But this does not alter the fact that throughout the century the debate on the 'Caravaggio case' was widespread and continuous, with echoes that resounded even at some distance from the centres of his activity, as is clear from the passages quoted below. Basically, the seventeenth century regarded Caravaggio as a 'genius but...', a flawed artist of immense gifts and potential benefit to art who, by misusing those gifts, threatened to undermine the foundations of good painting. Characteristically, the critics found an ancient Greek precedent for him, the sculptor Demetrius, who, according to Pliny, was noted for his realistic rendering of low life.

During the eighteenth century interest in Caravaggio declined and he is not even mentioned in, for instance, Reynolds's *Discourses on Art.* Judgements tend to repeat those of the seventeenth century, particularly Bellori's, but in shortened and simplified form. Caravaggio was no longer a controversial figure but the historical representative of a type – the bohemian artist – with whom contemporary painters were sometimes compared, just as he had been compared with Demetrius. Nor did this situation change much in the Romantic period, which found other, more appealing old masters – Salvator Rosa (more bizarre) and Rembrandt (more universal) – to take over Caravaggio's role as the arch-rebel against classic art. In the mid-nineteenth century, however (apart from Ruskin), Caravaggio began to be treated with more respect. The old references to his naturalism were repeated but without the qualifying objection that he had neglected ideal beauty. In representations of religious subjects his very rejection of ideal beauty was seen to have the advantage of truth. This view has been maintained down to our own day.

Modern historical research into Caravaggio's art began with Kallab's article in the Vienna *Jahrbuch* in 1906. The attempt to document and reconstruct Caravaggio's *oeuvre* and to analyse his use of light, his revolutionary methods of composition and the quality of his religious feeling was first decisively undertaken in the 1920s by Marangoni, L. Venturi and, above all, Roberto Longhi. Since World War II and the great exhibition at Milan in 1951 the interest in Caravaggio has become as intense as it was in his own lifetime. While it is true that the bibliographies of all seventeenth-century artists have increased spectacularly in the last twenty years, that of Caravaggio has increased even more than most. In our time we have seen a new, literary Caravaggism, as feverish, as argumentative and as mixed in its results (there have been some notable triumphs as well as a larger-than-usual crop of ponderous or merely foolish speculations) as the first, pictorial Caravaggism which grew up among painters in the decade after the master's death.

He (Caravaggio) does not execute a single brushstroke without taking it directly from life. And this is not a bad way of attaining a good end, for to paint from drawings (even if copied from life) is not so reliable as keeping reality in sight and following nature with all her different colours; but the painter must first have the insight to enable him to select from the beauty of life that which is most beautiful.
K. VAN MANDER, *Het Leven der Moderne oft dees-tijtsche doorluchtighe Italienische Shilders*, 1603 (Part III of *Het Schilder-Boek ...* Haarlem, 1604).

... Caravaggio, most excellent in colour, may be compared to Demetrius, for he has abandoned the idea of beauty, intent only on the attainment of likeness.
G. B. AGUCCHI, *Trattato* (MS), 1607–15 (published by D. Mahon, *Studies in Seicento Art and Theory*, 1947).

(Caravaggio)
the great Protopainter,
Marvel of Art,
Wonder of Nature,
Though later a victim of ill fortune.
G. C. GIGLI, *La Pittura trionfante*, 1615.

... he was so accurate and ingenious an imitator of nature, that what other painters are wont merely to promise he has accomplished.
G. BORSIERI, *Il Supplimento della Nobiltà di Milano*, 1619.

The peculiarity of this school (Caravaggio's) is the use of an unvaried light shining from above without reflections, as would occur in a room with one window and with walls painted black,

so that, the lights being very light and the darks very dark, they give depth to the picture ... In this method of working this school is highly observant of the truth and always keeps reality before it while working; it is deft at executing a single figure but, depicting as these painters do the reality which they always keep before them, they do not seem to me particularly worthy in the composition of the story and the expression of emotion, since the latter depends on the imagination and not on observation and it is impossible to place inside a room lit from a single window a multitude of men that act out the story, and to have one that laughs, weeps or walks and at the same time stands still to let himself be portrayed; and thus their figures, although they possess force, lack movement and emotion and grace, as a result of that method of working.

G. MANCINI, *Considerazioni sulla pittura* (MS), 1619–21 (MS published by A. Marucchi, with commentary by L. Salerno, 1956–7).

Michelangelo Amerigi (Merisi) was a mocking and arrogant man; and he often spoke ill of all painters past and present no matter how renowned, for it seemed to him that through his works alone he had excelled all others in his profession. In fact, it is believed by some that he ruined the art of painting: for many young artists, by following his example, are led to imitate a head from life, and studying neither the foundations of drawing nor the depth of art, are content with mere colours, with the result that they are unable to put two figures together, or weave a story of any sort, through not understanding the excellence of so noble an art ...

G. BAGLIONE, *Le Vite de' pittori, scultori e architetti* ... 1642.

... a unique prodigy of naturalism, led by his own instinct to the imitation of reality, and thus rising from the copying of flowers and fruit, from imperfect bodies to the most sublime, then from imaginary to human portraits, and finally executing whole figures, and also on occasion compositions of histories, with such truth, force, and relief, that quite often, if nature was not equalled and conquered, it nevertheless caused confusion in the viewer through deceiving the eye, and fascinated and ravished all humanity; therefore was he believed by many to surpass all others.

... endowed with a particular genius ... deprived, however, of the necessary basis of good drawing, he later revealed himself to be lacking in inventiveness, and somehow devoid of fine idea, grace, decorum, architecture, perspective, and other similar necessary fundamentals, which make both capable and worthy the truly great and principal masters ...

F. SCANNELLI, *Il Microcosmo della pittura*, 1657.

There is no question that Caravaggio advanced the art of painting because he came upon the scene at a time when realism was not much in fashion and when figures were made according to convention and manner and satisfied more the taste for gracefulness than for truth. Thus by avoiding all prettiness and vanity in his colour, Caravaggio strengthened his tones and gave them flesh and blood ... He followed his model so slavishly that he

did not take credit for even one brush stroke but said that it was the work of nature. He repudiated every other precept and considered it the highest achievement in art not to be bound by the rules of art. Because of these innovations he received so much acclaim that some artists of great talent, instructed in the best schools, were impelled to follow him ...

Such praise caused Caravaggio to appreciate no one but himself and he claimed to be the one faithful imitator of nature. With all this, many of the best elements of art were not in him; he possessed neither invention, nor decorum, nor design, nor any knowledge of the science of painting. The moment the model was taken away from his eyes his hand and his imagination remained empty. Nevertheless, many artists were infatuated by his manner and accepted it willingly, since without study or effort it enabled them to make facile copies after nature and to imitate forms which were vulgar and lacking in beauty. With the majesty of art thus debased by Caravaggio, everyone did as he pleased, and soon the value of the beautiful was discounted. The antique lost all authority, as did Raphael, and because it was so easy to obtain models and paint heads from nature, these painters abandoned the use of histories which are proper to painters and redirected themselves to half-length figures which were previously little used. Now began the representation of disgusting things; some artists began to revel in filth and deformity. If they had to paint armour, they chose the rustiest; if a vase, they did not show it whole, but chipped and broken. The costumes they painted were stockings, breeches and large hats and when they painted figures they gave all their attention to the wrinkles and defects of the skin and the outlines, depicting knotted fingers and limbs disfigured by disease.

G. P. BELLORI, *Le Vite de' pittori, scultori e architetti moderni*, 1672.

In sum, this man was a great individual, but not an idealist, which means he was unable to represent anything without keeping reality before him.

L. SCARAMUCCIA, *Le Finezze de' pennelli italiani*, 1674.

(Albani) could never bear that painters should imitate Caravaggio, perceiving in that practice the downfall and total ruin of the most noble and valuable power of painting; for, although simple imitation was in part worthy of praise, it was to spawn all that followed from it in the course of forty years ... Painters cannot be excellent in all parts. If Caravaggio had possessed these requisites, he would have been a painter I should term Divine, whereas he had no knowledge of things supernatural, but remained too close to nature.

C. C. MALVASIA, *La Felsina Pittrice*, 1678.

Poussin liked nothing about Caravaggio who, according to him, had come into the world to destroy painting. Nor should such intolerance cause surprise, for if Poussin pursued decorum in his compositions, Caravaggio allowed himself to be carried away by natural truth just as it appeared to him: they stood at opposite poles. Nevertheless, in considering the essence of painting, which consists in imitating what one sees, it must be admitted that

Caravaggio possessed it thoroughly ...
A. FÉLIBIEN, *Entretiens sur les Vies et les Ouvrages des plus excellents Peintres Anciens et Modernes*, 1666–88.

... to such an extent were the minds of patrons and of the painters themselves overwhelmed by that new manner full of darks with few lights, and ending in shadow, into which the outlines faded away for the most part, that they must constitute a clear example, to instruct and serve as a norm for students of the art of painting.
B. DE DOMINICI, *Vite de' pittori, scultori et architetti napoletani*, 1742.

... Caravaggio: the Rembrandt of Italy. This artist took too much advantage of the saying of that Greek painter who, when asked who his teacher was, indicated the crowd that passed in the street; and such was the magic of his chiaroscuro that, although he copied nature in its defective and base aspects, he almost had the power to seduce such painters as Domenichino and Guido (Reni).
F. ALGAROTTI, *Saggio sopra la pittura*, 1762.

Caravaggio had neither variety nor correctness; and consequently he was all bad in drawing.
A. R. MENGS, *Lezioni pratiche di pittura*, 1760–70.

... he is a memorable figure of this period, in that he brought back painting from mannerism to truth, both in his forms which he always drew from nature, and in his colours which, having almost banned vermilions and azures, he composed of few but real hues in the manner of Giorgione. Therefore did Annibale (Carracci) say, in praise of him, that this man ground up flesh (to make his colours); and Guercino and Guido much admired him, and profited by his example.
L. LANZI, *Storia pittorica della Italia*, 1789.

Because of the horror he felt for the insipid ideal, Caravaggio corrected none of the defects of the models whom he stopped in the street to ask to pose for him. I have seen in Berlin some paintings of his which were refused by the persons who had commissioned them for being too ugly. The reign of ugliness was yet to come.
STENDHAL, *Rome*, 1806.

It is not the absence of faults, but the presence of eminent qualities that constitutes a temperament and even a genius. Some men, capable of intense passion, cannot resign themselves to the impeccable wisdom of mediocrity. Among these, Caravaggio ...
V. SCHOELCHER, *Salon de 1835*, 'Revue de Paris', 1835.

... Without teachers, without rules, so much did he do and dare that there is no saying what he could have attained if he

had lived a century earlier or if, in imitating nature with such truthfulness, he had also borrowed from the painters of that blessed century the norms for beautifying it. But these norms, applied with such skill by the disciples of Ludovico (Carracci), were despised by him: and hence we find posterity placing him beside Guercino and Albani, rather than Annibale (Carracci), Domenichio, Guido (Reni) ...
G. ROSINI, *Storia della pittura italiana*, 1839–47.

... he painted with equal mastery portraits, devotional and genre scenes, flowers and fruit. A naturalist always, his paintings possess an extraordinary plasticity and often a peculiar grandeur that causes their author to be forgiven for any lack of distinction in the choice of forms, the exaggerated effects and the dark hues devoid of transparency.
F. VILLOT, *Notice des Tableaux ... du Musée National du Louvre*, 1852.

... beneath these again, we find others on whose works there are definite signs of evil mind, ill repressed, and then inability to avoid, and at last perpetual seeking for and feeding upon horror and ugliness, and filthiness of sin, as eminently in Salvator and Caravaggio, and the lower Dutch schools, only in these last less painfully as they lose the villainous in the brutal, and the horror of crime in its idiocy.
J. RUSKIN, *Modern Painters*, Vol. II, 1846.

Modern naturalism in the strict sense begins in its simplest form with Michelangelo Amerigi da Caravaggio ... His aim is to show the viewer that the sacred events of the beginning of time had unfolded exactly in the same way as in the alleys of southern cities towards the end of the sixteenth century. He held in honour only passion, for the truly forceful interpretation of which he possessed a great talent. And this passion, expressed in vigorous characters, frankly plebeian and sometimes highly striking, represents in fact the fundamental tone of his school.
J. BURCKHARDT, *Der Cicerone*, 1855.

Caravaggio was one of the most illustrious propagators in Italy of the method that was later to prevail in the Dutch school, which consisted in transforming that which is repulsive in nature into artistic beauty. Nobility of thought was not his aim: his aim was the imitation of anything in nature no matter what it was.
P. SELVATICO, *Storia estetico-critica delle arti del disegno*, 1856.

The painter who initiated the movement had to be almost of necessity an uncultivated man, devoid of interest in a cultural past he did not know. But despite this, he was a genius who contrived to display culture through the modes with which he realized his own very personal intentions. These are precisely the characteristics of that innovator, Michelangelo da Caravaggio – an uncultivated man, but a genius.
A. RIEGL, *Die Entstehung der Barockkunst in Rom*, 1907.

What should really be kept in view is his novel conception of style. The note that characterizes it is a quest for a concision so strict as to recall the restraint of archaic art. To this end Caravaggio employed two principal means: light and composition. As is well known, he immersed his scenes in darkness, injecting into them a beam of intense illumination, so that only some parts of the forms emerge from darkness into light.

Regarded down to this day, and perhaps by his own followers, as a realistic expedient, this was if anything a concession to the imagination, as it also was for Rembrandt. But above all it represented a striving for unity of style, a means of throwing into relief some essential parts and lines, causing them to show in the light, and of cloaking in darkness others that were secondary, useless, or destructive of a concise representation.

The other means which Caravaggio employed to attain stylistic unity lay in the composition of the painting. The decisive break with the centuries-old method of constructing a composition by lines and planes parallel to the picture surface had first been achieved by Michelangelo, who had shown what greater resources of movement and energy were afforded by the oblique arrangement of some of his figures – a resource which Tintoretto had taken to the furthest extreme, though he limited it mainly to single isolated figures. It remained for Caravaggio to crown the initiative of his predecessors by extending this constructional system to the whole context of the composition, so as to achieve at a stroke, with an unsurpassed power of synthesis, the maximum result in plastic and dynamic terms.
M. MARANGONI, *Il Caravaggio*, 1922.

It is in this relation that the figure of Caravaggio appears as a great and sinister portent in the history of modern art. We may almost call him the first popular artist. The first effective black-leg among painters, the first, that is, to throw over allegiance to the general standards of the profession and to appeal direct to the uninstructed public without first gaining some sort of licence from his fellow artists.
R. FRY, Essay on 'The Seicento' in *Transformations*, 1926.

His obstinate adherence to reality may indeed have strengthened his ingenuous belief that it was 'the eye of the room' which looked at him and which suggested everything to him. Many times must he have stood spellbound before that 'natural magic'; and what most amazed him was the realization that the mirror has no need of the human figure if, once the latter has moved out of its range, it continues to reflect the slanting floor, the shadow on the wall, the ribbon fallen to the ground. It is not difficult to conceive what further results might flow from this resolve to paint through the direct mirroring of reality. What resulted was a complete contradiction of current artists' usage. Themes had normally been developed with paper and pencil;

the basis had been historical learning and an abstract mode of stylization. A complex classification of what was thought fit for representation had been evolved whereby, the better to serve the society of the time, the portrayal of the ruling class was preferred. Instead, Caravaggio dwelt on common life, simple feelings, the everyday appearance of things which, in the mirror, rated as highly as men.

Caravaggio also perceived the danger of reverting to the worship of the human body, celebrated by Raphael or Michelangelo, or to the melodramatic chiaroscuro of Tintoretto. But the idea which was fitfully and confusedly illuminating his vision at this time was not so much the way bodies were thrown into relief as the form of the shadows that broke them up. There lay the more compelling drama of reality which he glimpsed after he had given up his calm mirrorings of young boys. And the scenes of sacred history, which he now mastered, came to him as a succession of brief and decisive dramas whose climaxes could not be treated in a leisurely, sentimental narrative, but had to be expressed in a flash of lightning which revealed and pierced the rents in the shadow. Good, even saintly, men were to be entangled in that arbitrary web. For, to remain faithful to the nature of reality, it was necessary for the calculation of the shadows to appear casual and not as if caused by the forms; otherwise there would again have been attributed to man the nullifying humanistic role of eternal 'chief character' and lord of creation. Therefore Caravaggio continued – and it was a labour of years – to study the incidence of light and shadow ...
R. LONGHI, *Il Caravaggio*, 1952.

The aversion of the people to his truly popular art is not the only paradox in Caravaggio's life. In fact the very character of his art is paradoxical, and the resulting feeling of awe and uneasiness may have contributed to the neglect and misunderstanding which darkened his fame. There is in his work a contrast between the tangibility of figures and objects and the irrational devices of light and space; between meticulous study from the model and disregard for representational logic and coherence; there is a contrast between his *ad hoc* technique and his insistence on solid form; between sensitivity and brutality. His sudden changes from a delicacy and tenderness of feeling to unspeakable horror seem to reflect his unbalanced personality, oscillating between narcissism and sadism. He is capable of dramatic clamour as well as of utter silence. He violently rejects tradition but is tied to it in a hundred ways. He abhors the trimmings of orthodoxy and is adamant in disclaiming the notion that supernatural powers overtly direct human affairs, but brings the beholder face to face with the experience of the supernatural. But when all is said and done, his types chosen from the common people, his magic realism and light reveal his passionate belief that it was the simple in spirit, the humble and the poor who hold the mysteries of faith fast within their souls.
R. WITTKOWER, *Art and Architecture in Italy, 1600–1750*, 1958.

Note on Caravaggism

Caravaggio does not appear to have had any direct pupils or to have encouraged other painters to imitate him. Nevertheless his influence was sensational and was operative in ever widening circles, like a stone dropped in a pool. As the ripples spread outwards they diminished in strength yet, paradoxically, it was those artists who were physically furthest from Caravaggio, like Velasquez, Georges de la Tour and Rembrandt, who profited most from his example, in the sense of producing the greatest pictures.

Many early copies of Caravaggio's paintings exist; several are mentioned in documents before 1620, some in Rome, others as far away as Valencia and Amsterdam (there was a copy of the *Crucifixion of St Peter* in Valencia by 1611). No copies or imitations can definitely be dated to before 1600 but echoes of Caravaggio's style began to appear very soon afterwards, once his fame was secured with the *Scenes from the Life of St Matthew*. Rubens borrowed an effect of light from him in a picture of 1601, Reni adopted his realism in his *Crucifixion of St Peter* of 1603 and Baglione imitated him in several works before 1603, when he and Caravaggio quarrelled. None of these painters became permanent Caravaggists and Baglione's biography of Caravaggio was, not surprisingly, grudging. However, by 1610 Caravaggism had become established as an artistic movement in Rome, its leading practitioners being Orazio Gentileschi, Borgianni, Saraceni (in some works) and probably Manfredi. There were also other, lesser adherents, from northern Europe as well as from provincial cities in Italy, although their contribution to the movement at this date is problematical. The German Elsheimer also felt Caravaggio's influence during this period.

Caravaggism probably first became popularized in genre paintings of drinkers, card players, lute players, etc., rather than altarpieces, which most of the artists concerned only gained the opportunity to paint in the second decade. During the second decade Manfredi was the leading painter of this type of genre, establishing a 'Manfredi manner' which was taken up by a circle of imitators, mainly Frenchmen. Orazio Gentileschi headed another group, which included his daughter Artemisia. Saraceni too produced his most Caravaggesque works during this decade (but not Borgianni, who began to desert the style before his death in 1616 and indeed was never a truly Caravaggesque painter in his altarpieces). Despite some deaths, departures and defections, mostly among minor artists, the period 1610–20 represented the high tide of Caravaggism in Rome, with cross-currents of influence between artists, although the movement was never homogeneous. Younger Italian artists came to maturity during this decade, such as Cavarozzi. The period was also marked by an influx of painters from northern Europe, notably Honthorst and Vouet. Caravaggesque painters now frequently obtained commissions for altarpieces. However, they never quite dominated painting in Rome as their style was unsuited to that most prestigious form of art, fresco. Caravaggism was moreover highly susceptible to coarsening and dilution. It was essentially 'fluid' and was more popular with visiting artists than with permanent residents. It not only attracted painters to Rome, or, more accurately, seduced them when they got there; it was also readily exportable. Painters sent their works to patrons in other parts of Italy and abroad and took the style with them when they went home. As a result 'pockets' of Caravaggism sprang up all over Europe in the 1620s and 1630s.

Caravaggism had begun to go out of fashion in Rome by 1620 but it flourished in two main centres in the next two decades: Utrecht and Naples. The Utrecht painters, Terbrugghen, Honthorst, Baburen and others, formed a school in Dutch painting, though they increasingly replaced Caravaggio's dark manner by a lighter tonality. Neapolitan Caravaggism, led by Caracciolo, grew from Caravaggio's two visits to Naples in 1607 and 1609–10. Even after Caravaggio's figure style had been more or less discarded in Naples in the 1630s his powerful chiaroscuro and penchant for violence seem to have appealed to the Neapolitan temperament and were absorbed into the Neapolitan Baroque. The style of the Neapolitan Spanish emigré, Ribera, despite its baroque brushwork, is unthinkable without Caravaggio's example.

Finally Velasquez, Georges de la Tour and Rembrandt, all of whom derived their knowledge of Caravaggio chiefly at second hand, although they may have seen a few of his works in the original. Of the three La Tour was the nearest to Caravaggio in style, although even his work is very different in spirit. Each was great as or greater than Caravaggio himself, and Velasquez and Rembrandt were of course far more than Caravaggists.

In the narrow sense Caravaggism was virtually dead in Europe by the mid-seventeenth century, apart from sporadic revivals. Yet in a wider sense Caravaggio's style and still more his example have continued to haunt European painting ever since.

Some data are appended below on the more important of Caravaggio's followers, including all those mentioned above and others whose works have been wrongly attributed to Caravaggio himself (as appears from the lists on pp. 110–11).

Baburen, Dirck van. Born Utrecht c.1590; in Rome c.1617–21, when returned to Utrecht and died there (soon?) after 1623. Adapted compositions and subjects from Caravaggio, treating them in a coarse, vigorous style.

Baglione, Giovanni. Born Rome c.1573; died there 1644. Best known as an artists' biographer; his 'Lives' published 1642. Began as a late Mannerist, then imitated Caravaggio 1600–03, when he brought a libel action against Caravaggio, Gentileschi and others for circulating scurrilous verses about him. Afterwards declined into a watered-down classicism.

Borgianni, Orazio. Born Rome 1578; in Sicily c.1591–98; in Spain c.1598–c.1602; in Rome again 1603; returned to Spain 1604–05, after which settled in Rome and died there 1616. Influenced by Spanish art, including El Greco; painted some Caravaggesque works probably 1605–10 but his most important pictures – chiefly devotional altarpieces – are in a very personal early baroque style, only marginally indebted to Caravaggism.

Caracciolo, Giovanni Battista (called *Battistello*). Born Naples c.1580 and died there 1637; probably visited Rome c.1616. A prolific painter, he was the founder of Caravaggism in Naples and was one of Caravaggio's closest followers, at least until the mid 1620s.

Caroselli, Angelo. Born Rome 1585 and died there 1652; visited Florence c.1610 and Naples c.1615. Possibly knew Caravaggio personally and was an able copyist; also influenced by Gentileschi. Only some of his works are Caravaggesque, mainly genre pieces.

Cavarozzi, Bartolomeo. Born Viterbo c.1590; arrived Rome before 1610 and died there 1625; visited Spain 1617–c.1619. One of the most sensitive and lyrical of Caravaggio's followers, using idealized figure types but retaining Caravaggio's chiaroscuro.

Finson (or *Finsonius*), *Lowys* (or *Louis*). Born Bruges before 1580; in Rome for much of the first decade but in Naples by 1610; from c.1612 in Aix-en-Provence where he remained until shortly before his death in 1617. Important as one of the first northern Caravaggists to come to Rome; he took his style to the south of France where some of his works still remain.

Gentileschi, Artemisia. Born Rome 1597, the daughter of Orazio; spent her life up to 1626 partly in Rome, partly in the Marches and Florence; in Rome 1626–30; from 1630 in Naples, apart from a visit to England 1638–39; died Naples 1652/3. Although trained by her father she was precocious and independent, with a taste for bloodthirsty paintings of *Judith murdering Holofernes.*

Gentileschi, Orazio. Born Pisa 1563; arrived Rome c.1576/78; in Rome until 1612, when began spending part of his time in the Marches; in 1621 left for Genoa, then Paris and finally London where he died 1639. Trained as a Tuscan Mannerist, he became intimate with Caravaggio c.1600 and remained on good terms with him at least until 1603. His conversion to Caravaggism began c.1605, reached its peak in the next ten years, after which he painted with a much lighter palette. He was one of the most important, sensitive and original of Caravaggists.

Honthorst, Gerrit van (called in Italy *Gherardo delle Notte*). Born Utrecht 1590; in Italy, mainly Rome, 1610/12–1620, when returned to Utrecht; died Utrecht 1656. The most famous and prolific of the Dutch Caravaggists, he already had a reputation in Italy for his candle-light scenes. In Utrecht he gradually discarded Caravaggio's chiaroscuro and ended as a history and court portrait painter in the manner of Van Dyck.

La Tour, Georges de. Born Lunéville (Lorraine) 1593 where he mainly worked and died 1652; possibly visited Rome shortly before or after 1620 but derived his knowledge of Caravaggism mainly from sources in Utrecht. This elusive French provincial was perhaps the most refined and gifted Caravaggist of them all.

Manfredi, Bartolomeo. Born near Mantua c.1580(?); arrived Rome possibly by 1603 but his career hardly traceable before 1610; died Rome 1620/21. He was the closest Roman follower of Caravaggio, specializing in genre pieces with which he had a considerable influence.

Mao (properly *Tommaso Salini*). Born Rome c.1575; worked and died there 1625. Chiefly important as a still-life painter. He was Baglione's one defender in the libel action of 1603, as Caravaggio, who despised him, maliciously pointed out.

'Pensionante del Saraceni'. This is the name given by modern scholars to an anonymous artist, possibly French, who imitated Saraceni.

Rodriguez, Alonzo. Born Messina 1578; in Rome by 1606, then visited Naples but returned to Messina by 1610 where he died in 1648. One of the few painters to know and be influenced by Caravaggio's late Sicilian works.

Saraceni, Carlo. Born Venice 1578/79; in Rome possibly by 1600 where he worked until shortly before his death in Venice 1620. He owed something to Elsheimer but more to Caravaggio and painted several Caravaggesque altarpieces in the second decade.

Spada, Lionello. Born Bologna 1576; in Rome some time between 1608 and 1614 and possibly visited Malta with Caravaggio in 1608; had returned to Bologna by 1614, in and near which he worked until his death in 1622. As a Bolognese he was, not surprisingly, only slightly affected by Caravaggism and then only in easel pictures of violent subjects, not altarpieces, but some works by him have been wrongly attributed to Caravaggio.

'Lo Spadarino' (properly *Giacomo Galli*). Born Rome (?) before 1590; died Rome (?) after 1649. His career as a Caravaggist, influenced by Saraceni, probably began about 1616–17 and may have continued into the 1630s.

Terbrugghen, Hendrik. Born Deventer 1588; in Rome c.1604–1614, when settled in Utrecht and died there 1629; may have revisited Rome shortly before 1620. No work is known from his Roman period but he was the most individual and poetic of the Utrecht school of Caravaggists.

Vaccaro, Andrea. Born Naples 1604; worked and died there 1670. Influenced by Caracciolo but like most Neapolitan painters moved away from Caravaggism in the later part of his career.

Valentin de Boullogne. Born Coulommiers 1591; in Rome c.1612 until his death in 1632. One of the ablest French painters in the 'Manfredi manner', a style he maintained through the 1620s when it was becoming unfashionable in Rome.

Vouet, Simon. Born Paris 1590; in Italy, mainly Rome, 1614–27, when he returned to Paris and worked and died there 1649. One of the best Caravaggesque painters in Rome in the second decade, he gradually abandoned the style in the 1620s in favour of a decorative form of baroque-classicism which he took back with him to France. His late works are bright in colour, smooth in texture and entirely un-Caravaggesque.

The Paintings in Colour

List of Plates

In the captions to the plates, the actual width of the original or of the section of the work illustrated is given in centimetres.

16

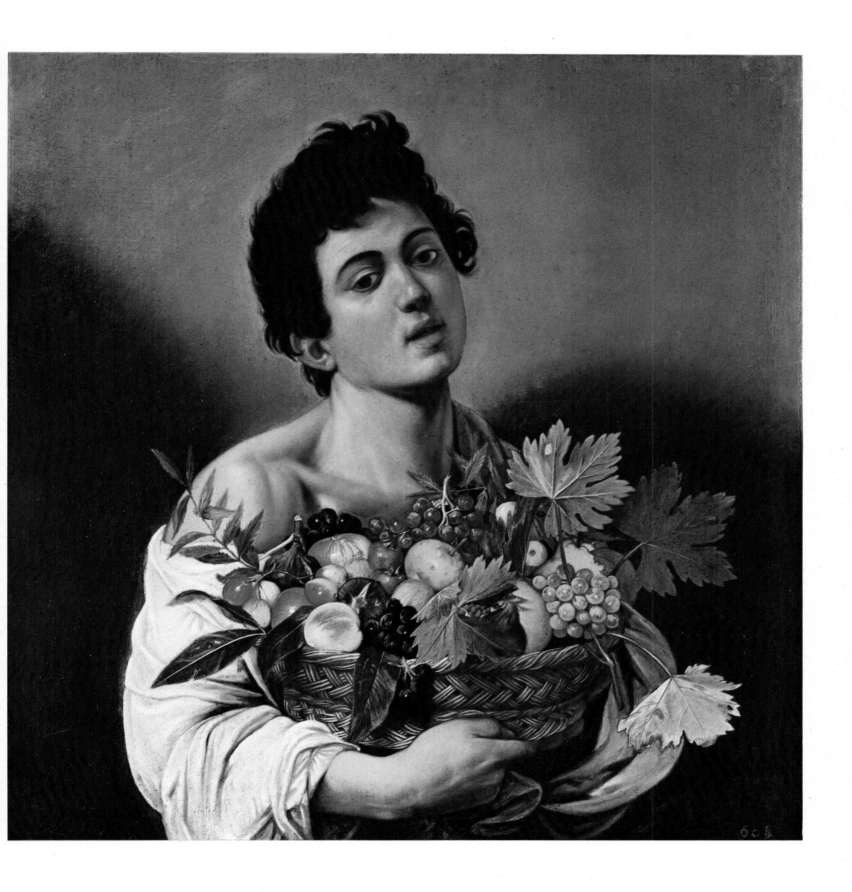

PLATE I BOY WITH A BASKET OF FRUIT Rome, Galleria Borghese
Whole (67 cm.)

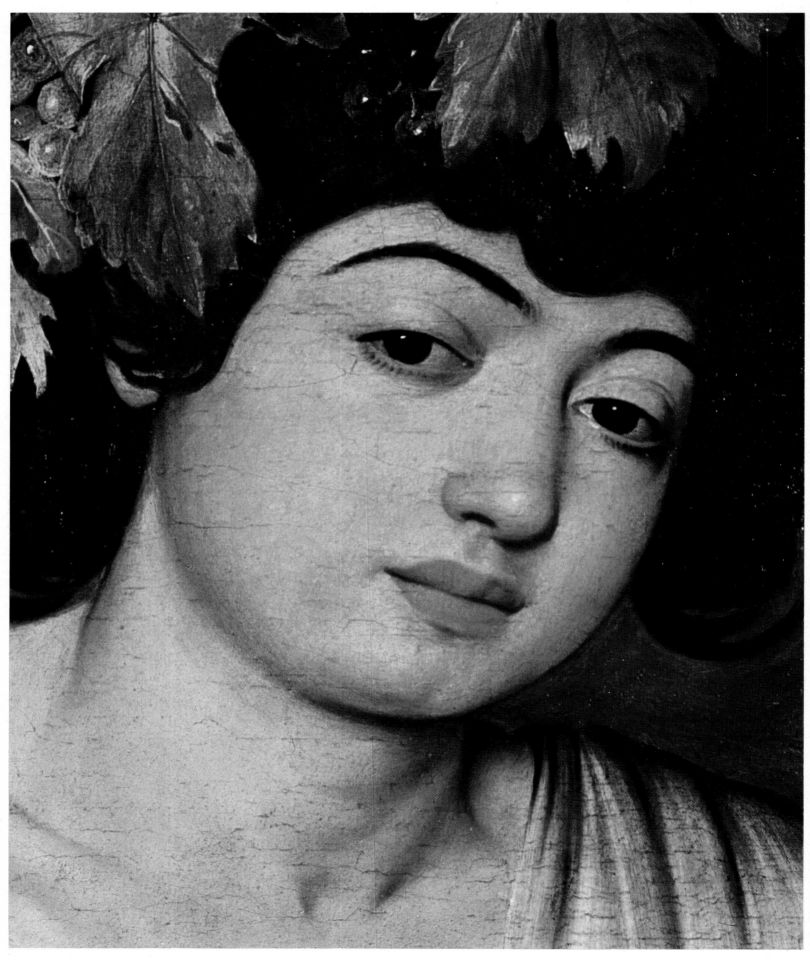

PLATE II BACCHUS Florence, Uffizi
Detail (life size)

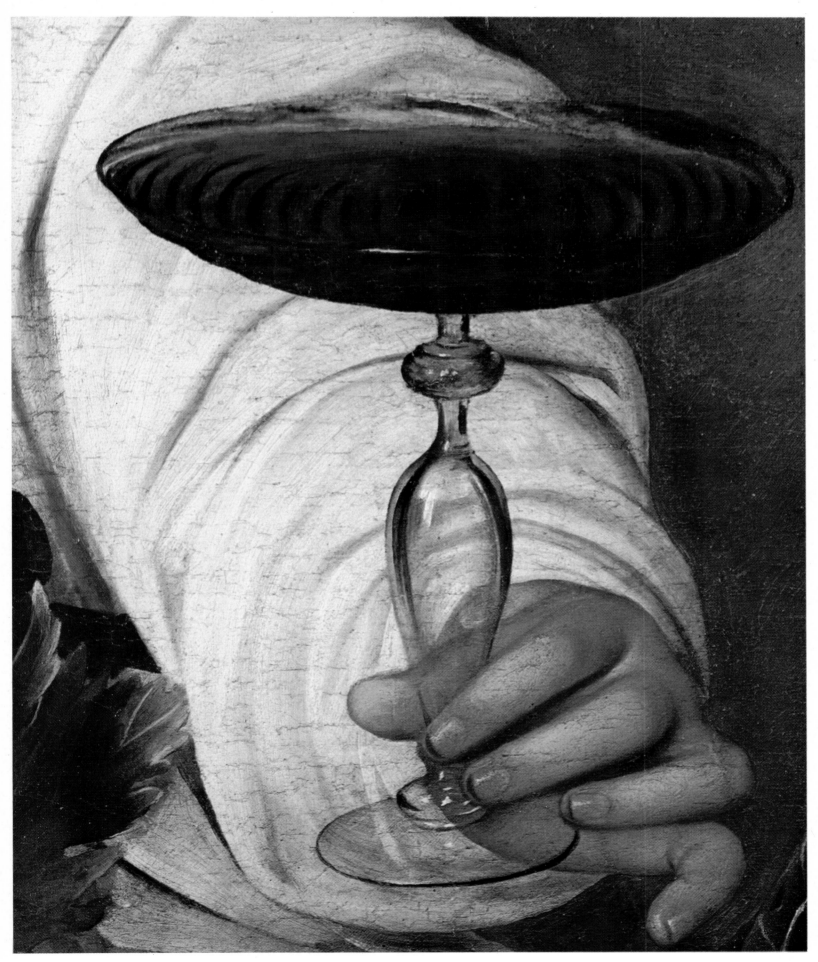

PLATE III BACCHUS Florence, Uffizi
Detail (life size)

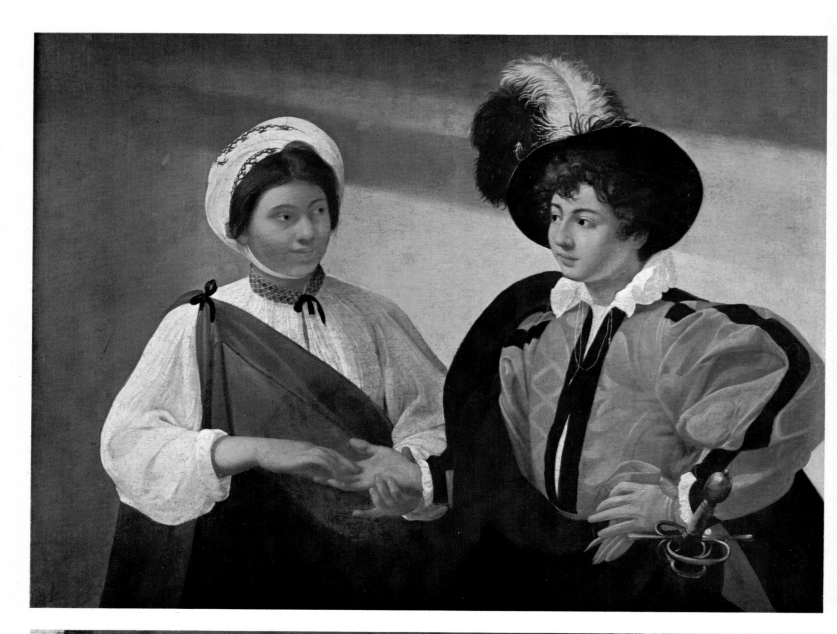

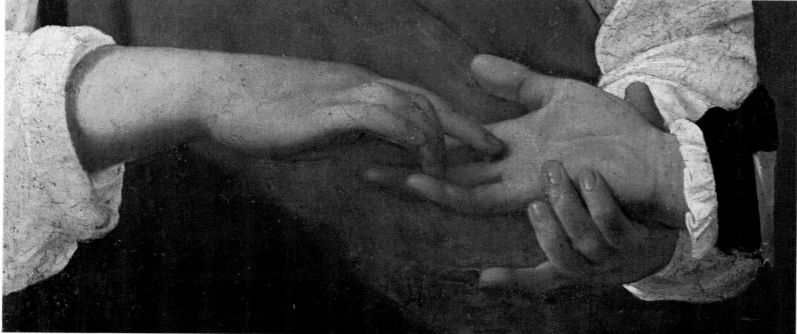

PLATE IV THE FORTUNE TELLER Paris, Louvre
Whole (131 cm.) and detail (44 cm.)

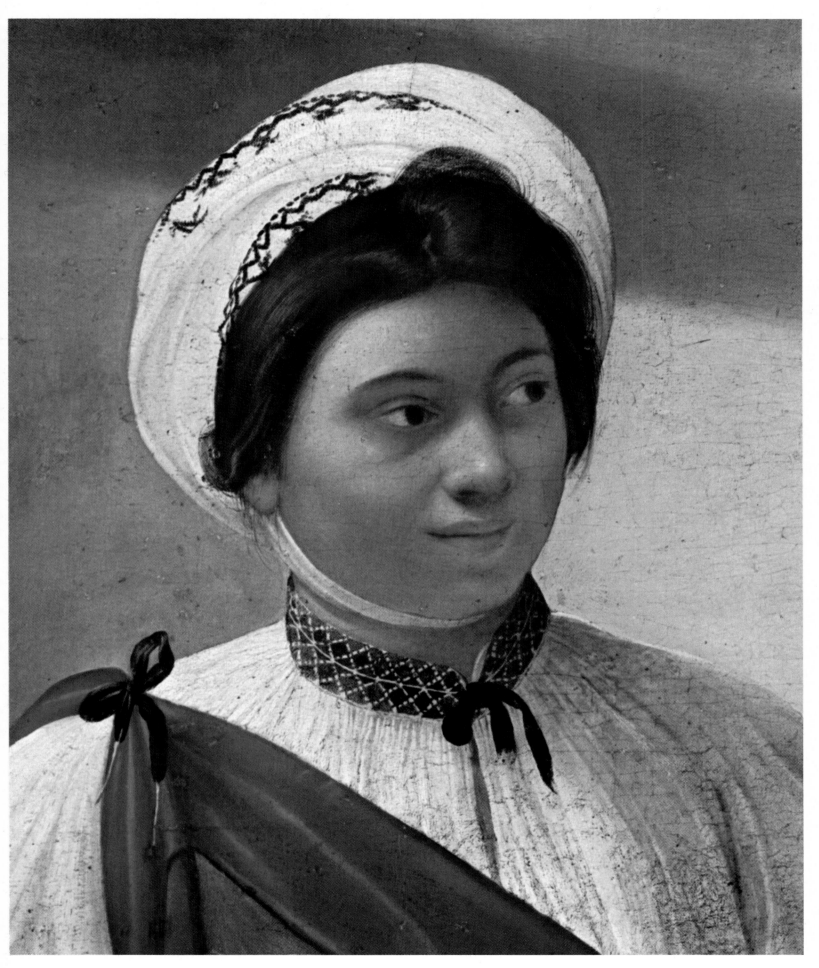

PLATE V THE FORTUNE TELLER Paris, Louvre
Detail (38 cm.)

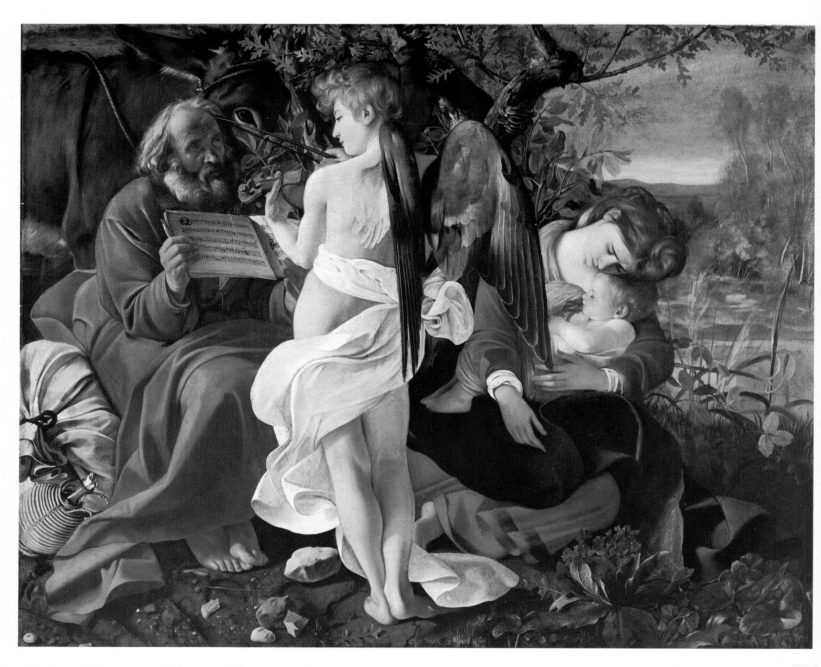

PLATE VI THE REST ON THE FLIGHT INTO EGYPT Rome, Galleria Doria Pamphilj
Whole (160 cm.) and detail (68 cm.)

PLATE VII　　THE REST ON THE FLIGHT INTO EGYPT　Rome, Galleria Doria Pamphilj
Detail (life size)

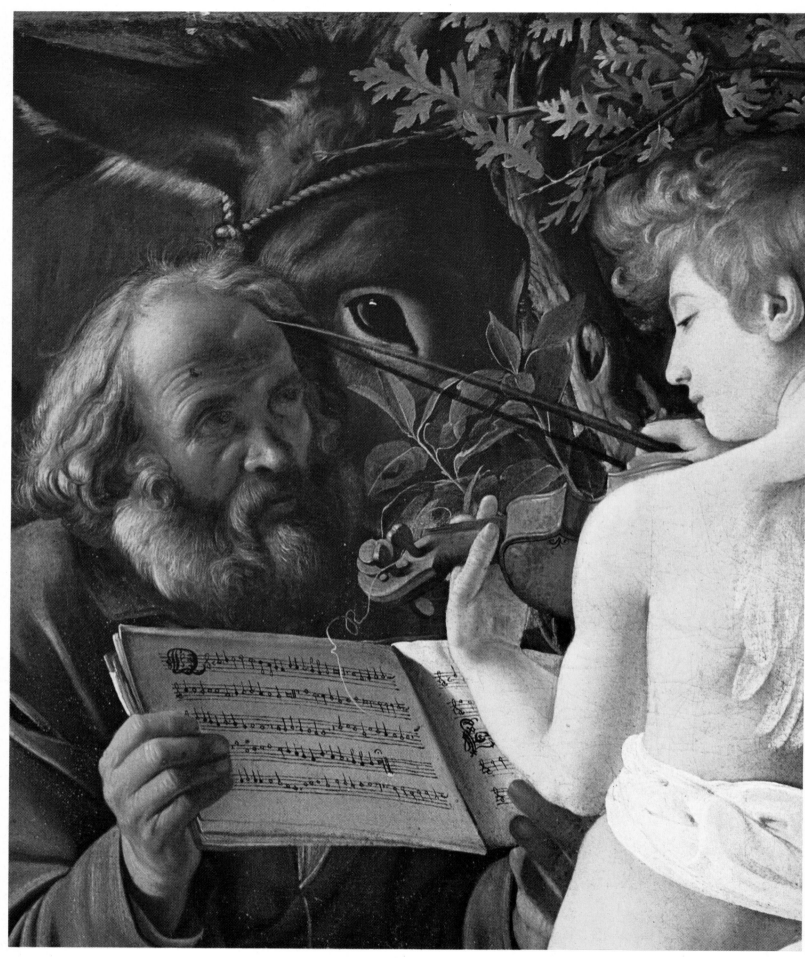

PLATE VIII THE REST ON THE FLIGHT INTO EGYPT Rome, Galleria Doria Pamphilj
Detail (48 cm.)

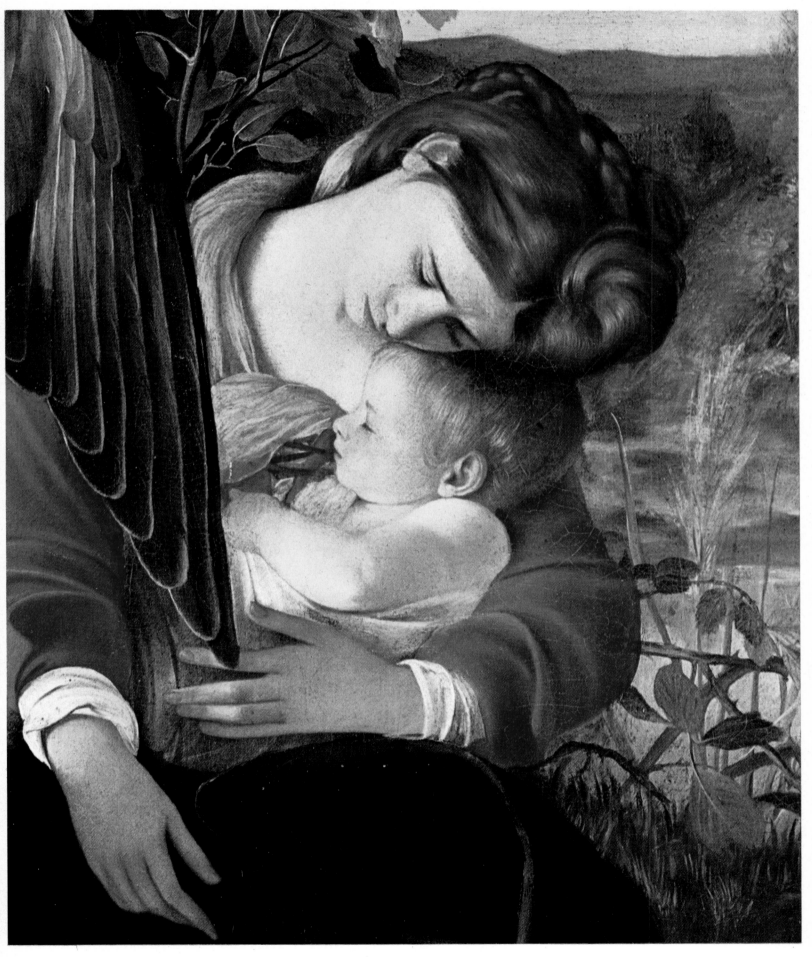

PLATE IX THE REST ON THE FLIGHT INTO EGYPT Rome, Galleria Doria Pamphilj
Detail (48 cm.)

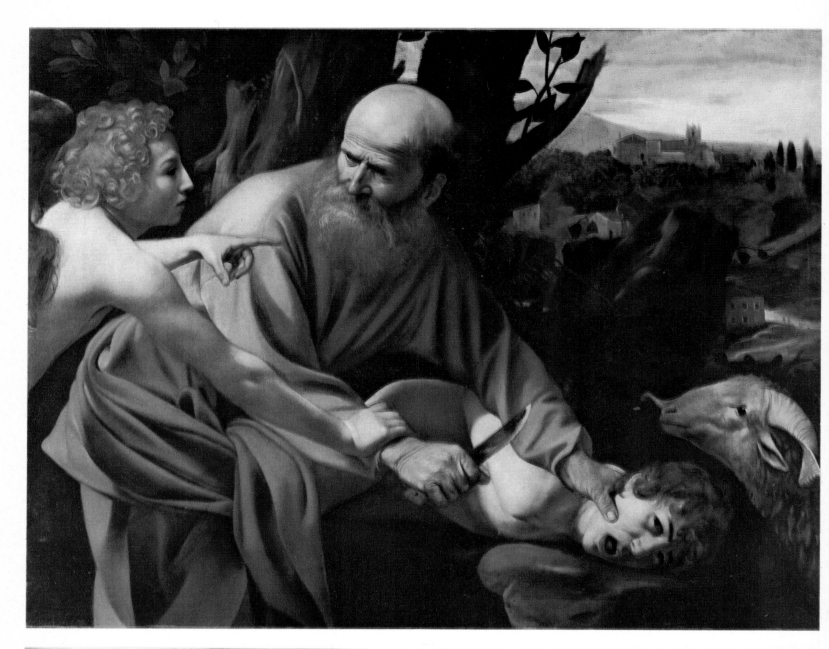

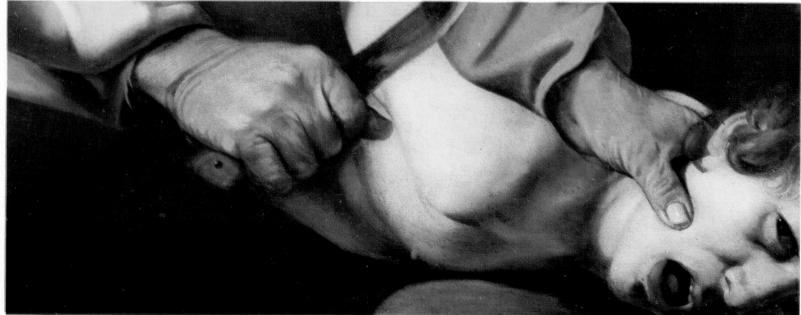

PLATE X THE SACRIFICE OF ISAAC Florence, Uffizi
Whole (135 cm.) and detail (55 cm.)

PLATE XI THE SACRIFICE OF ISAAC Florence, Uffizi
Detail (55 cm.)

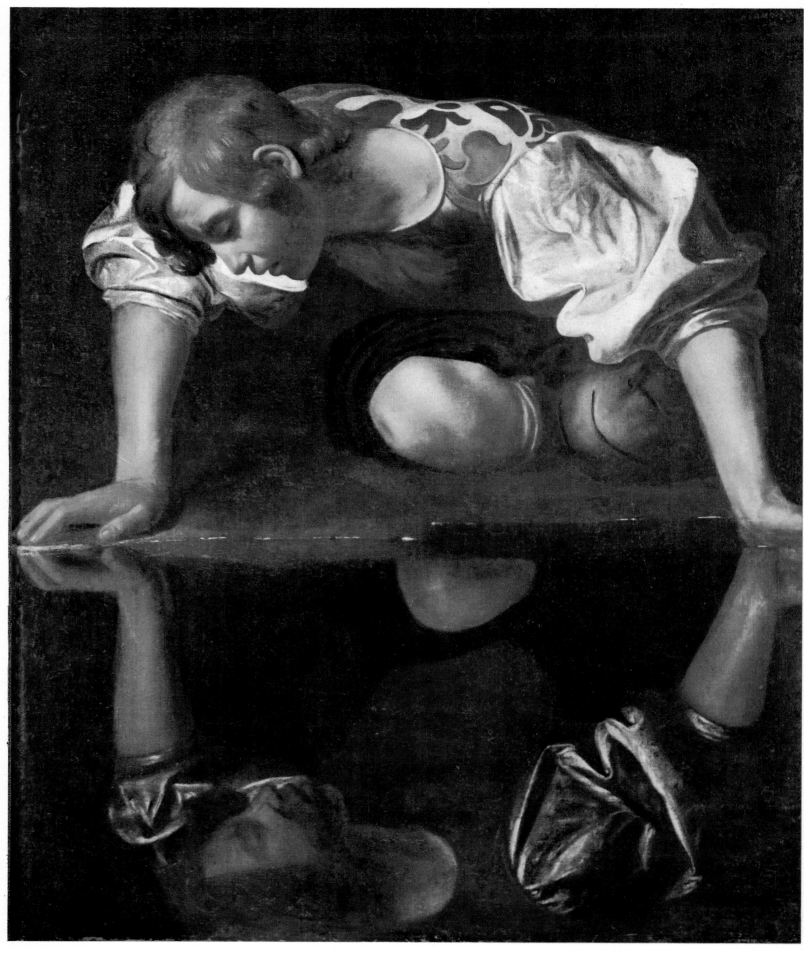

PLATE XII NARCISSUS Rome, Galleria Nazionale
Whole (92 cm.)

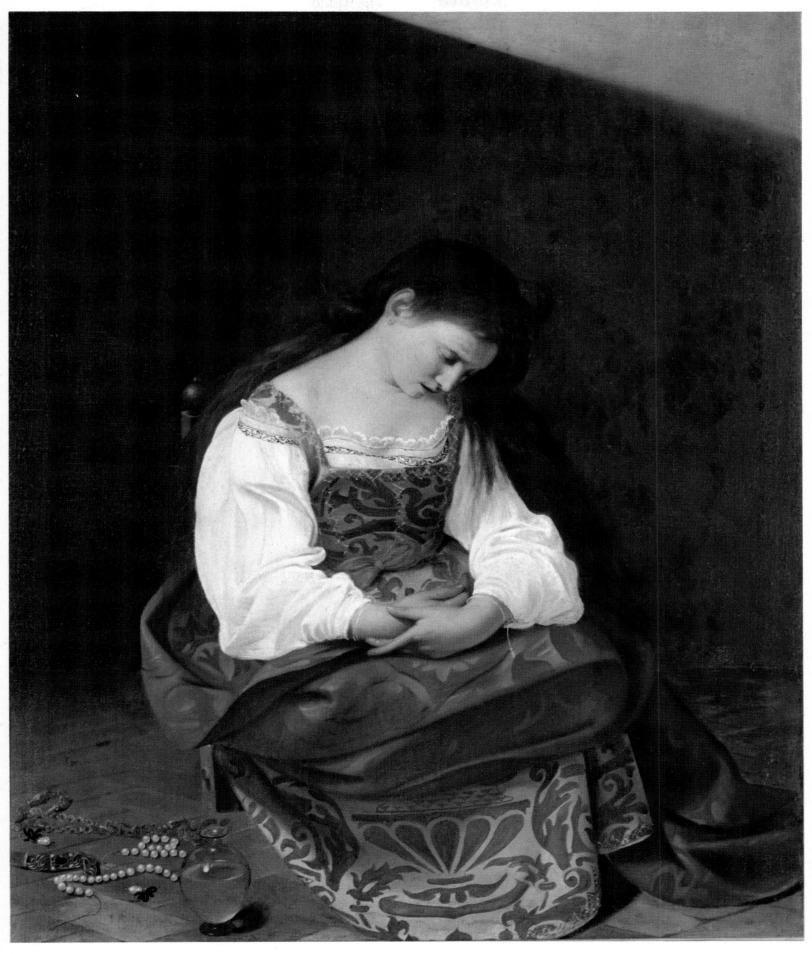

PLATE XIII THE MAGDALENE Rome, Galleria Doria Pamphilj
Whole (97 cm.)

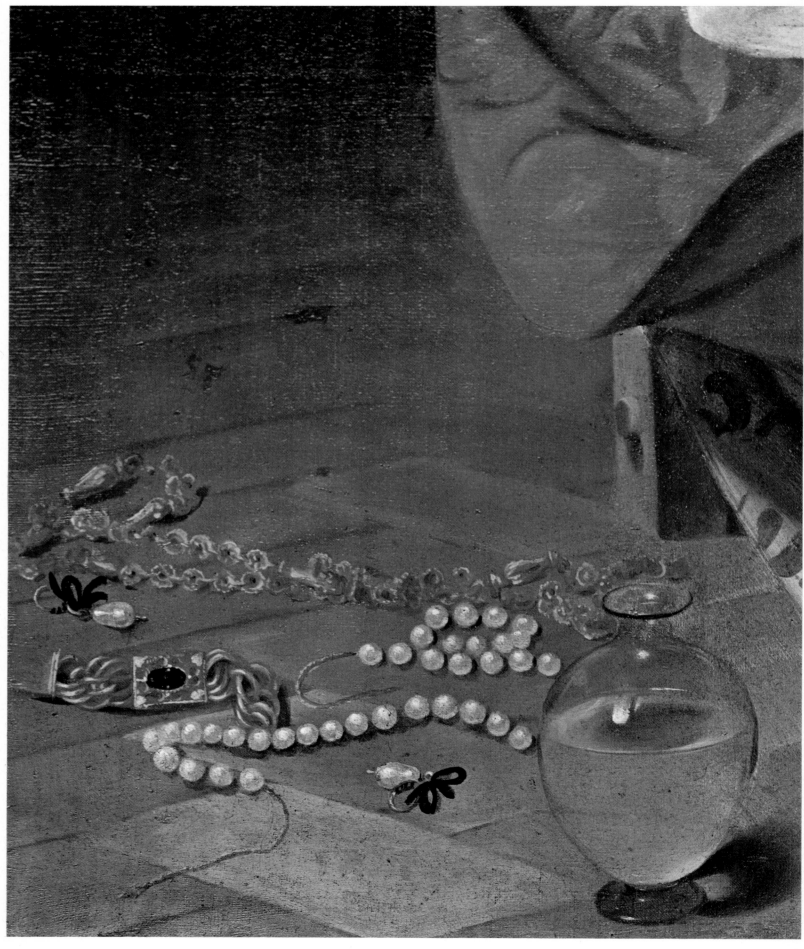

PLATE XIV THE MAGDALENE Rome, Galleria Doria Pamphilj
Detail (30 cm.)

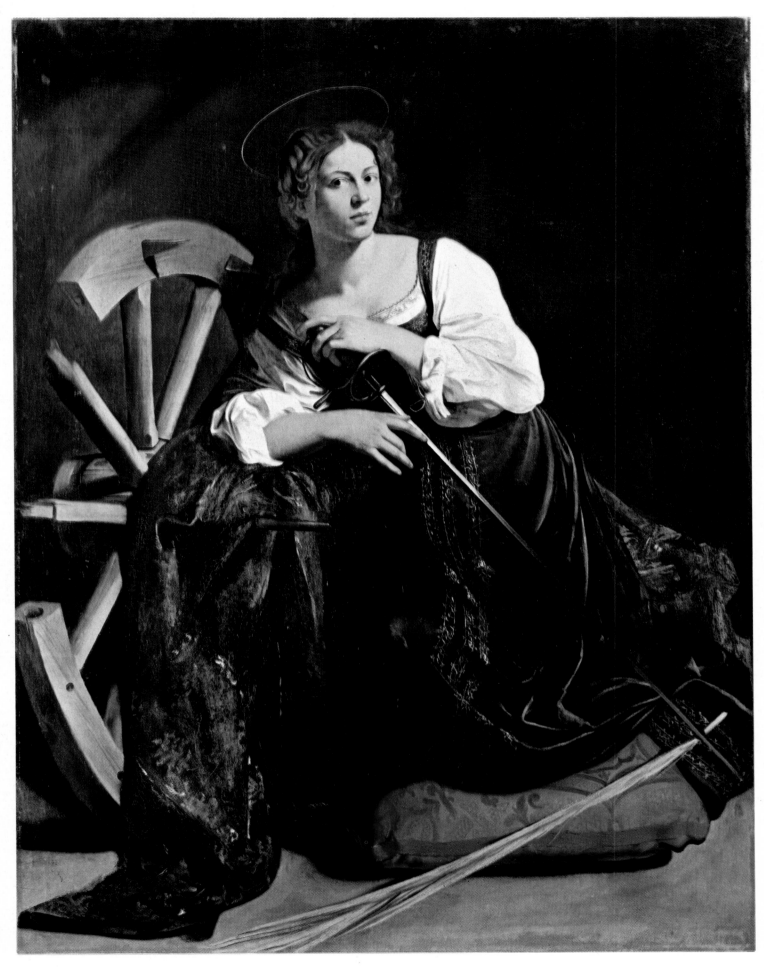

PLATE XV ST CATHERINE OF ALEXANDRIA Lugano, Thyssen Collection
Whole (133 cm.)

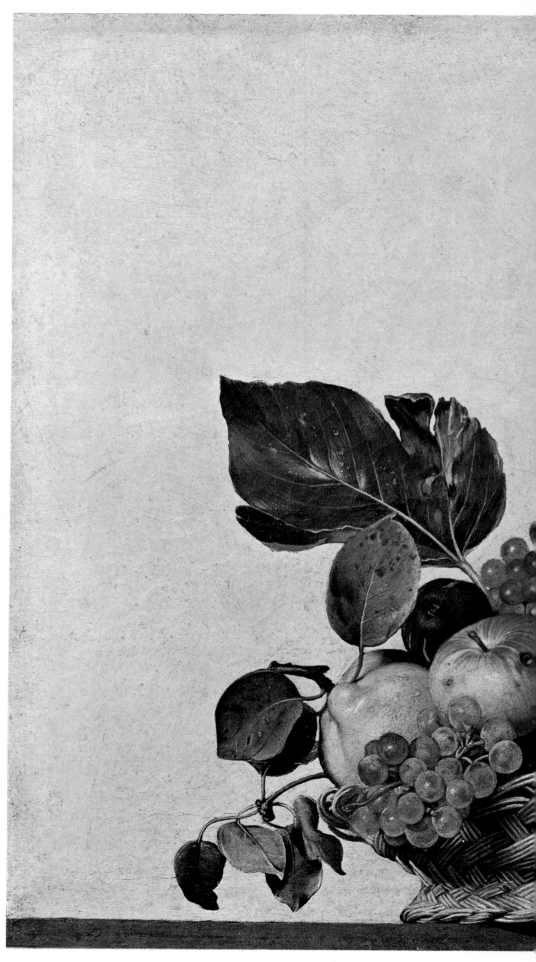

BASKET OF FRUIT Milan, Pinacoteca Ambrosiana
Whole (64.5 cm.)

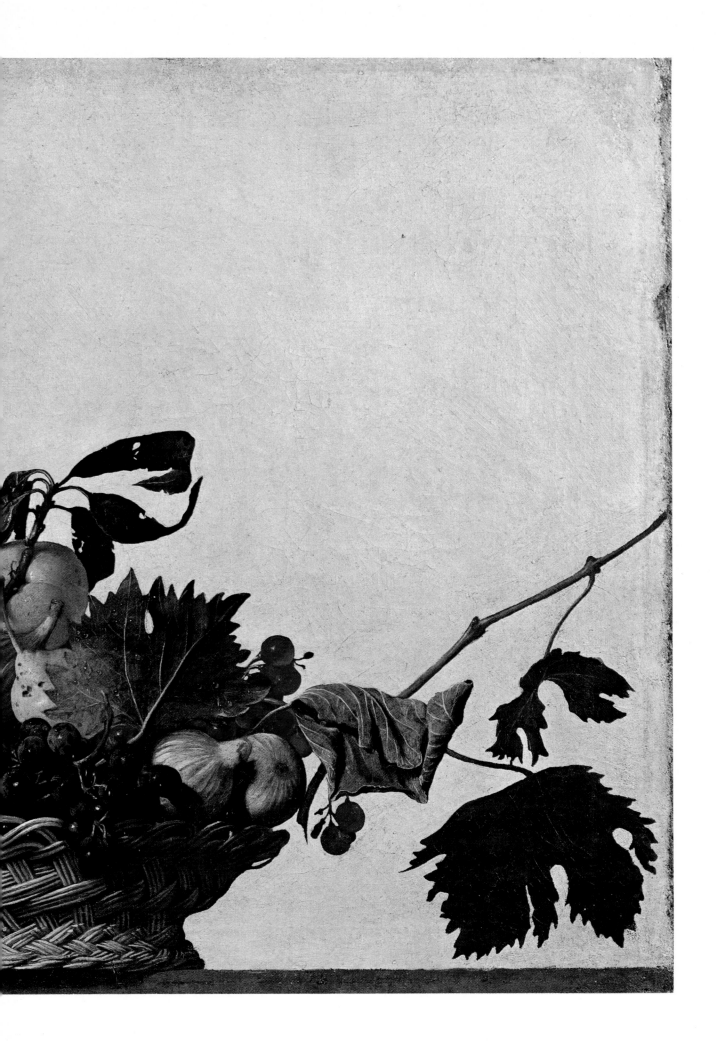

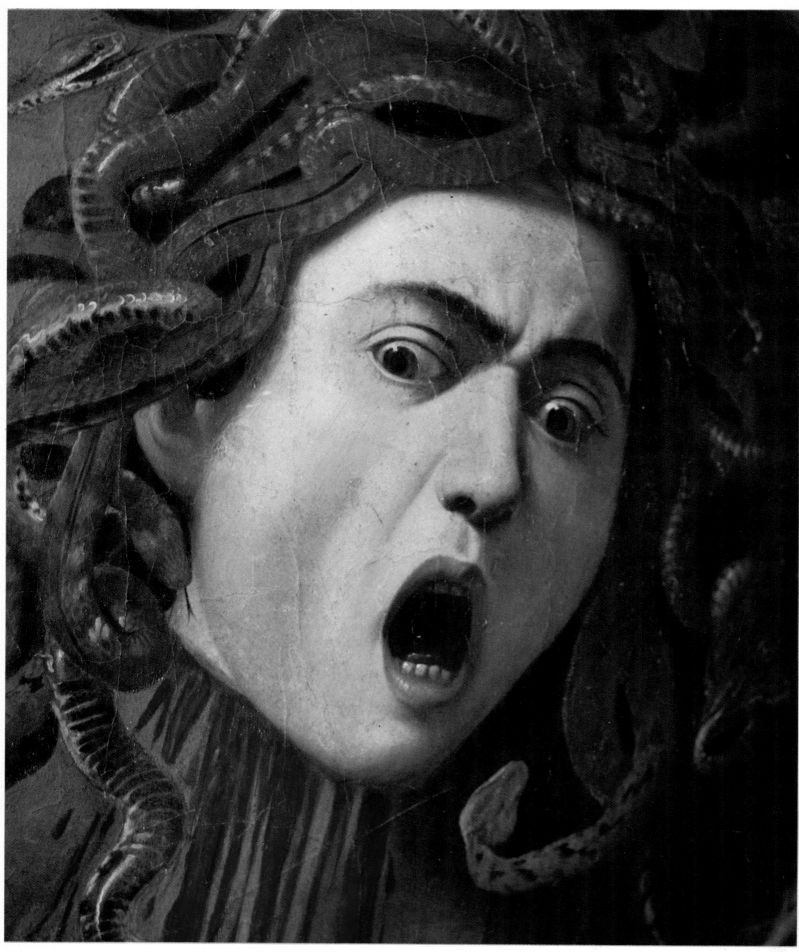

PLATE XVIII HEAD OF THE MEDUSA Florence, Uffizi
Detail (24 cm.)

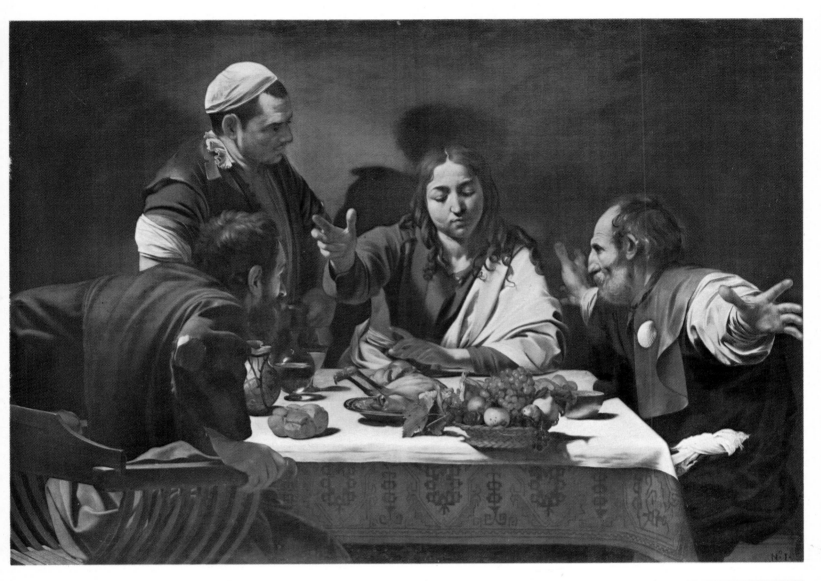

PLATE XIX THE SUPPER AT EMMAUS London, National Gallery
Whole (195 cm.) and detail (38 cm.)

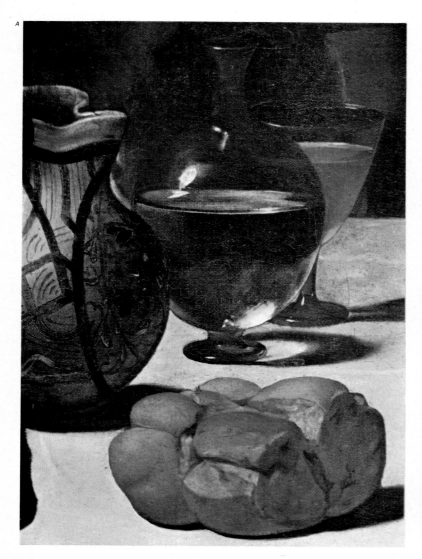

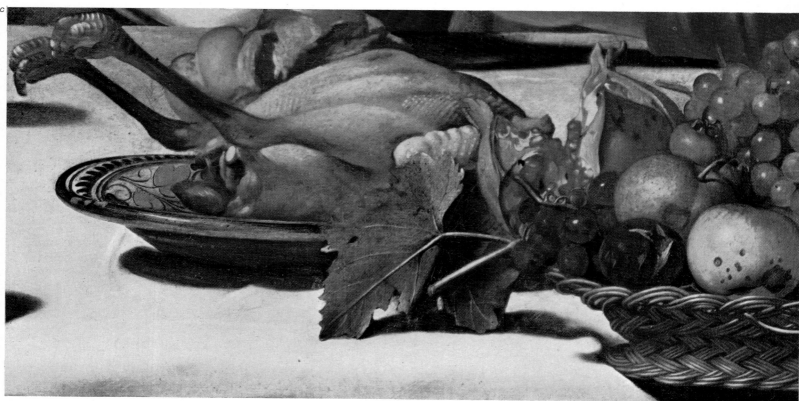

PLATE XX THE SUPPER AT EMMAUS London, National Gallery
Details (the top two 22 cm., the bottom 45 cm.)

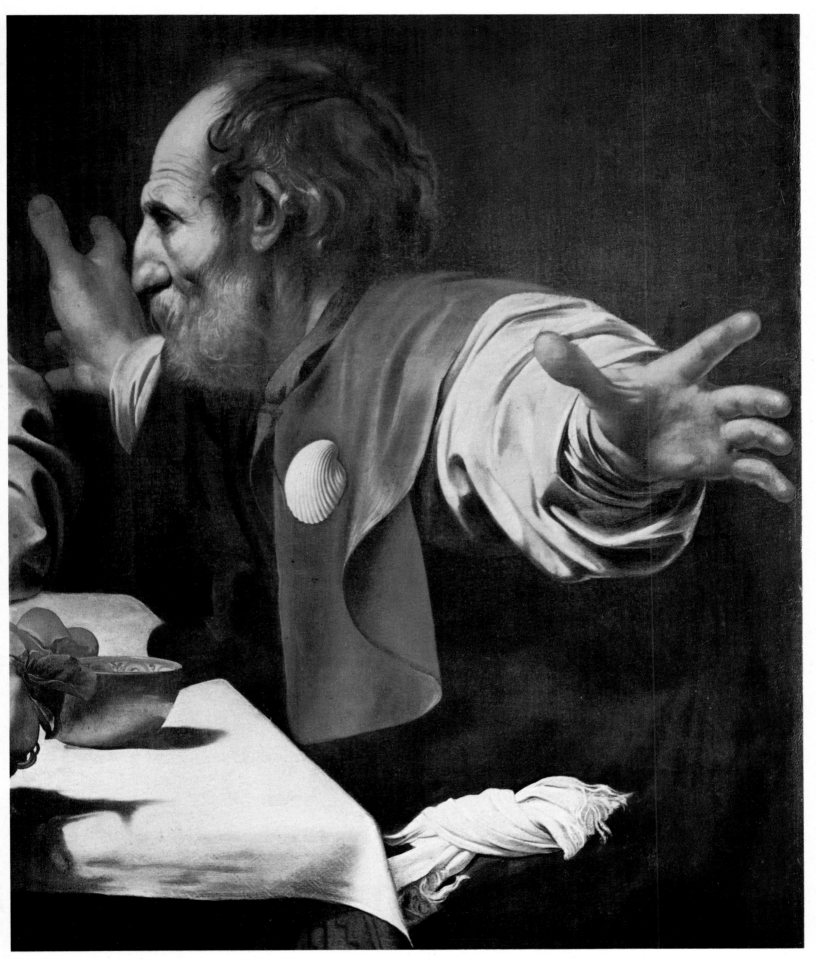

PLATE XXI THE SUPPER AT EMMAUS London, National Gallery
Detail (63 cm.)

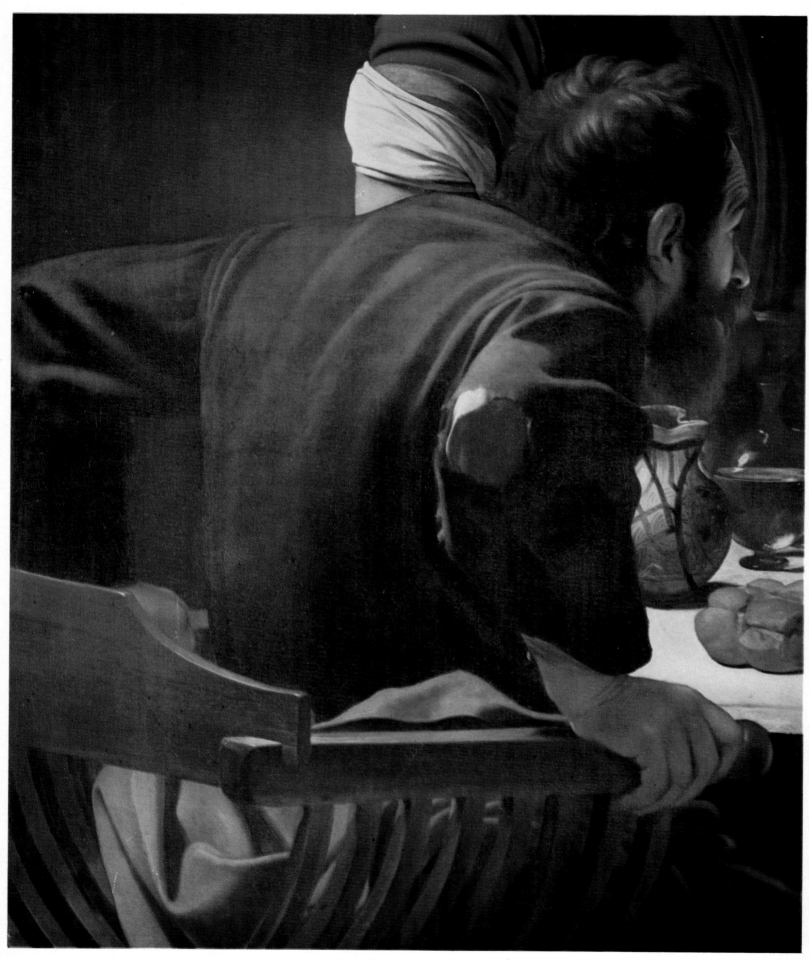

PLATE XXII THE SUPPER AT EMMAUS London, National Gallery
Detail (72 cm.)

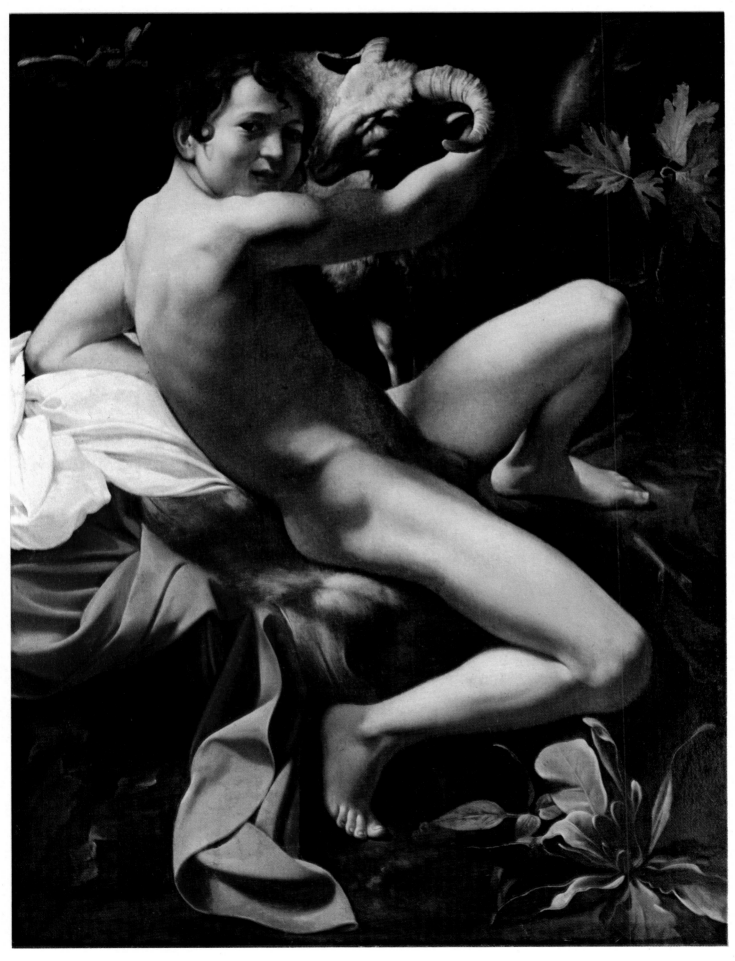

PLATE XXIII ST JOHN THE BAPTIST Rome, Musei Capitolini
Whole (97 cm.)

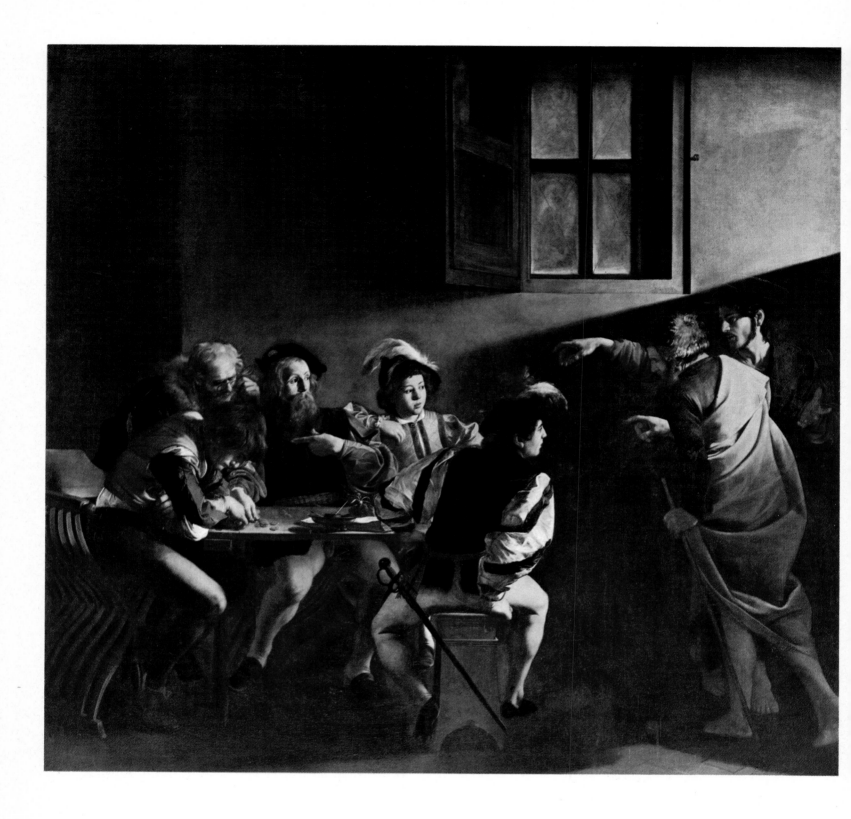

PLATE XXIV THE CALLING OF ST MATTHEW Rome, S. Luigi dei Francesi
Whole (340 cm.)

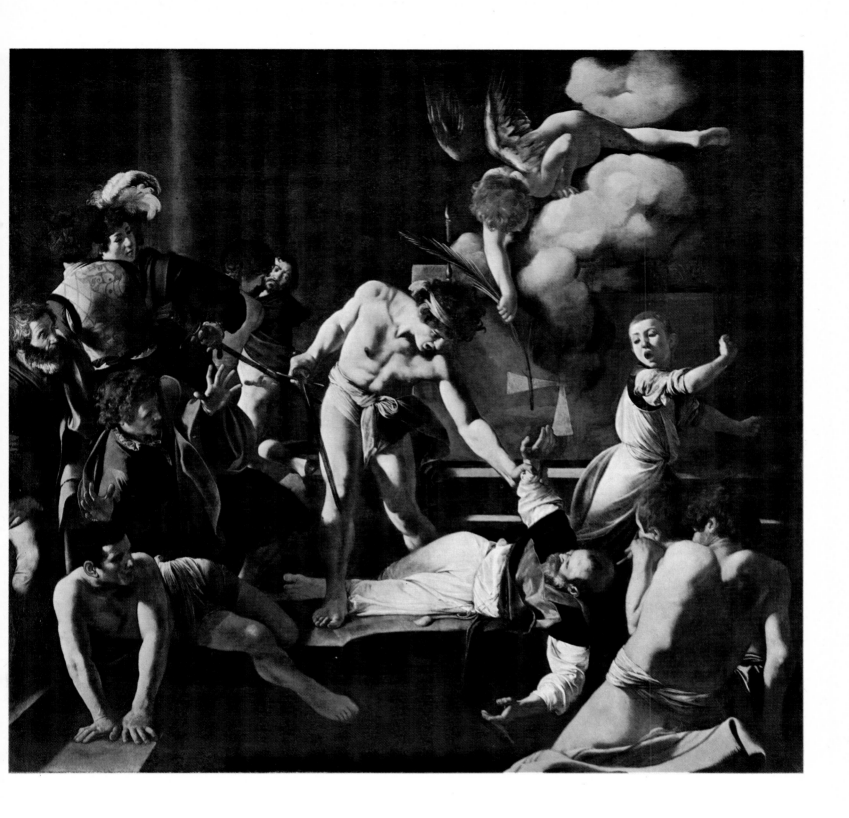

PLATE XXV THE MARTYRDOM OF ST MATTHEW Rome, S. Luigi dei Francesi
Whole (343 cm.)

PLATE XXVI THE CALLING OF ST MATTHEW Rome, S. Luigi dei Francesi
Detail (86 cm.)

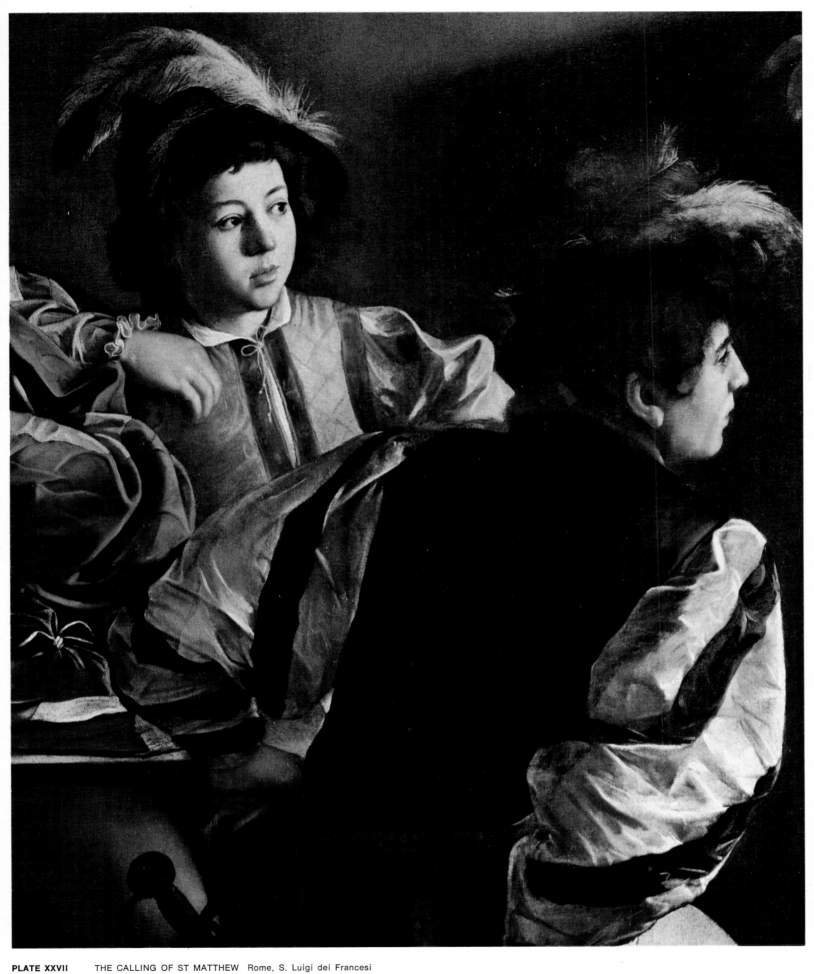

PLATE XXVII THE CALLING OF ST MATTHEW Rome, S. Luigi dei Francesi
Detail (92 cm.)

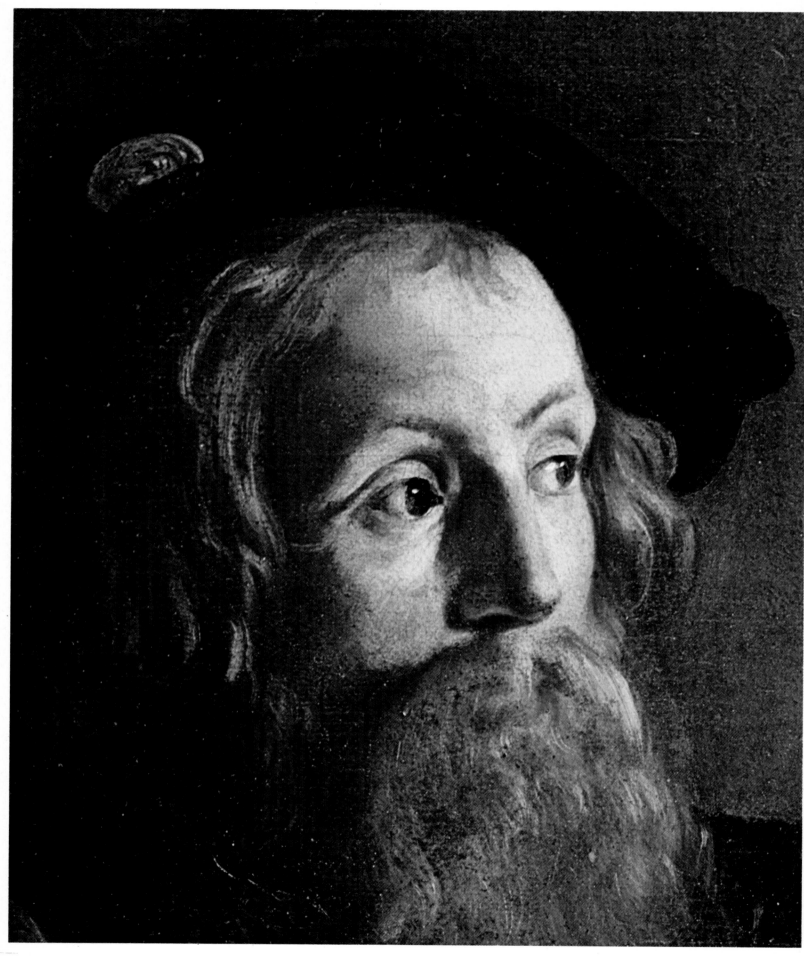

PLATE XXVIII THE CALLING OF ST MATTHEW Rome, S. Luigi dei Francesi
Detail (30 cm.)

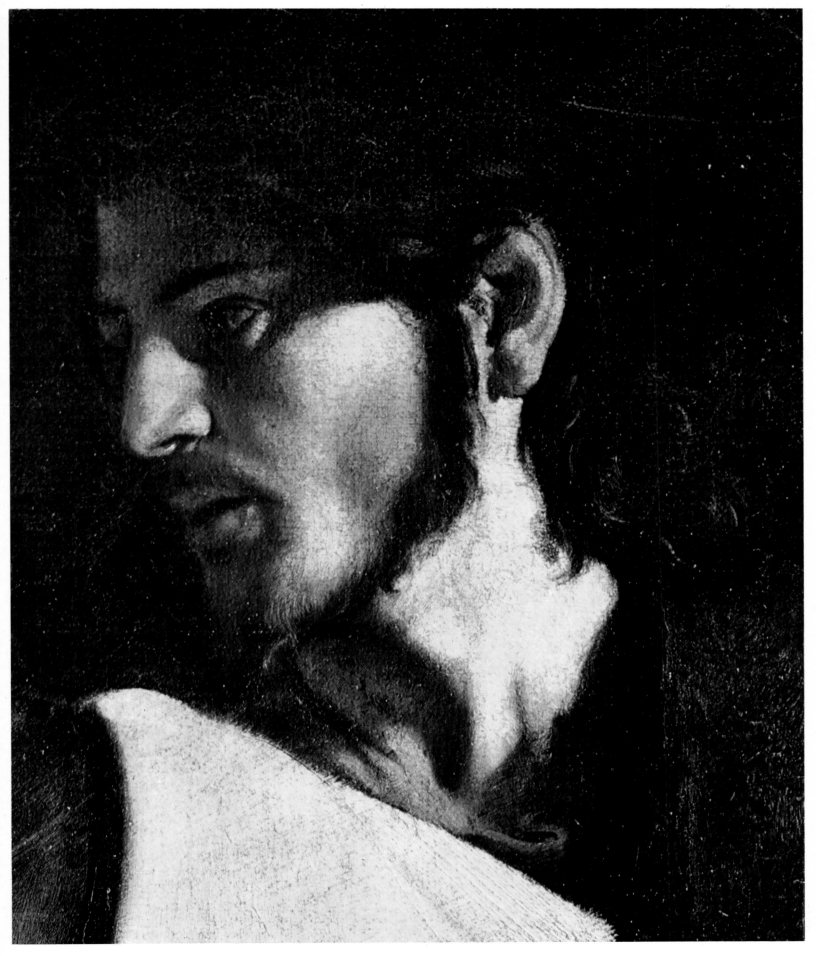

PLATE XXIX THE CALLING OF ST MATTHEW Rome, S. Luigi dei Francesi
Detail (30 cm.)

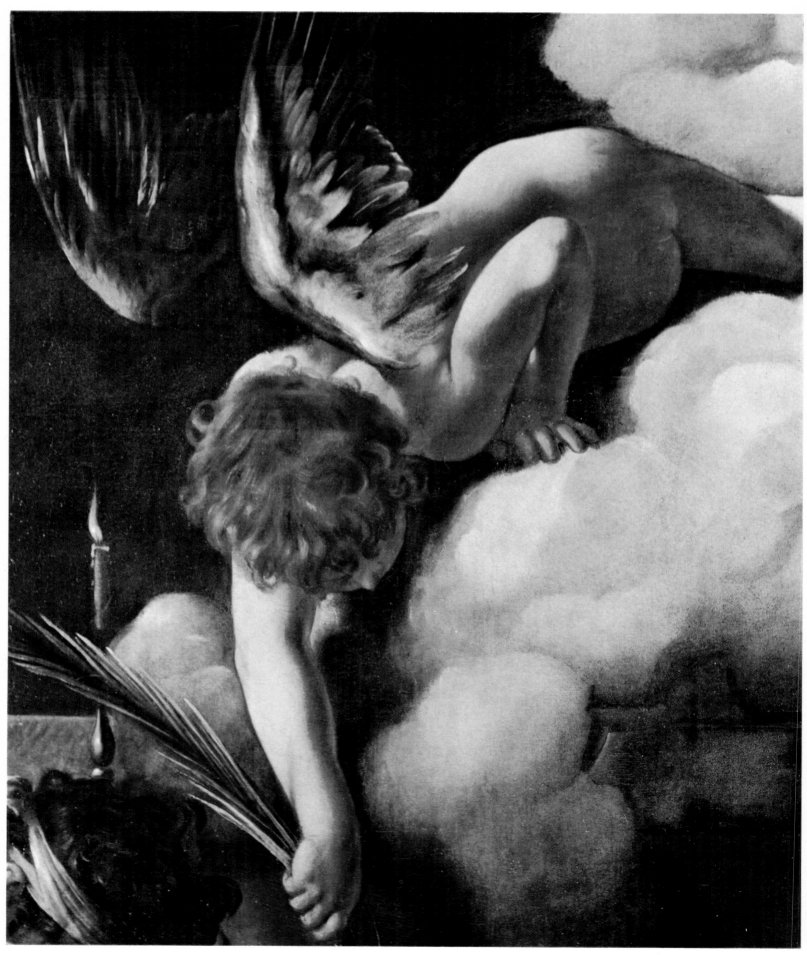

PLATE XXX THE MARTYRDOM OF ST MATTHEW Rome, S. Luigi dei Francesi
Detail (90 cm.)

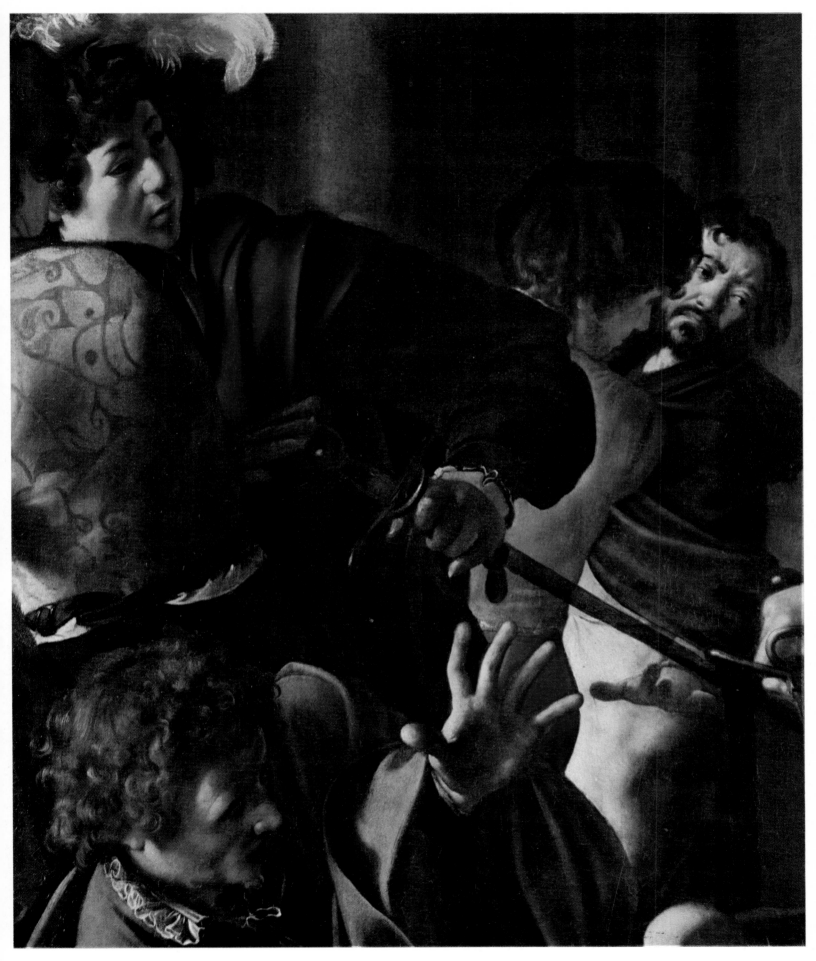

PLATE XXXI THE MARTYRDOM OF ST MATTHEW Rome, S. Luigi dei Francesi
Detail (90 cm.)

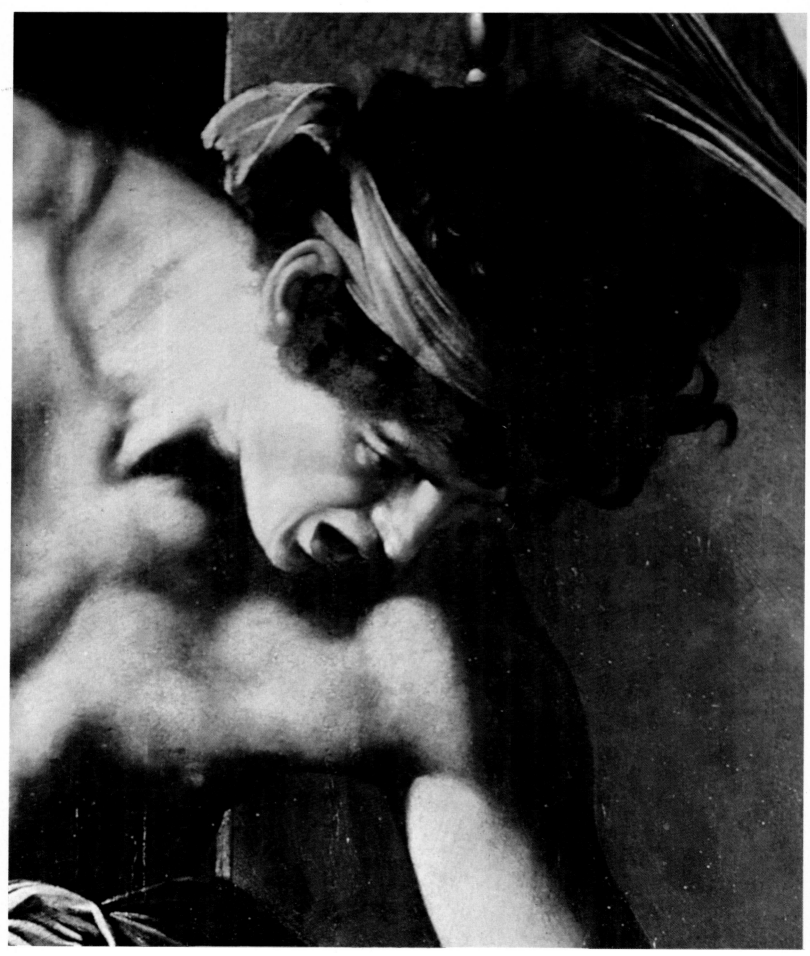

PLATE XXXII THE MARTYRDOM OF ST MATTHEW Rome, S. Luigi dei Francesi
Detail (49 cm.)

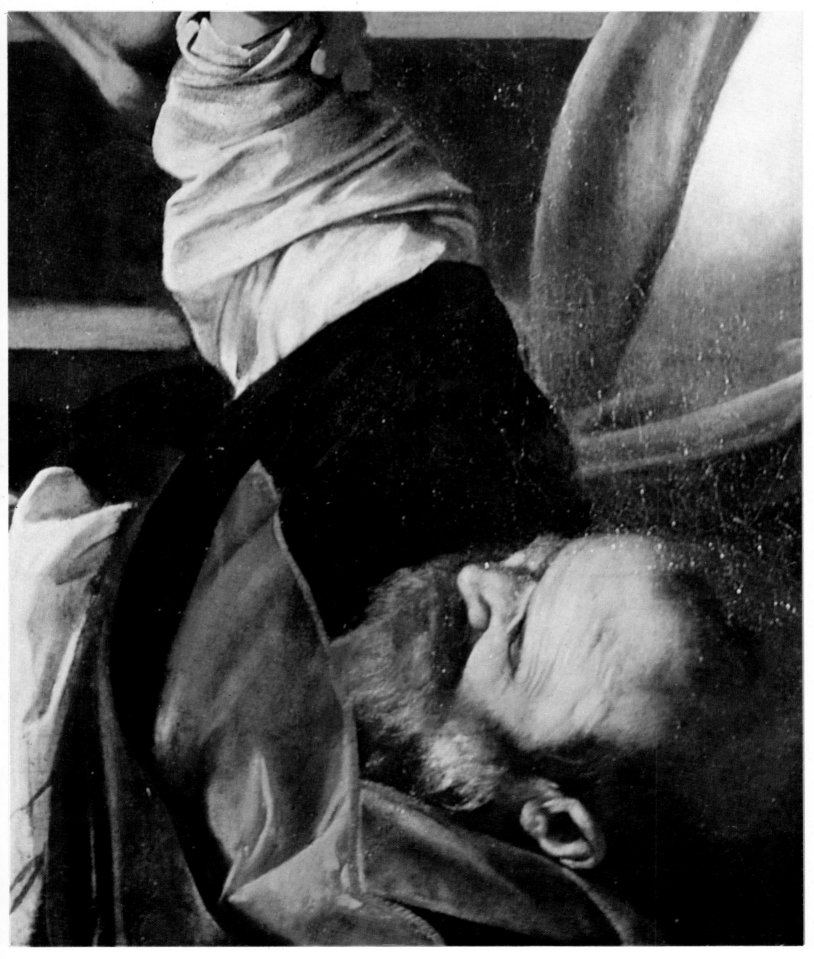

PLATE XXXIII THE MARTYRDOM OF ST MATTHEW Rome, S. Luigi dei Francesi
Detail (49 cm.)

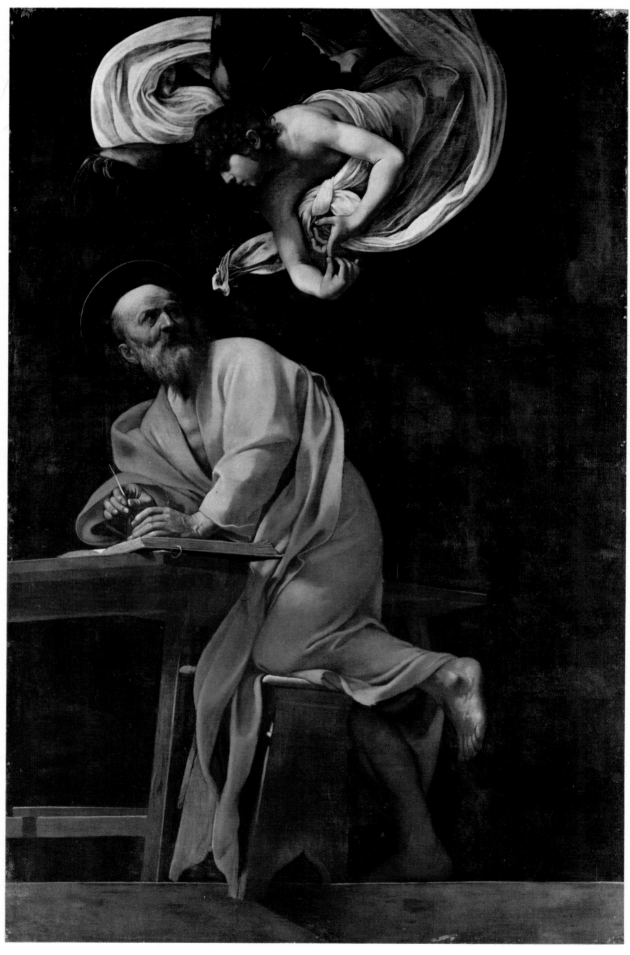

PLATE XXXIV ST MATTHEW AND THE ANGEL Rome, S. Luigi dei Francesi
Whole (189 cm.)

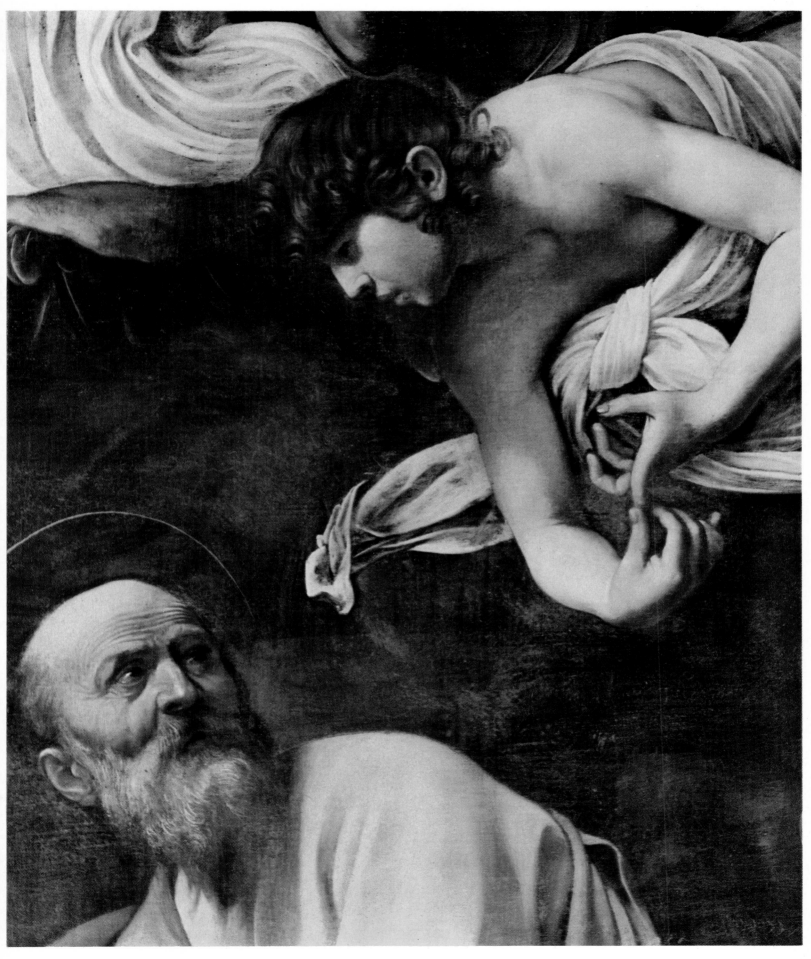

PLATE XXXV ST MATTHEW AND THE ANGEL Rome, S. Luigi dei Francesi
Detail (87 cm.)

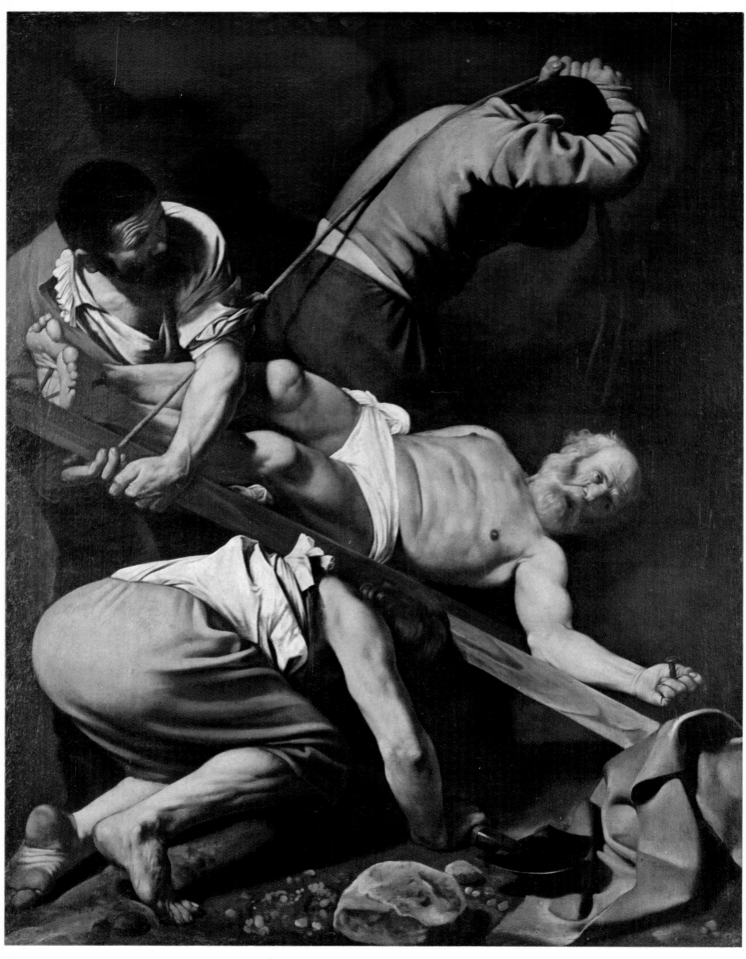

PLATE XXXVI THE CRUCIFIXION OF ST PETER Rome, Sta Maria del Popolo
Whole (175 cm.)

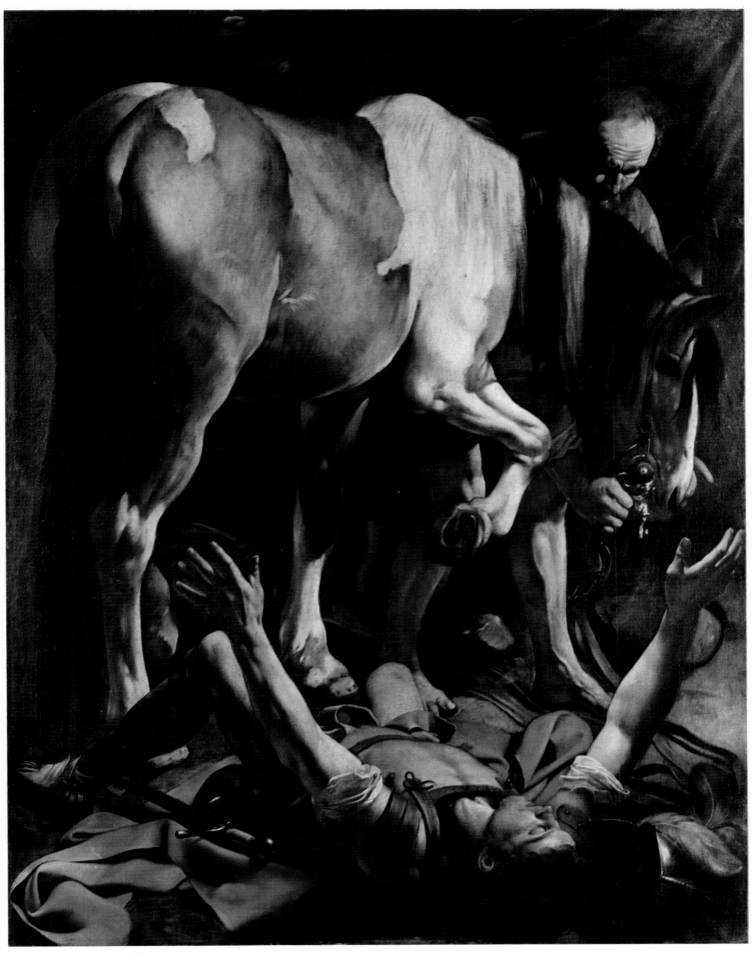

PLATE XXXVII THE CONVERSION OF ST PAUL Rome, Sta Maria del Popolo
Whole (175 cm.)

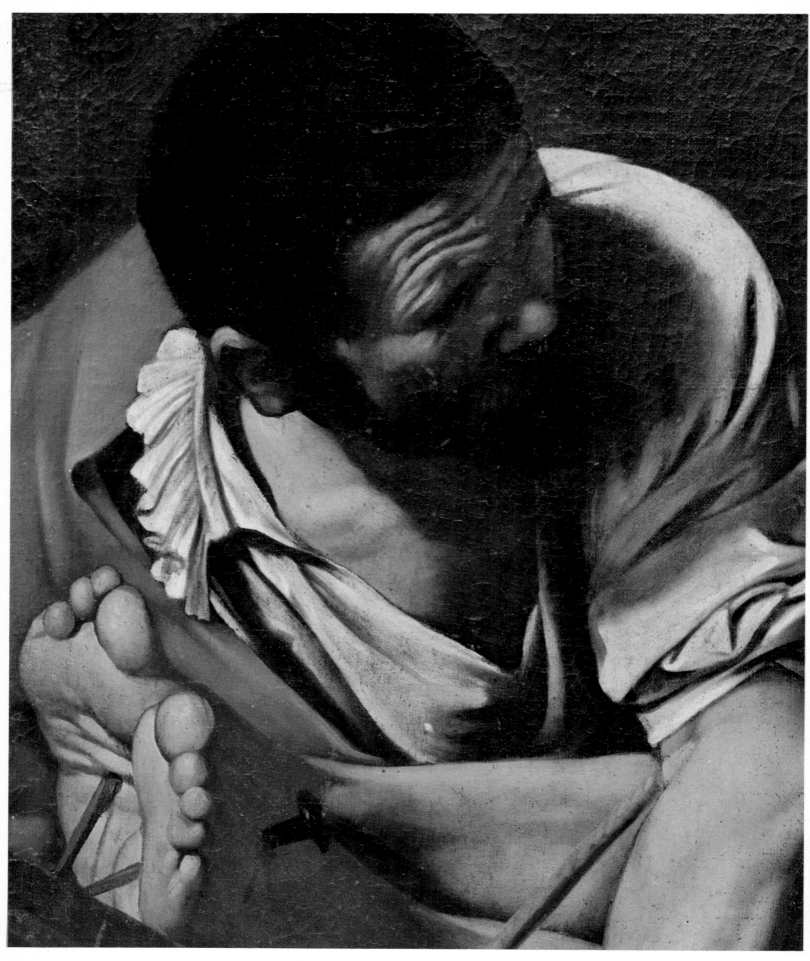

PLATE XXXVIII THE CRUCIFIXION OF ST PETER Rome, Sta Maria del Popolo
Detail (51 cm.)

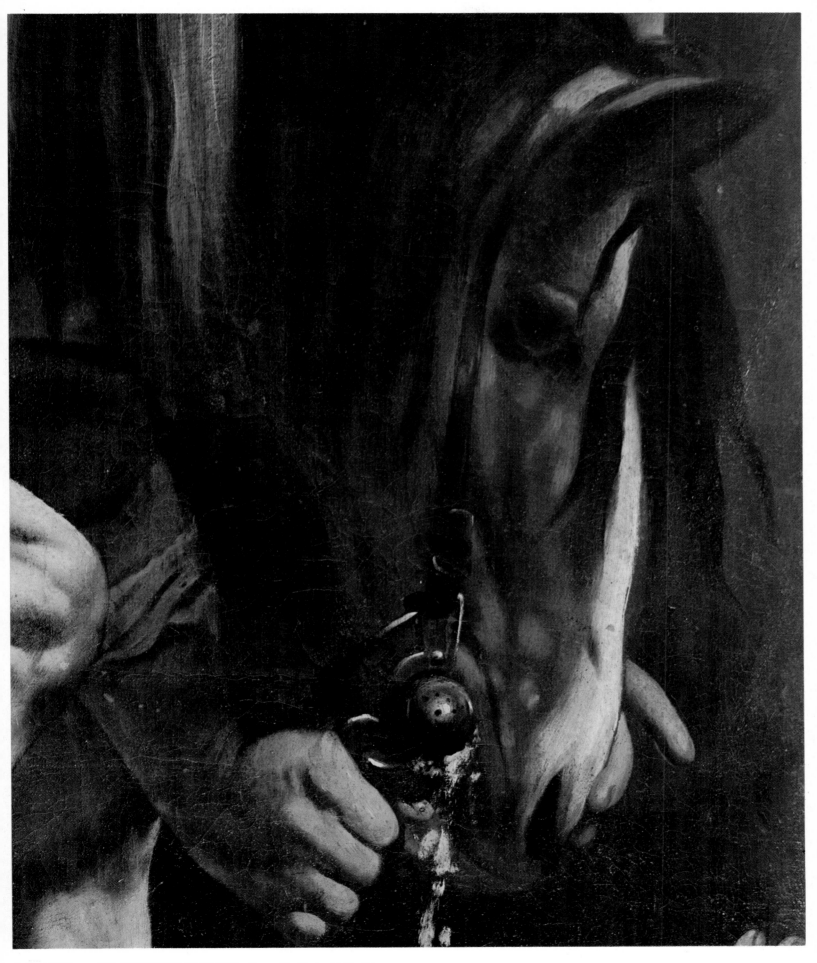

PLATE XXXIX THE CONVERSION OF ST PAUL Rome, Sta Maria del Popolo
Detail (51 cm.)

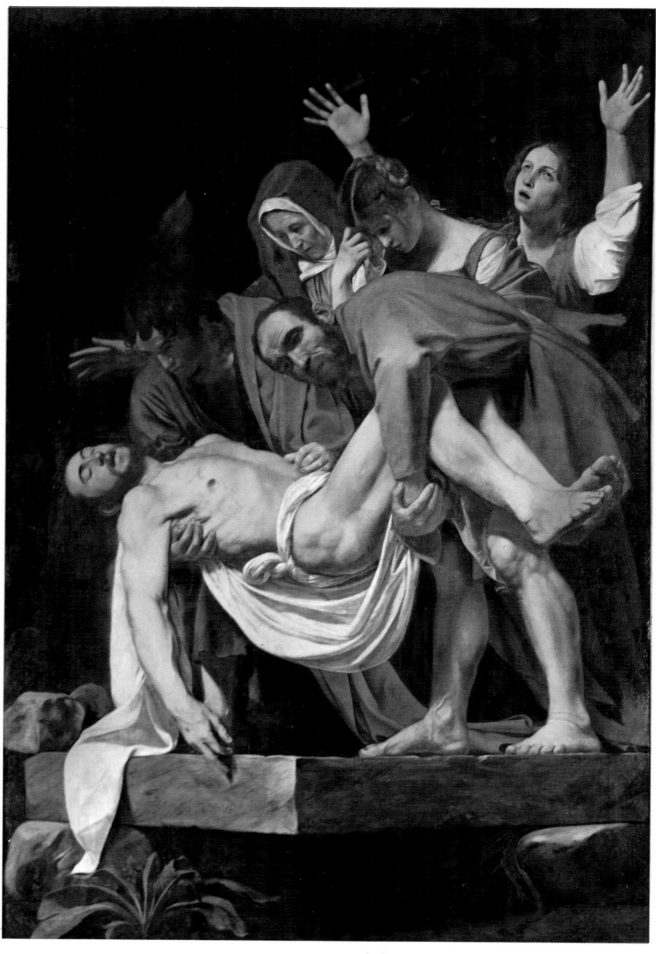

PLATE XL THE ENTOMBMENT OF CHRIST Rome, Pinacoteca Vaticana
Whole (203 cm.)

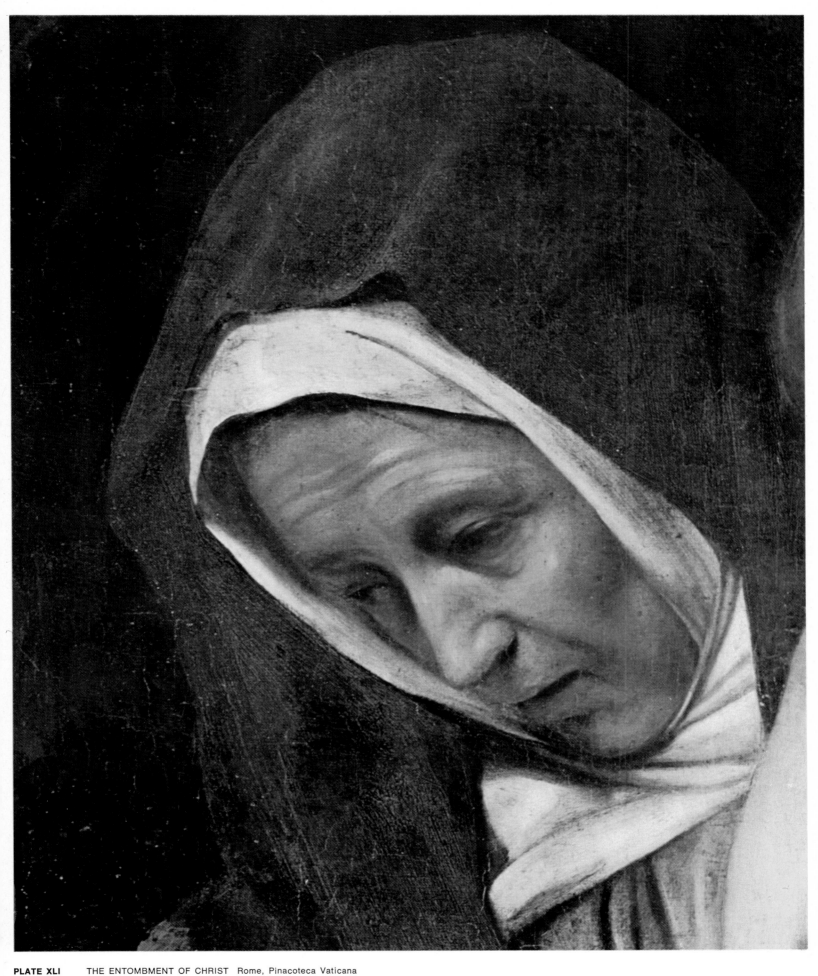

PLATE XLI THE ENTOMBMENT OF CHRIST Rome, Pinacoteca Vaticana
Detail (30 cm.)

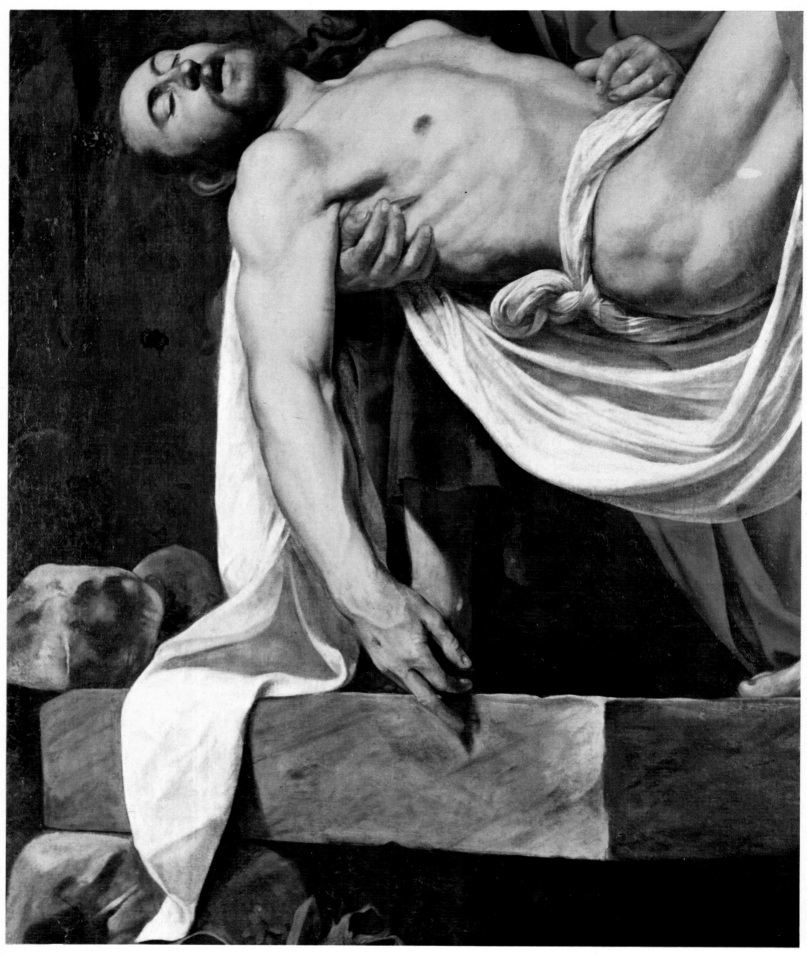

PLATE XLII THE ENTOMBMENT OF CHRIST Rome, Pinacoteca Vaticana
Detail (118 cm.)

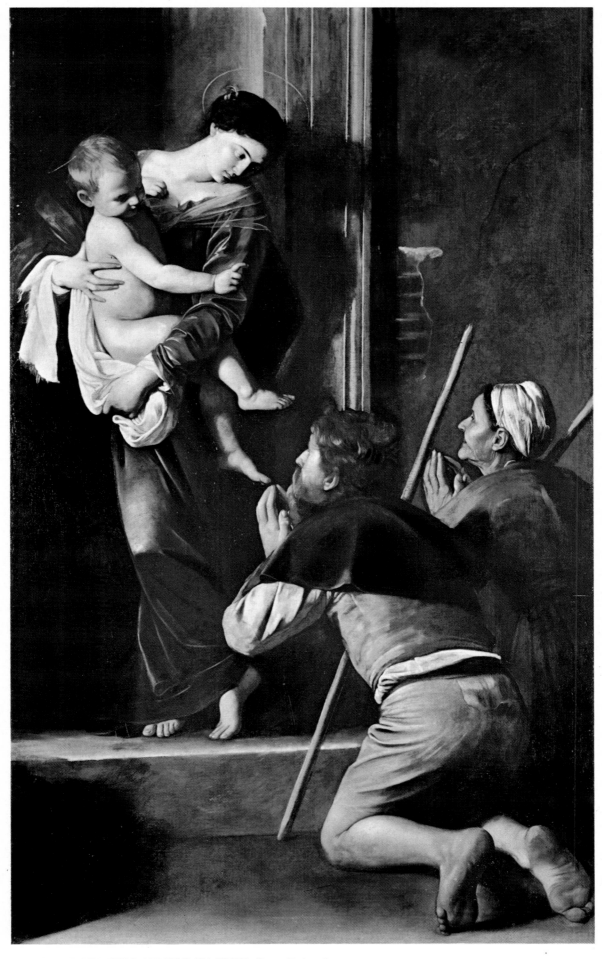

MADONNA DEI PELLEGRINI (MADONNA DI LORETO) Rome, S. Agostino
Whole (150 cm.)

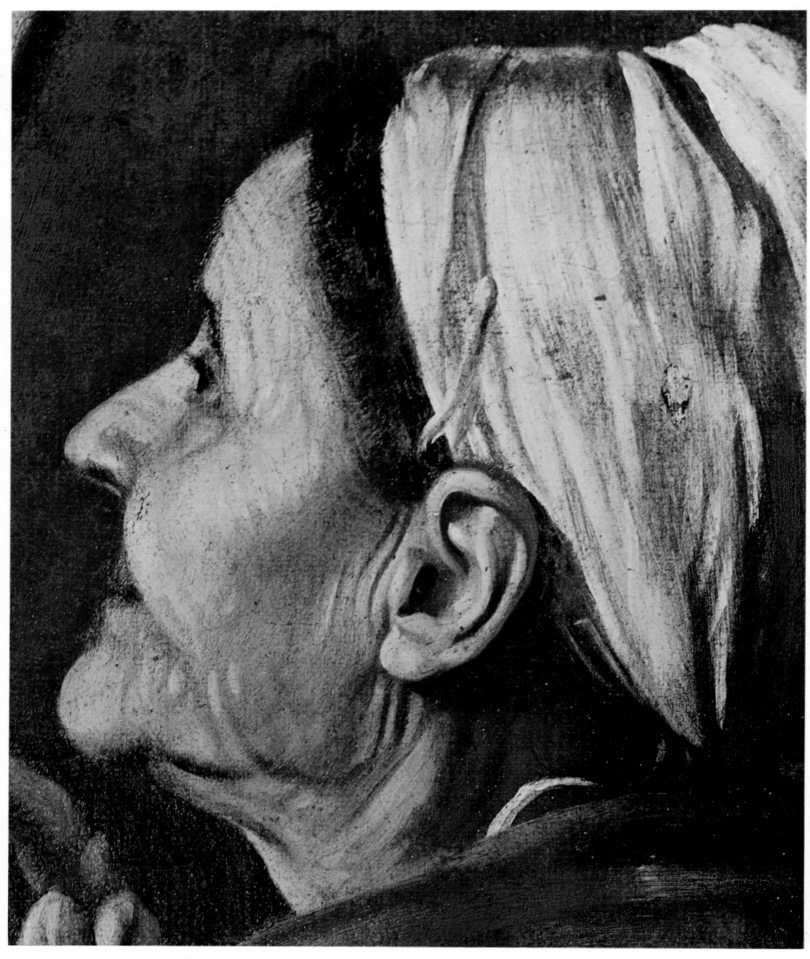

PLATE XLIV MADONNA DEI PELLEGRINI (MADONNA DI LORETO) Rome, S. Agostino
Detail (life size)

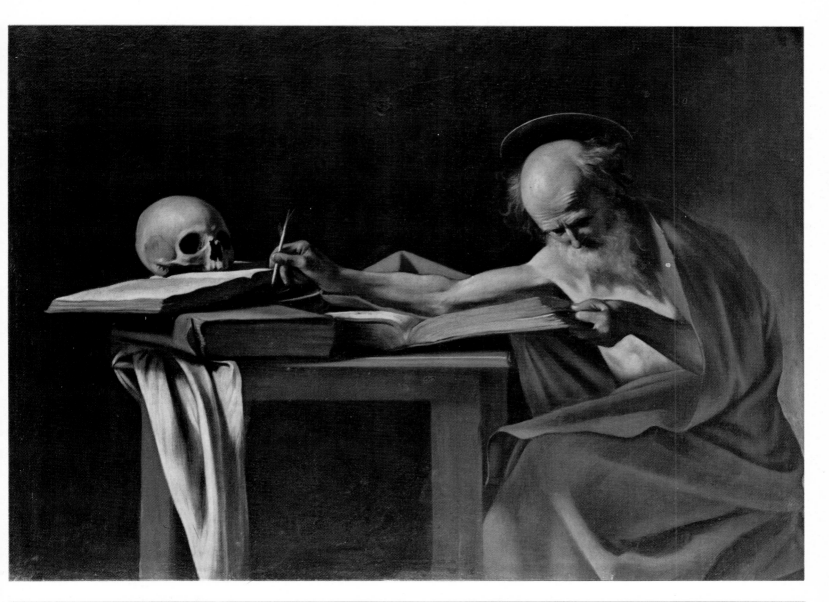

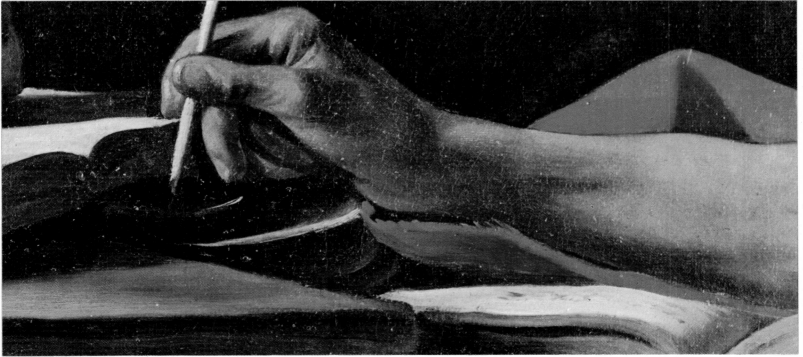

PLATE XLV ST JEROME WRITING Rome, Galleria Borghese
Whole (157 cm.) and detail (43 cm.)

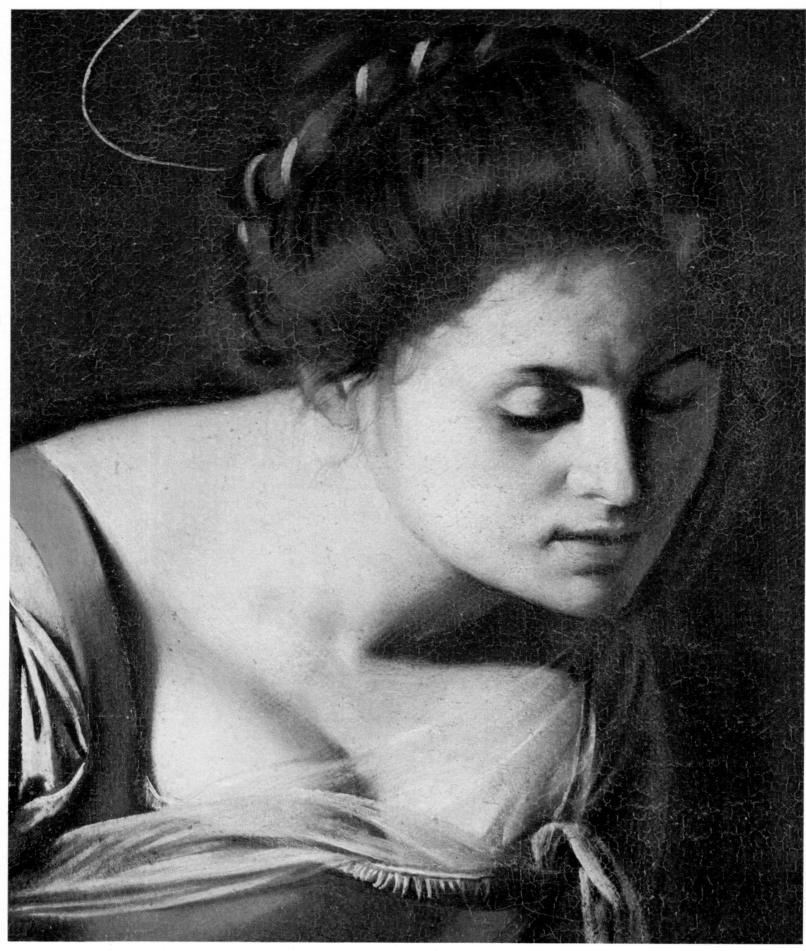

PLATE XLVI THE MADONNA OF THE SERPENT (MADONNA DEI PALAFRENIERI) Rome, Galleria Borghese
Detail (47 cm.)

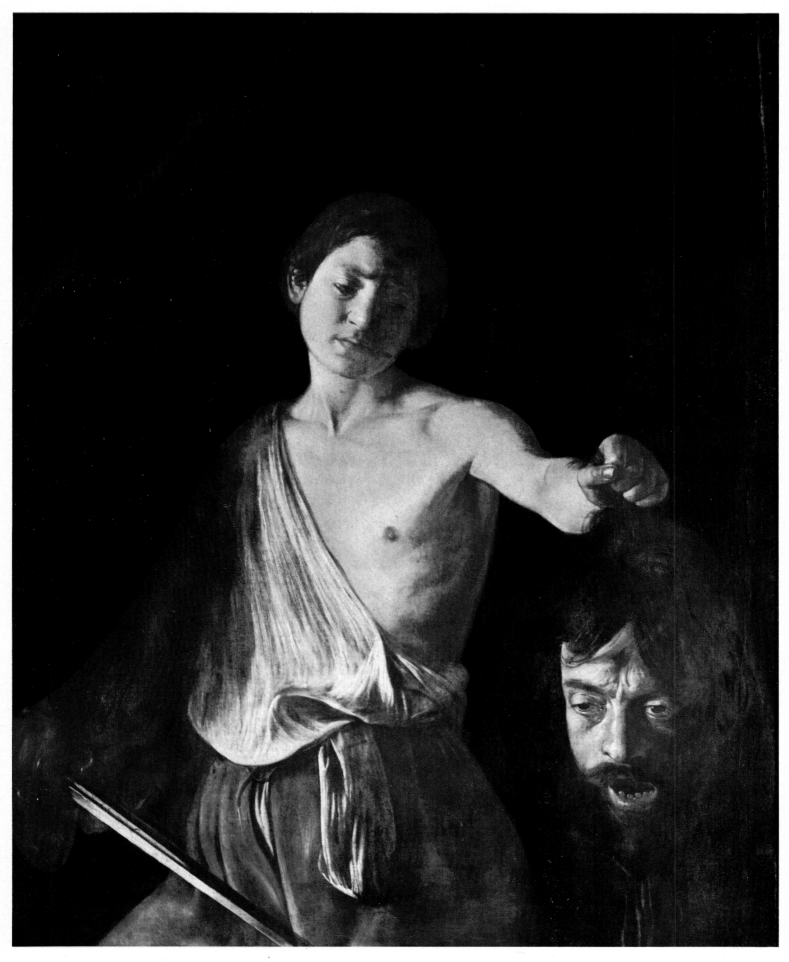

PLATE XLVII DAVID WITH THE HEAD OF GOLIATH Rome, Galleria Borghese
Whole (100 cm.)

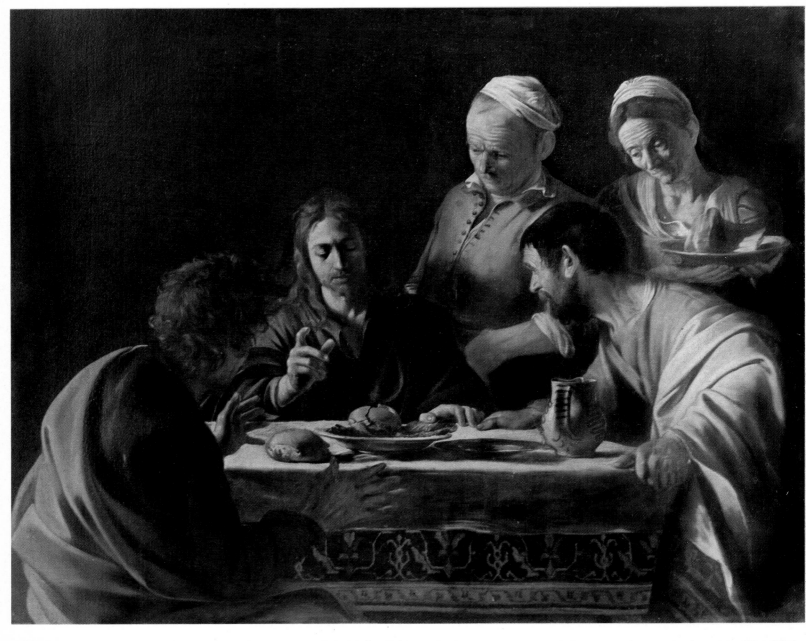

PLATE XLVIII THE SUPPER AT EMMAUS Milan, Brera
Whole (175 cm.) and details (20 cm. each)

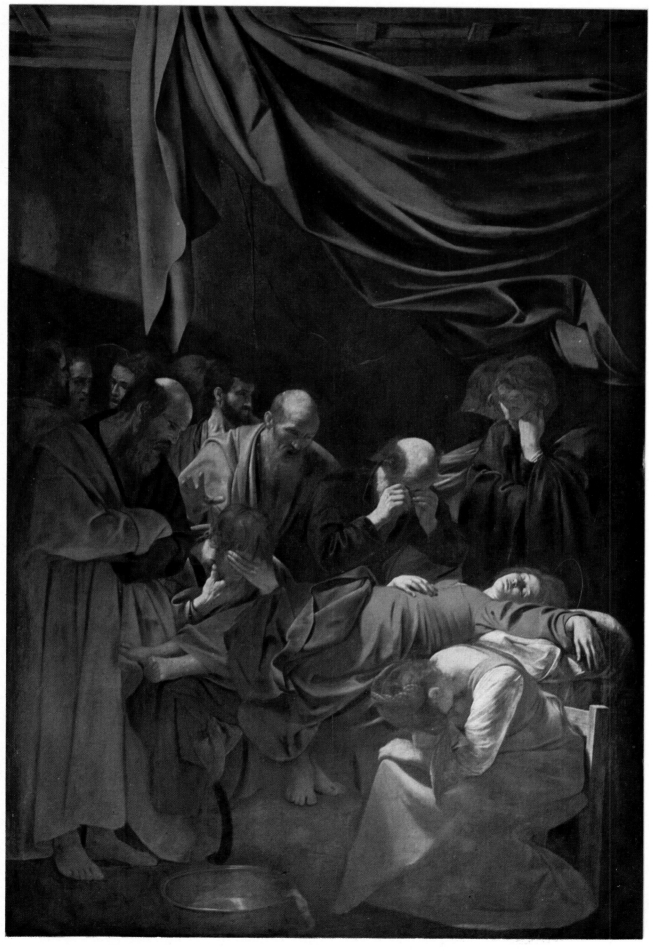

PLATE XLIX THE DEATH OF THE VIRGIN Paris, Louvre
Whole (245 cm.)

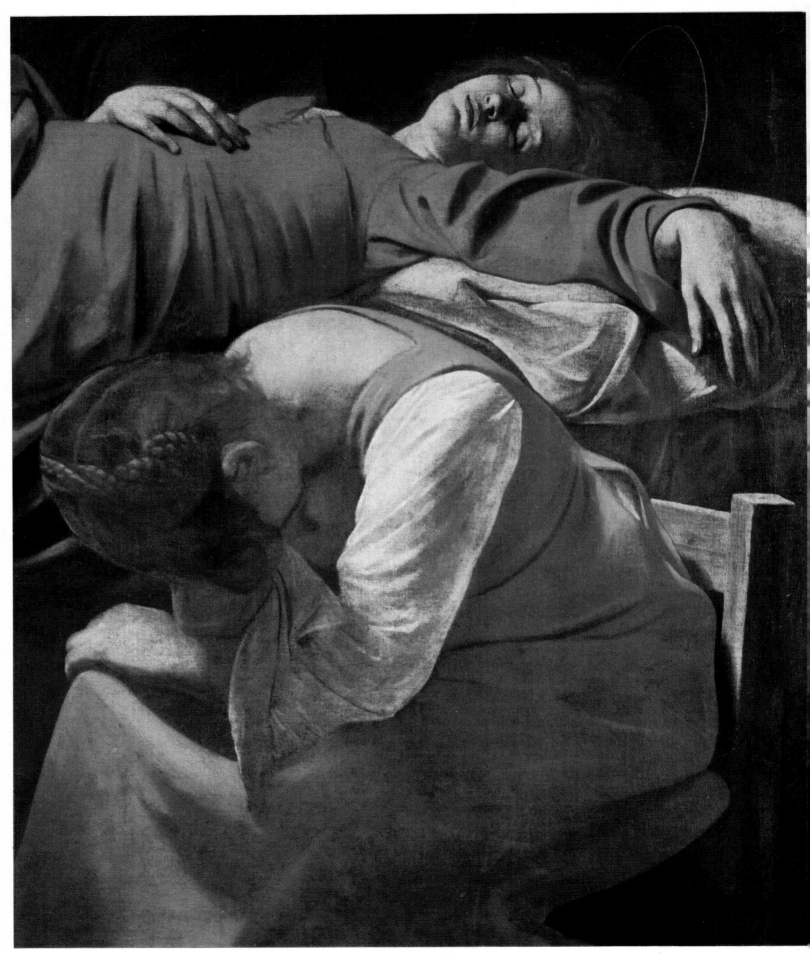

PLATE L THE DEATH OF THE VIRGIN Paris, Louvre
Detail (97 cm.)

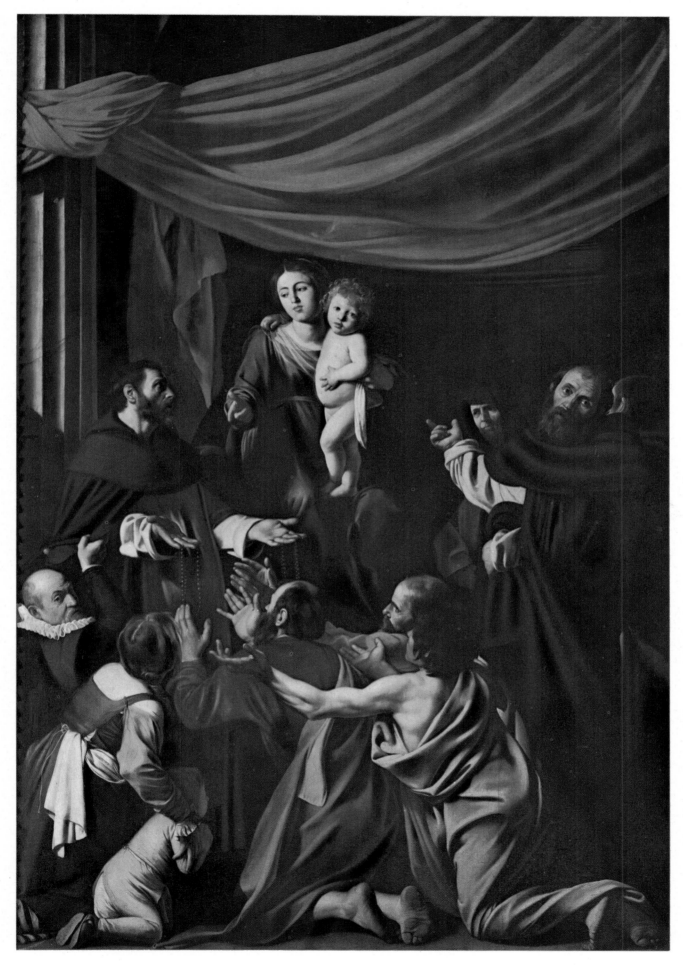

PLATE LI THE MADONNA OF THE ROSARY Vienna, Kunsthistorisches Museum
Whole (249 cm.)

PLATE LII THE MADONNA OF THE ROSARY Vienna, Kunsthistorisches Museum
Detail (64 cm.)

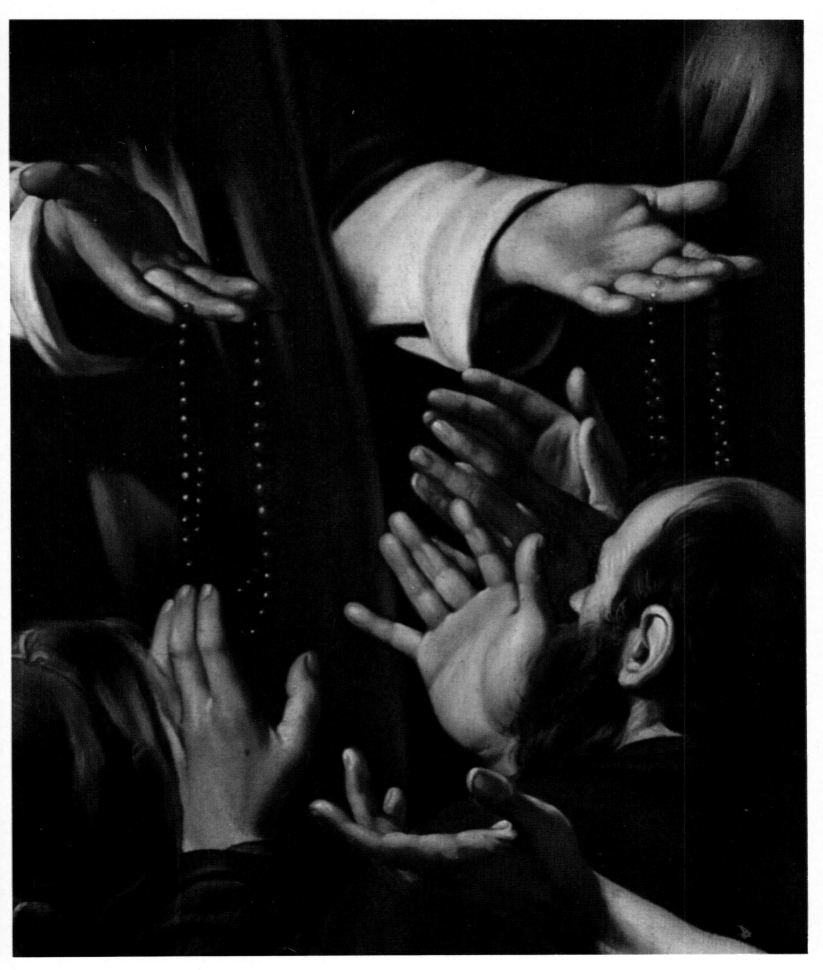

PLATE LIII THE MADONNA OF THE ROSARY Vienna, Kunsthistorisches Museum
Detail (64 cm.)

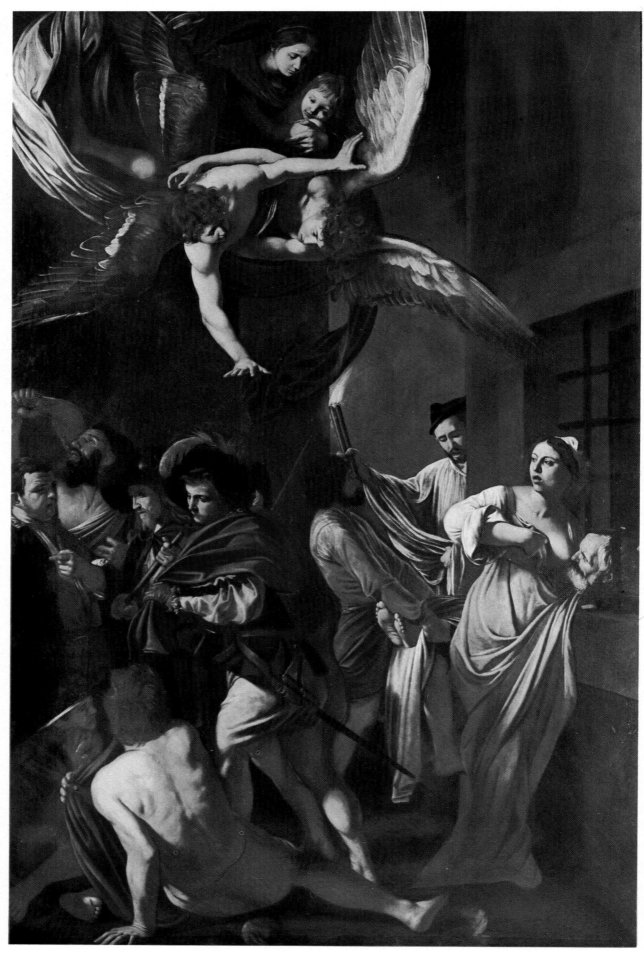

PLATE LIV THE SEVEN WORKS OF MERCY Naples, Pio Monte della Misericordia
Whole (260 cm.)

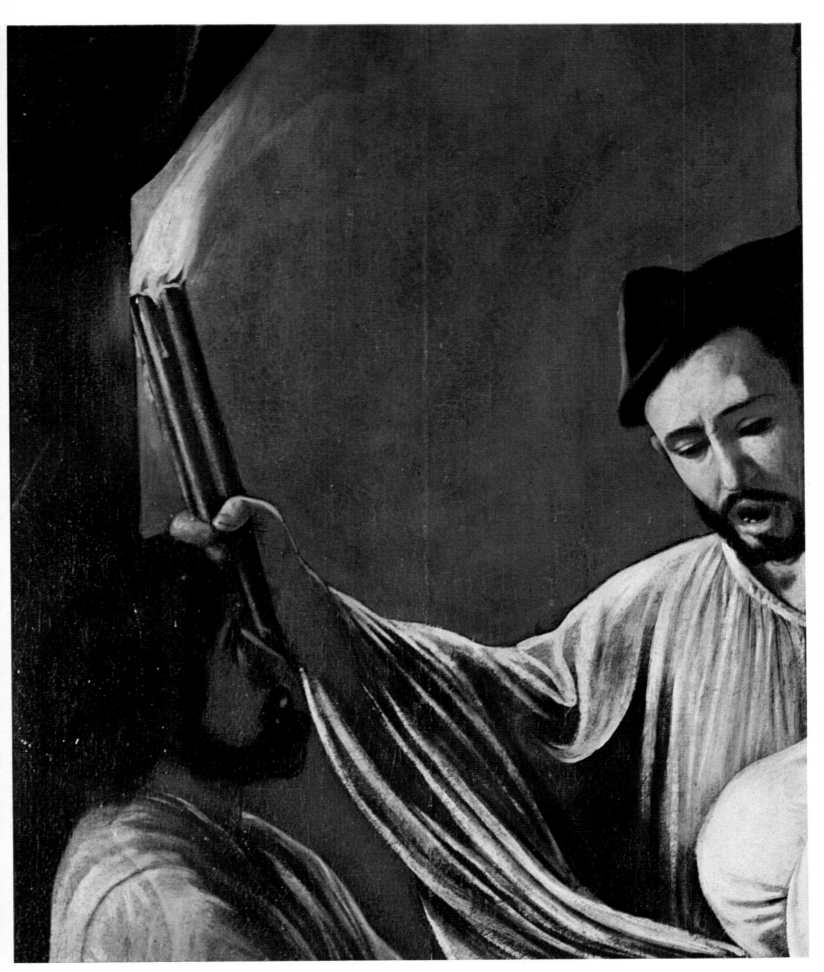

PLATE LV THE SEVEN WORKS OF MERCY Naples, Pio Monte della Misericordia
Detail (70 cm.)

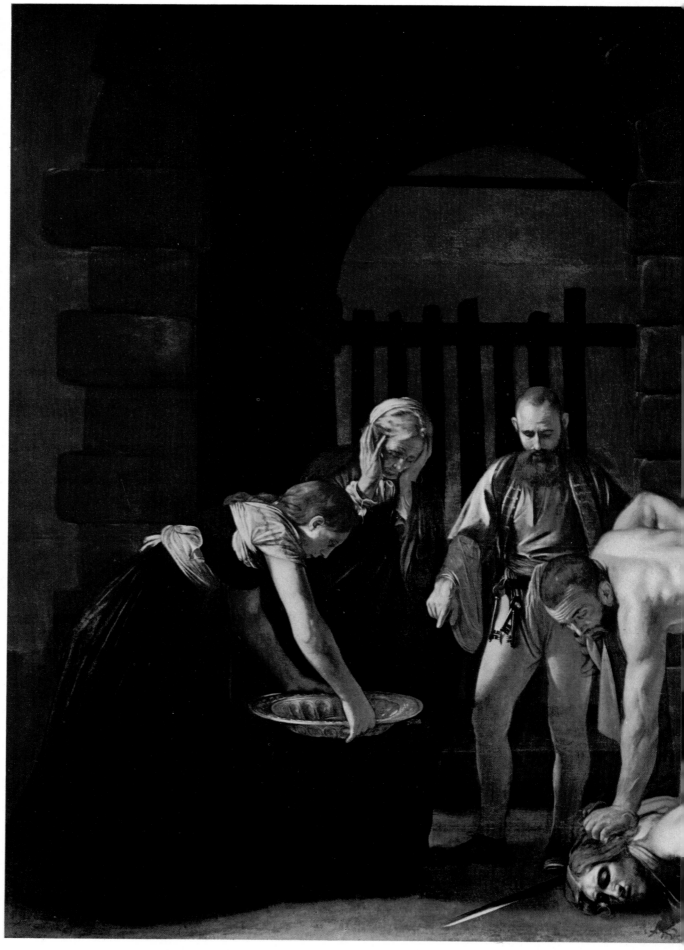

PLATES LVI-LVII THE EXECUTION OF ST JOHN THE BAPTIST Valetta (Malta), Cathedral of St John
Whole (520 cm.)

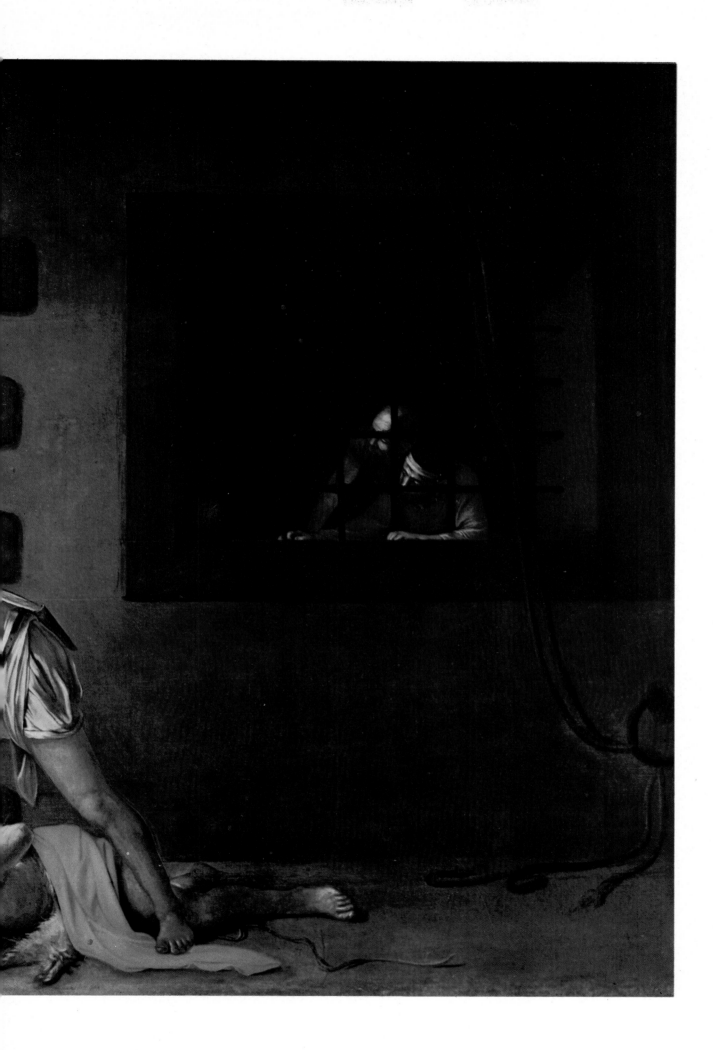

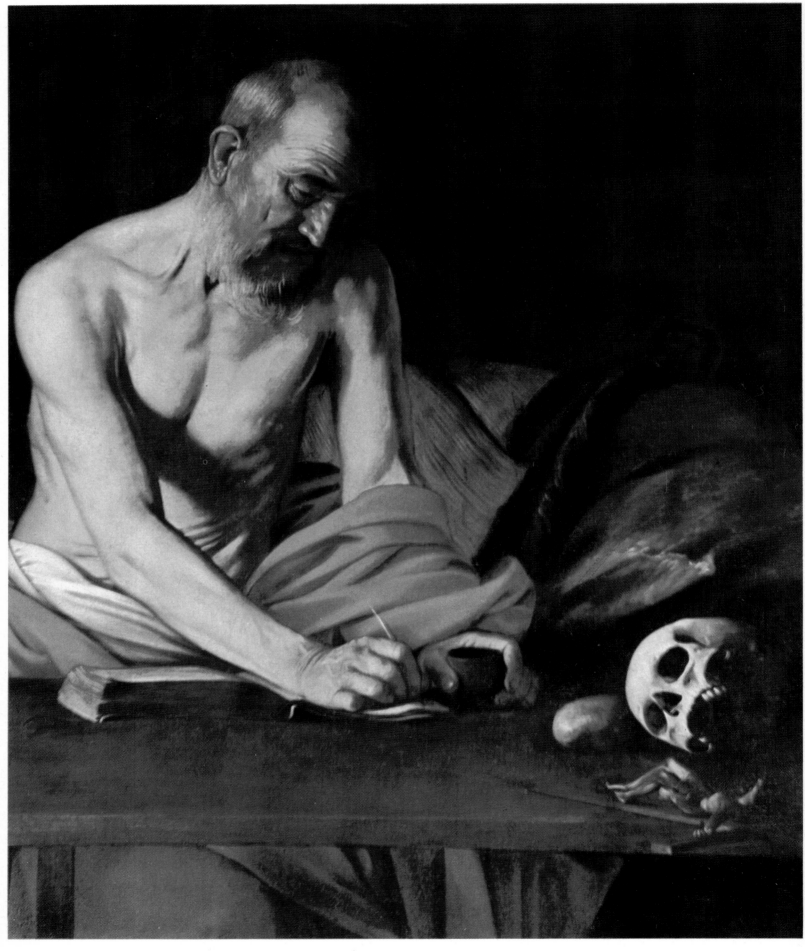

PLATE LVIII ST JEROME Valetta (Malta), Cathedral of St John
Detail (87 cm.)

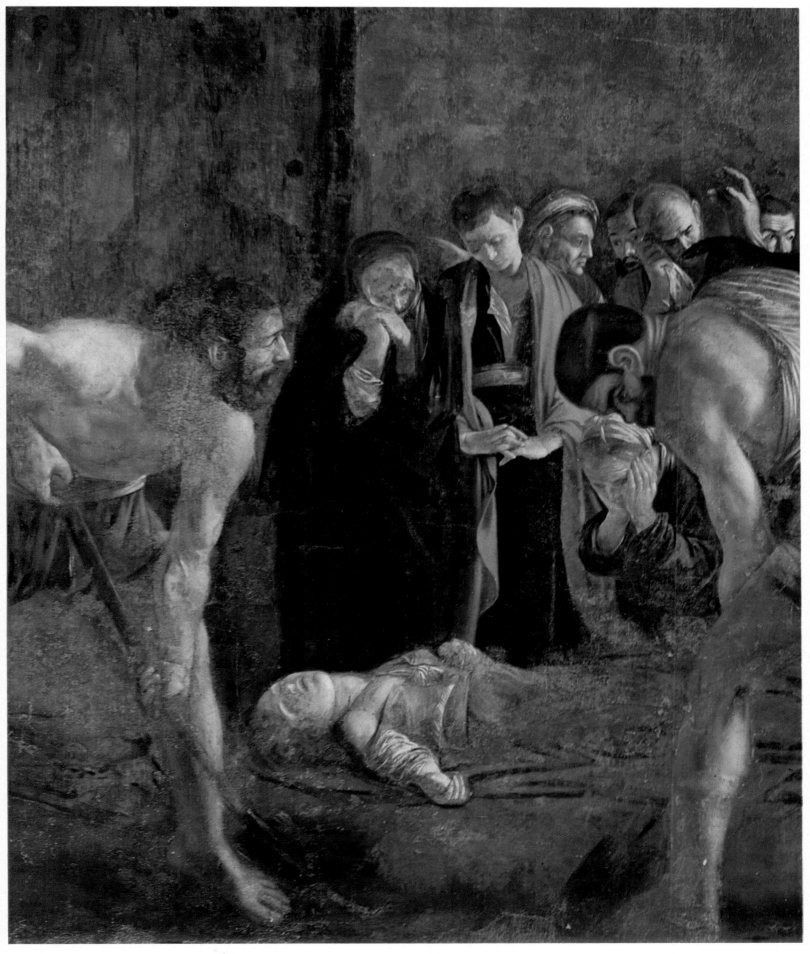

PLATE LIX THE BURIAL OF ST LUCY Syracuse, Sta Lucia
Detail (207 cm.)

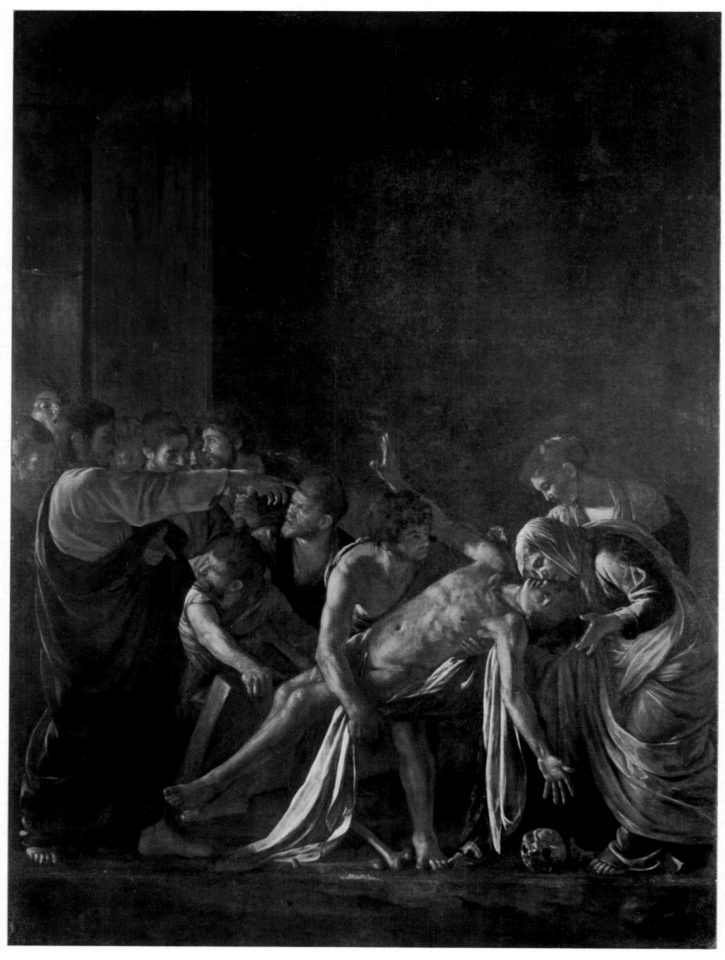

PLATE LX THE RAISING OF LAZARUS Messina, Museo Nazionale
Whole (275 cm.)

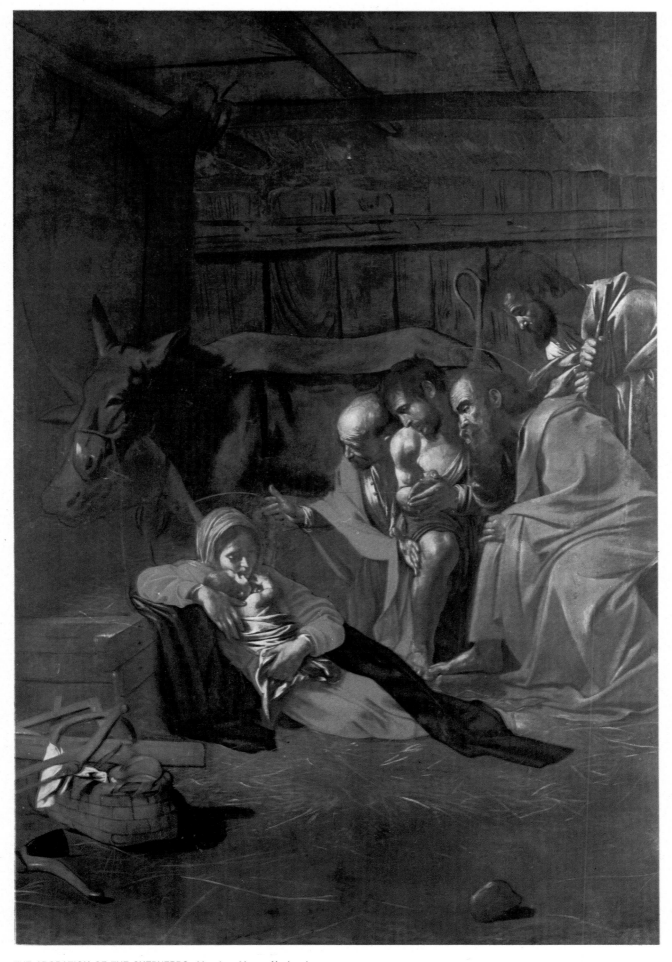

PLATE LXI THE ADORATION OF THE SHEPHERDS Messina, Museo Nazionale
Whole (211 cm.)

PLATE LXII THE ADORATION OF THE SHEPHERDS Messina, Museo Nazionale
Detail (67 cm.)

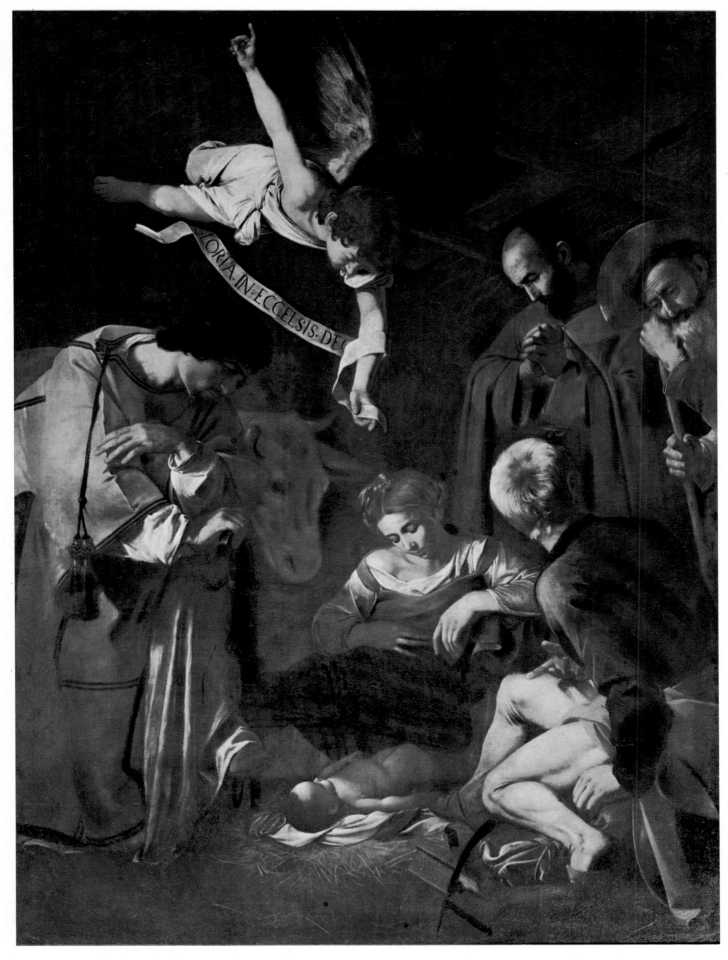

PLATE LXIII THE NATIVITY WITH ST FRANCIS AND ST LAWRENCE Palermo, S. Lorenzo
Whole (197 cm.)

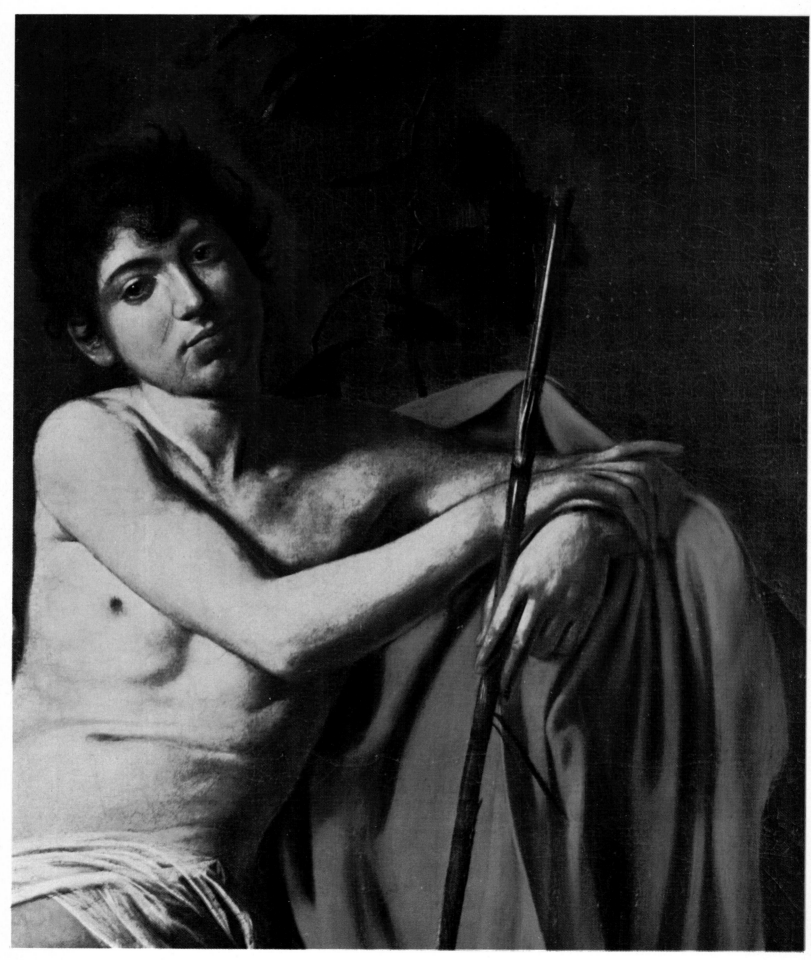

PLATE LXIV ST JOHN THE BAPTIST Rome, Galleria Borghese
Detail (67 cm.)

Key to symbols used

In order to provide a readily accessible guide to the basic data normally required, each entry in the Catalogue is preceded by the number of the painting (decided on the basis of the most reliable information available concerning the actual chronological order of execution, and used to identify each work in all references thereto throughout this publication) together with a series of symbols denoting the following : 1 execution of the work, i.e. to what extent it is the artist's own work ; 2 medium ; 3 support ; 4 location ; 5 other information such as : whether the work is signed or dated ; whether it is now complete ; whether it was originally finished. The remaining numerals denote respectively the size, in centimetres, of the painting (height x width) and the date. These figures are preceded or followed by an asterisk* in all cases in which the information given is approximate only. All such data are based on the general consensus of opinion in the field of modern art historiography. Outstanding differences of opinion and any further relevant data are discussed in the text.

Execution

Artist's own work	
Done by artist with assistance	
Done by artist and associates	
Copy	
Copy after a lost work possibly by the artist	
Attributed to artist by most authorities	
Execution by artist doubted by most authorities	
Traditionally attributed to artist	
Recently attributed to artist	

Medium

 Oil

 Fresco

 Tempera

Support

Panel

Wall

Canvas

Location

 Premises open to the public

Private collection

 Whereabouts unknown

 Work lost

Other data

Work signed

Work dated

Work incomplete or now fragmentary

Work unfinished

Key to these symbols provided in text

Bibliography

The following are the seventeenth-century biographers : K. VAN MANDER (*Het Schilderboek*, Haarlem 1604) ; G. MANCINI (*Considerazioni sulla pittura*, Biblioteca Marciana, ms. Ital. 5571, commentary by L. Salerno, Rome, 1956–57) ; V. GIUSTINIANI (*Raccolta di lettere a cura di G. Bottari*, Milan 1822) ; G. BAGLIONE (*Le Vite de' pittori, ...*, Rome 1642) ; F. SCANNELLI (*Il Microcosmo della pittura*, Venice 1657) ; G. P. BELLORI (*Le Vite de'pittori, ...*, Rome 1672) ; J. VON SANDRART (*Der Teutschen Academie*, Nuremberg 1675). For these and for the documents known up to 1952, see S. SAMEK LUDOVICI (*Vita del Caravaggio dalle testimonianze del suo tempo*, Milan 1956), supplemented by the valuable *Antologia caravaggesca rara*, which R. LONGHI edited with various collaborators ('Paragone' 1951, Nos. 17, 19, 21 and 23). The main biographies and many of the documents are printed in English translation as well as in the original language in W. FRIEDLAENDER's *Caravaggio Studies* (Princeton 1955). The course of criticism up to 1959 is summarized in *Le Dossier Caravage* by A. B. JOFFROY (Paris 1959). The best-known books and monographs, in alphabetical order, are by : C. BARONI (*Tutta la Pittura del Caravaggio*, Milan 1951 and 1956, English translation, London, n.d.) ; F. BAUMGART (*Caravaggio: Kunst und Wirlichkeit*, Berlin 1955) ; E. BENKARD (*Caravaggio-Studien*, Berlin 1928) ; B. BERENSON (*Del Caravaggio, delle sue incongruenze e della sua fama*, Florence 1951, English translation, London 1953) ; A. BERTOLOTTI (*Artist Lombardi a Roma*, Rome 1881) ; G. DE LOGU (*Caravaggio*, Milan 1962) ; R. LONGHI (*Il Caravaggio*, Milan 1952) ; M. MARANGONI (*Il Caravaggio*, Florence 1922) ; A. MOIR (*The Italian Followers of Caravaggio*, Cambridge, Mass. 1967) ; G. NICCO FASOLA (*Caravaggio anticaravaggesco*, Florence 1951) ; A. OTTINO DELLA CHIESA (*Caravaggio*, Bergamo 1962) ; N. PEVSNER (*Barock-malerei in der romanische Ländern*, Leipzig 1928) ; G. ROUCHES (*Le Caravage*, Paris 1920) ; L. SCHUDT (*Caravaggio*, Vienna 1942) ; M. VALSECCHI (*Caravaggio*, Milan-Florence 1951) ; L. VENTURI (*Il Caravaggio*, Rome 1921, and *Caravaggio*, Novara 1951) ; H. WAGNER (*Michelangelo da Caravaggio*, Bern 1958) ; L. ZAHN (*Caravaggio*, Berlin 1928). For the English reader the most useful introduction is the monograph by R. HINKS (*Michelangelo Merisi da Caravaggio*, London 1953) and the most comprehensive the book by W. FRIEDLAENDER (*Caravaggio Studies*, Princeton 1955). The most complete catalogue in any language is R. JULLIAN's *Caravage*, (Lyon-Paris 1961). The most important articles are by : J. AINAUD ('Anales y Boletin de los Museos de Arte de Barcelona' 1947) ; G. C. ARGAN (in *Studi in onore di L. Venturi*, Roma 1956) ; E. ARSLAN ('Aut Aut' 1951 and 'Arte antica e moderna' 1959) ; F. BAUMGART ('Das Werk des Kunstlers' 1939–40 ; 'Zeitschrift für Kunstwissenschaft' 1952) ; E. and C. BACK-VEGA ('Art Bulletin' 1958) ; M. BENEDETTI ('Emporium' 1949) ; S. BORLA ('Emporium' 1962) ; S. BOTTARI ('L'Arte' 1935) ; H. CHERAMY ('Rassegna d'arte' 1922) ; M. CUTTER ('Marsyas' 1941) ; A. DE RINALDIS ('Bollettino d'arte' 1935 ; 'Archivi' 1935) ; J. HESS ('Burlington Magazine' June 1951 ; 'Connoisseur' 1958) ; N. IVANOFF ('Le Arti' 1951) ; W. KALLAB ('Jahrbuch der kunsthistorischen Sammlungen der allerhöchsten Kaiserhauses' 1906) ; R. LONGHI ('L'Arte' 1913–16 ; 'Vita artistica' 1927–28 ; 'Pinacotheca' 1928–29 ; 'Proporzioni' 1943 ; 'Paragone' 1950 (No. 1), 1951 (Nos. 15, 17, 19, 21), 1954 (Nos. 51, 55, 57), 1959 (No. 111), 1960 (No. 121), 1963 (No. 165) ; D. MAHON ('Burlington Magazine' July and September 1951, January 1952, 1956 ; 'Zeitschrift für Kunstwissenschaft' 1953 ; 'Art Bulletin' 1953) ; N. PEVSNER ('Zeitschrift für bildende Kunst' 1927–28) ; H. RÖTTGEN ('Zeitschrift für Kunstgeschichte' 1964, 1965) ; V. SACCA ('Archivio storico messinese' 1906–07) ; L. STEINBERG ('Art Bulletin 1959) ; H. SWARZENSKI ('Bulletin of the Museum of Fine Arts', Boston 1954) ; L. VENTURI ('L'Arte' 1909, 1910 ; 'Bollettino d'arte' 1912, 1935 ; 'Commentari' 1950, 1952 ; 'Atti dell'Accademia nazionale dei Lincei' 1952) ; H. VOSS ('Jahrbuch der preussischen Kunstsammlungen' 1923 ; 'Zeitschrift für bildende Kunst' 1924 ; 'Burlington Magazine' 1927 ; 'Apollo' 1938 ; 'Die Kunst' 1951 ; 'Kunstchronik' 1951).

Outline Biography

1573 28 September Michelangelo Merisi (or, as spelt in various documents, Amerigi, Merigi, Merighi, Merizi, Amarigi, Marigi, Maresio, Amorigi, Morigi, etc.) is born in Caravaggio near Bergamo, Lombardy, 'of highly esteemed citizens, since his father was majordomo and architect to the Marquis of Caravaggio' (Mancini, c.1620.). The date of birth and the father's name, Fermo, appear in two epigraphs in a collection of *Inscriptiones et elogia* (Cod. Vat. Lat. 7927) compiled by the legal expert Marzio Milesi, a friend of the painter's. These epigraphs, published by Longhi ('Pinacotheca', 1928–29), read: (1) MICH.ANGEL. MERISIUS DE. CARAVAGIO / EQUES HIEROSOLIMITANUS / NATURAE AEMULATOR EXIMIUS / VIX. ANN. XXXVI. M. IX. D. XX / MORITUR XVIII JULI MDCX (Michel Angelo Merisi from Caravaggio / Knight of Jerusalem (of Malta) / excellent imitator of nature / lived 36 years 9 months 20 days / died 18 July 1610); (2) 'MICHAELLANGELO. MERISIO. FIRMI. F. / DE CARAVAGIO IN PICTURIS JAM NON PICTORI / SED NATURAE PROPE AEQUALI / OBIIT IN PORTU HERCULIS / E PARTENOPE ILLUC SE CONFERENS / ROMAM REPETENS / XV KAL. AUGUSTI / ANNO CHRI. MDCX / VIX. ANN. XXXVI. MENS. IX. D. XX / MARTIUS MILESIUS JUR. CONS. / AMICO. EXIMIAE. INDOLIS' (Michelangelo Merisi son of Fermo / from Caravaggio, in his paintings not just a painter / but nearly the equal of nature, / died in Porto Ercole / having arrived there from Naples / to return to Rome / 15 days before the calends of August / AD 1610. / (He) lived 36 years 9 months 20 days. / Marzio Milesi legal adviser / to his good-natured friend). The parish register covering Caravaggio's date of birth (1569–85) was removed in 1903 – and never returned – by Professor Camillo Terni from Treviso, who is said to have sent it to Dr V. Sacca (Samek).

1584 6 April Caravaggio is apprenticed at Milan for four years to Simone Peterzano, a painter of Bergamasque origin (document discovered and. published by Pevsner in 'Zeitschrift für bildende Kunst', 1927–28). His elder brother Battista stood surety for him, showing that at this date Caravaggio, aged ten years and seven months, was already an orphan.

1588 6 April Date of expiry of the apprenticeship with Peterzano; Caravaggio is fourteen and a half years old. We do not know whether his association with Peterzano lasted the time stipulated, or was terminated earlier, or possibly extended. 'In his youth he studied diligently for four or five years in Milan, even though he was occasionally guilty of some eccentricities caused by his quickness of temper and high spirits' (Mancini), but there is no documentary evidence for the suggestion made by Bellori that Caravaggio committed a murder at this stage and was imprisoned. Bellori's statement that Caravaggio stayed in Venice on his way from Milan to Rome and Calvesi's view ('Bollettino d'arte', 1954) that he may have made a first visit to Rome with Peterzano, as the latter's workshop assistant, in 1585, are also eithout external confirmation, although a short stay in Venice is not impossible. The logic of the situation calls for an initial phase of Milanese or Lombard activity, either a prolongation of the apprenticeship with Peterzano, or an apprenticeship with some other painter, or independent work of a humble kind, during the four or five years from 1588. However, no trace of this activity has emerged so far, despite a recent attempt (by S. Borla in 'Emporium', 1963) to date some of the early Roman works to this period.

1592–93 Caravaggio arrives in Rome. Until the early 1950s it was assumed that the painter's move to Rome took place in 1588–89, partly because the seventeenth-century biographers imply that he travelled there directly after finishing his apprenticeship in Milan and partly because an inscription dated 1590 in the floor of the Contarelli Chapel was generally thought to refer to the commencement of Caravaggio's paintings in this chapel of the *Scenes from the Life of St Matthew* (39–41) (hence the painter would have had to have arrived in the City at least two years previously in order to execute some half a dozen other works which must be earlier on stylistic grounds – an unlikely feat.) Since 1951, however, after it was demonstrated by Hess (in the 'Burlington Magazine') that the date 1590 referred not to the inception of the paintings but only to the placing of a memorial tablet to the donor of the chapel, critics have tended to move the date of Caravaggio's arrival forward to the early 1590s (Hess to 1591–92, Mahon to 1593, subsequently going back to 1591, Hinks to about 1591); Longhi and Baumgart, rejecting until recently the later dating of the Contarelli Chapel paintings, have clung to 1588–89, as has Friedlaender, though he accepts the later dating of these paintings. More recently (in 'Emporium', January 1962), Silvina Borla has pointed out that a manuscript 'Lives of the Painters of Messina', dated 1724, by the priest and painter Francesco Susinno (published by V. Martinelli, Florence, 1960), provides strong supporting evidence for Caravaggio's arrival in Rome late in 1592 or early in 1593, although there is still no proof. This confirms the statement of one of the earliest biographers, Mancini (c.1620), that Caravaggio arrived in Rome 'at about twenty years of age'. Briefly, the new evidence concerns a Sicilian painter, Mario Minniti, born in Syracuse on 8 December 1577, who, according to Susinno, reached Rome when just over the age of fifteen (i.e. around Christmas 1592). Minniti apparently joined up almost at once with Caravaggio in the workshop of another Sicilian artist (named Lorenzo Siciliano, according to Bellori's marginal notes to Baglione's 'Lives'), who 'sold paintings by

the dozen' (Susinno). All the early biographers agree that Caravaggio's stay in this work-shop occurred very early in his career in Rome and that he did not remain in it long; hence the date of late 1592 to early 1593 for his arrival in the city. If Susinno is to be trusted Caravaggio struck up a close friendship with Minniti and lived with him for some seven or eight years (in the Baglione libel action of 1603, see below, Caravaggio referred to a certain Mario who had once lived with him but whom he had not seen for three years). It was also probably Minniti with whom Carravaggio stayed in Syracuse after his flight from Malta in October 1608.

1593–96(?). Caravaggio spends these years (the end date is uncertain but is unlikely to be after 1596) moving from workshop to workshop and house to house in Rome, assisting various painters and trying to find his feet as an independent artist. His earliest known works date from this period. To judge from the biographers the sequence of events appears to have been as follows :

– Work with the Sicilian painter Lorenzo Siciliano (Bellori) 'who ran a workshop where crude paintings were produced' (Baglione) : 'he (Caravaggio) ground colours in Milan and learnt to paint ; but, for having killed a friend of his, he fled from the city and took refuge in Rome in the workshop of Lorenzo Siciliano where, being extremely poor and practically naked, he painted (?) heads for one groat each and produced three a day', (Bellori's marginalia to Baglione's 'Lives').

– Stay 'of a few months' with Monsignor Pandolfo Pucci of Recanati, beneficed priest of St Peter's, 'where he (Caravaggio) agreed to go in

exchange for his board and lodging and other services unsuited to his temperament and, which is worse, he had to make do in the evening with a salad that was served to him as hors-d'oeuvre, main course and dessert and, according to Caporale, as packed lunch and snacks as well. Hence ... he later nicknamed this munificent patron Monsignor Insalata' (Mancini).

– Quasi-commercial activity with the painter Antiveduto Gramatica, of noble Sienese origin, born in Rome, Caravaggio's senior by three years, and endowed with financial means (Bellori in his marginal notes to Baglione).

– Admitted (for malaria ?) to the Consolazine Hospital. During his convalescence he painted 'many pictures for the prior who took them with him to Sicily, his homeland', or to 'Sivilia' (Seville), according to the Florentine version of the manuscript (Mancini).

– Stay 'of a few months' with Giuseppe Cesari, known as the Cavaliere d'Arpino (Van Mander, Mancini, Baglione, Bellori), by whom Caravaggio was set to 'painting flowers and fruit so deftly imitated that through him they regained that greater beauty which today causes such delight' (Bellori). The Cavaliere d'Arpino, born in 1568, was five years older than Caravaggio. Several paintings by Caravaggio, some of which d'Arpino owned, may be dated in this period, and some collaboration between the two artists can be presumed. The importance of d'Arpino for Caravaggio has recently been further underlined by H. Röttgen ('Zeitschrift für Kunstgeschichte' 1964) in connection with the Contarelli Chapel (see below).

– To free himself from bondage 'he took an

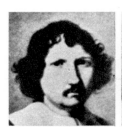 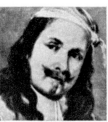

Hypothetical self-portraits by Caravaggio (details). That on the left, belonging to the Alberoni gallery at Piacenza, was published by Jullian (1961); the others are to be found, respectively, in the Szépmüvészeti Museum at Budapest, with the inscription: Da Caravaggio io son pittor meschino / che il mio ritratto, / per un par di polli, / qual lo vedete feci al Sansovino *(A poor painter from Caravaggio am I / who for a brace of chickens painted my portrait / such as you see it, for Sansovino); in the picture gallery at Brunswick and in the Uffizi at Florence. All serious critics have long since dismissed the last three paintings from Caravaggio's oeuvre, while the first, the only one which may be at all like the artist, is even doubted by the scholar – Jullian – who published it.*

opportunity offered him by Prospero (Orsi), a painter of grotesques, and left Giuseppe's house to vie with him for artistic fame' (Bellori). At about this time he is said to have stayed in the house of Monsignor Fantin Petrignani, 'who gave him the use of a room' (Mancini). There is reason to believe that Petrignani arrived in Rome from Forli in 1595, which would place Caravaggio's stay with him in that year or the following one.

– 'He then attempted to make out on his own and painted some small pictures which he drew from his own reflection in a mirror ... Yet he could not manage to sell them and was unable to give them away, and he was in dire straits and without money, so that some gentlemen of his profession offered him assistance as an act of charity ; finally maestro Valentino, an art dealer near San Luigi dei Francesi, contrived to sell some paintings for him and on this occasion brought him to the notice of Cardinal del Monte' (Baglione). 'In case of necessity even the artist who has attained fame and who at other times has sold his works well, as shown by Caravaggio who sold the *Boy Bitten by a Lizard* for fifteen giuli (a coin named after Pope Julius II, 1503–13, who first minted it) and the *Fortune Teller* for eight scudi ...', (Mancini).

– Cardinal del Monte welcomes Caravaggio into his palace, agreeing to give him 'board and wages' (Baglione,

and also Bellori).

Until 1951–52, as mentioned above, all these events were assumed to have occurred in less than two years, no thought being given to the fact that, in order to leave a record in history, or at any rate in the chronicle of Caravaggio's life, these human and working relationships, these changes of address and contacts, must each have lasted a modicum of time. If we add the time spent in inns, taverns, rented rooms, hostels, improvised shelters, etc., there is no lack of material with which to fill, apart from any unrecorded events, the three to four years from 1592–93 to 1596, the year when the twenty-three year old painter, if not already a guest in Palazzo del Monte, was at least firmly attached to the household of the Cardinal.

1596 Caravaggio is possibly referred to by implication in a letter from Cardinal del Monte to Federico Borromeo in Milan. The Ambrosiana *Fruit Basket* (19), which Borromeo certainly owned a few years later, may have been among a group of paintings which Del Monte says he is intending to send Barromeo as a present. The *Fruit Basket* may thus have been painted in this or the following year (Longhi, 1928–29).

1597 The Abbot of Pinerolo, Don Ruggero Tritonio, bequeaths to his nephew in his will 'a painting of St Francis executed with great diligence by the famous painter Caravaggio' (document published by V. Joppi, 'Miscellanea di storia Veneta',

1894). This is the first recorded reference to Caravaggio's fame, at the same time showing that knowledge of him had begun to spread beyond Rome. It is likely that the painting in question is the *Ecstasy of St Francis* in the Wadsworth Atheneum, Hartford (7).

1599 23 July Caravaggio is awarded the contract for *The Calling and the Martyrdom of St Matthew* on the side walls of the Contarelli Chapel in S. Luigi dei Francesi (39–40). The paintings were finished by 4 July 1600. In 1602 Caravaggio painted two versions of the altarpiece for the chapel (41 A and B), the craftsman's bill for the frame being presented in February 1603 (documents, except the last, published by H. Röttgen in 'Zeitschrift für Kunstgeschichte', 1965). This was Caravaggio's first public commission and a major turning point in his career. The paintings created a sensation in Rome. 'Merisi' (his true surname) had become 'Caravaggio', a great name that resounded throughout Italy and, soon afterwards, Europe. Important patrons and clients supported him ; besides Cardinal del Monte, they included the Marchese Vincenzo Giustiniani, Ciriaco Mattei, Maffeo Barberini (later Pope Urban VIII) and the Massimi.

1600 Caravaggio is still living in the house of Cardinal del Monte. With him are 'Mario the painter' (doubtless Mario Minniti – see above) and a servant, Bartolomeo (Bertolotti).

Caravaggio's mutilated signature on The Execution of John the Baptist *at Valletta (82)*

1600 25 October. Caravaggio appears for the first time in police records, as a witness to a street brawl. He was then recovering from an illness. On 19 November he was himself involved in a fight.

1600 25 September – **1601** 10 November These are the dates of the contract and final payment for *The Conversion of St Paul* and *The Crucifixion of St Peter* (44–45) in the Cerasi Chapel in Sta Maria del Popolo.

1601 7 February Caravaggio makes peace with Flavio Canonico, a sergeant of Castel S. Angelo, whom he had wounded with a sword; his companion in the brawl had been his architect friend Onorio Longo (Bertolotti).

1603 January or February The artist asks Gentileschi for the loan of 'a Capuchin's habit and a pair of wings' (Bertolotti).

Portrait (engraving) of Michel Angelo Marigi da Carawagio (sic) published by J. von Sandrart (Der Teutschen Academie, 1675)

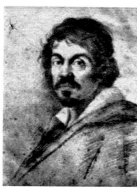

Caravaggio's portrait in the album of drawings executed by Ottavio Leoni (Florence, Biblioteca Marucelliana), the most faithful of the likenesses known

Copper engraving inscribed Michelange Merigi dit le Caravage, executed by E. Baudet after Leoni's drawing (above)

1603 28 August Action for ibel brought by Baglione against Caravaggio, Gentileschi, Longo and Trisegni. The records of the hearing are an important source of information concerning Caravaggio's attitude to other painters and his own aims as an artist. He admired d'Arpino, Zuccaro, Pomerancio and Annibale Carracci, none of them painters whose style was at all like his. He stated that 'a good artist is he who knows how to paint well and to imitate natural objects well.' In addition to confirming his hatred of Baglione the trial seems to have ended Caravaggio's friendship with Gentileschi. Caravaggio was released from jail on 25 September, through the intervention of the French ambassador. In November, a new scuffle broke out between Onorio Longo and Baglione backed by Mao Salini (Bertolotti).

1603 31 August Karel van Mander writes about Caravaggio in *Het Schilderboek* (*The Lives of the Painters,* Haarlem, 1604): 'There is also a certain Michelangelo da Caravaggio who paints wonderful things in Rome. He … has laboriously emerged from poverty by means of hard work, tackling and accepting everything with foresight and daring, as is done by some who do not wish to remain inferior through timidity and cowardice … He is one who cares little for the works of others, without at the same time overtly praising his own … He holds that all works are nothing but childish trifles, whatever their subject and by whomever they are painted, unless they are made and painted from life and that there can be no good or better way of painting than to follow nature … He is a mixture of grain and chaff: indeed he does not continuously devote himself to this study, but when he has worked for a couple of weeks, he swaggers about for a month or two, his sword at his side and a servant behind him, and goes from one ball-game to another, ever ready for a duel or a scuffle, so that it is almost impossible to get to know him.

1604 January Caravaggio probably spends some time at Tolentino in the Marches (Benadduci, 1888).

1604 24 April The artist is charged with throwing a plate of artichokes in the face of Fusaccia, a waiter in the Osteria del Moro (the Inn of the Moor) in Rome. In October he is arrested in the street leading from the Trinità dei Monti to the Piazza del Popolo for flinging stones at the police, and is again in trouble with the police on 18 November.

1605 16 February Caravaggic denounces a certain Alessandro Ricci who, in the artist's name, had obtained a rug by fraud from Cosimo Coli, quartermaster sergeant of the Pope.

1605 28 May The artist is arrested for unlawfully carrying arms but is released with his weapons on stating that the Governor of Rome had given him verbal permission to carry

Detail of The Martyrdom of St Matthew *in the church of S. Luigi dei Francesi in Rome (40), showing Caravaggio's self-portrait. This likeness and the one as Goliath in the Borghese* David *(60) are considered to be the most authentic*

them. In July he is jailed at Tor di Nona on a charge involving women and released on the guarantee of Cherubino Alberti and Prosperino Orsi.

1605 29 July Caravaggio wounds Mariano Pasqualone, a notary, in defence of Lena, a model and perhaps his mistress. He flees from Rome to Genoa, where he was on 6 August (Venturi, 'L'Arte', 1910), but returns to Rome on 24 August and apologizes to Pasqualone on the 26th.

1605 1 September The artist hurls stones at the windows of Prudenzia Bona, his former landlady, who, probably on the occasion of his flight to Genoa, had stolen some of his belongings. It seems he was then without fixed abode. (Bertolotti). Between October and November he requests thirty-two scudi from the agent of the Duke of Modena for a painting that was never delivered (Venturi, 'L'Arte' 1910)

1605–6 Caravaggio appears to be in contact with Cardinal Scipione Borghese, who took over *The Madonna of the Serpent* (refused by the Papal Grooms) and secured such works as *St Jerome* (56) and *David* (60).

1606 29 May A brawl takes place, four men on each side, after a ball-game in the playing field of the Muro Torto, below the Villa Medici. Backed by Onorio Longo and a Captain Antonio from Bologna, Caravaggio is wounded, but he kills Ranuccio Tommasoni of Terni ('Avvisi' (public announcements) of Rome, 31 May 1606).

1606 31 May Caravaggio flees from Rome and takes refuge on the estates of Prince Marzio Colonna, the brother-in-law of the Marquis of Caravaggio. His hiding places were at Palestrina, Paliano and Zagarolo. He paints for his patron a *Magdalene* and a *Supper at Emmaus* (Bellori).

1607 (possibly at the end of **1606**). Caravaggio moves to Naples.

1607, 7 April *The Death of the Virgin*, purchased by the Duke of Mantua on the advice of Rubens, is exhibited to the artistic community in Rome for eight days; then, on 28 April, it is taken to Mantua

(Correspondence of Giovanni Magno in Rome with Annibale Chieppo in Mantua. February to April 1607).

1607 May Much manoeuvring goes on in Rome to obtain a pardon for Caravaggio, who is feverishly working in Naples, where he paints *The Resurrection of Christ* and *St Francis receiving the Stigmata* in the church of Sta Anna dei Lombardi (these are now lost), *The Seven Works of Mercy* for the Pio Monte della Misericordia and *The Flagellation of Christ* in the church of S. Domenico (Bellori).

1607 19 September *The Madonna of the Rosary* (Vienna) and a *Judith and Holofernes* (lost) are for sale in Naples (Luzio, *La Galleria dei Gonzaga*, 1913).

1608 (or perhaps the end of **1607**) Caravaggio is in Malta

Presumed self-portraits by Caravaggio, respectively in The Game of Morra *(Siena, Galleria dell'Accademia; excluded from the master's oeuvre and perhaps by Antiveduto Gramatica), in the copy of* The Taking of Christ *at Odessa (52) and in the* St Francis *at Cremona (71)*

where, according to Bellori, he paints two portraits of the Grand Master, Alof de Wignacourt, the *Sleeping Cupid* (now in Florence), a *St Jerome* and *The Beheading of John the Baptist* for the cathedral.

1608 14 July Caravaggio is received into the Order of the Knights of Malta as a 'Cavaliere di Grazia'.

1608 6 October At the instance of the Head of the Treasury of the Order of the Knights of Malta – who had probably become aware of the true reasons for Caravaggio's flight from Rome – a criminal commission meets, which includes Jean Honoret and Blasio Suarez, with a view to opening proceedings against the artist. Summoned to appear on 1 December, Caravaggio, supposedly held in custody in the castle of S. Angelo, is discovered to have escaped, with the result that *extra Ordinem et consortium nostrum, tamquam membrum putridum et foetidum eiectus et separatus fuit* (he was expelled and rejected from our Order and association as a corrupt and foul member) (*Liber Concilium*, Vol. CIII, fol. 13V.)

1608 October Caravaggio lands in Syracuse 'so speedily that he could not be overtaken' (Bellori). He paints *The Burial of St Lucy* and names the well-known cave near the city 'Dionysius's Ear' (Dionysius the Elder and Younger, tyrants of Syracuse), as reported by Mirabella who witnessed the

event (*Dichiarazione della pianta delle antiche Siracuse,* 1613).

1609 (early months). Caravaggio arrives in Messina. On 16 June he delivers *The Raising of Lazarus*, perhaps preceded by *The Adoration of the Shepherds*. But here again, as in Syracuse, he does not feel safe from the vengeance of the Knights of Malta and so, in the same year 1609, the flight continues and leads him to Palermo, where he paints *The Nativity with St Lawrence and St Francis* for the oratory of S. Lorenzo.

1609 20 October The artist returns to Naples, where he is attacked and so grievously wounded at the door of the German inn of the Cerriglio that news of his possible death reaches Rome. The *Avviso* of 24 October ran the following

notice: 'Word is received from Naples that Caravaggio, the famous painter, has been killed'. A long convalescence ensued through the remainder of this very agitated year 1609 and the first months of 1610. In the meanwhile, efforts are being made in Rome, notable by Cardinal Gonzaga, to obtain the remission of Caravaggio's sentence; and the pardon seems at hand.

1610 July The painter boards a felucca for Porto Ercole, a Spanish garrison town bordering on the Papal States; upon landing, he is arrested and imprisoned by mistake. 'Once released, he could no longer find the felucca, so that raging and almost demented he strode along that shore under the merciless rays of the burning sun to try and catch sight of the ship that bore his belongings. Finally he reached a village on the shore and was put to bed with a malignant fever; without any human assistance he died within a few days as badly as he had lived' (Baglione). It was 18 July 1610. The pardon, as reported by the *Avviso* of 31 July, had been granted; but by then it was too late.

1610 31 July Michelangelo da Caravaggio, the famous painter, died at Porto Ercole while on his way from Naples to Rome because a pardon had been granted to him by His Holiness the Pope from the sentence of banishment which he was under for a capital crime.' (Orbaan, *Documenti sul Barocco …* 1920).

Catalogue of works

As with the events of his life, we possess no documentary evidence for the dates of Caravaggio's paintings before the *St Francis* (presumably the picture now in Hartford), which is known to have been painted before 1597, and the commission for the paintings in the Contarelli Chapel given in 1599. At present we have no reason to doubt that all Caravaggio's surviving paintings were executed after his arrival in Rome, which we can now fix with some degree of probability at the end of 1592 or the beginning of 1593. The early works, prior to the *Scenes from the Life of St Matthew*, must therefore belong to a period of about six years. It should be noted that this does not necessarily invalidate the order given by scholars who adhered to the old date 1588–9 for Caravaggio's arrival in Rome. The significant differences in opinion concern the order itself (and of course the attributions), rather than the specific dates proposed.

Even reference to the early biographers, who give no dates, is of limited value in determining the chronology of Caravaggio's works. Mancini, who wrote about 1620, was a well-informed amateur but he had never belonged professionally to the artistic community. Baglione, Caravaggio's contemporary and a painter himself, was handicapped by writing forty years later and by antagonism towards his subject. Bellori, whose 'Lives' were published in 1672, was still further removed from the events he was describing. The inherent unreliability of these writers is underlined by the fact that their accounts do not tally. Nevertheless these accounts should not be dismissed as mere guesswork. There is a considerable degree of overlap between them and each adds something to the others. Even Bellori, whose biography is the latest, probably depended on some fairly firm information; although he embellished freely, little of what he says is obviously absurd. With this in mind we should add that our reconstruction of Caravaggio's chronology, especially in his early period, is hypothetical like those of all other modern scholars. The exact sequence given below should not be taken too literally. There can be little doubt that Caravaggio sometimes worked in more than one style simultaneously and some groupings are dictated more by pictorial type than strict stylistic development.

1 ⊞ ◉ 65×52 / 1591* ▤ :
Boy Peeling Fruit
Formerly London, Sabin Collection
Listed by Mancini among the small paintings 'made for sale' in succession to the *Boy Bitten by a Lizard* while the artist was living in the house of Pandolfo Pucci: 'and then a boy peeling a pear (apple) with a knife'. This is perhaps the first painting by Caravaggio for which contemporary references exist and it is certainly earlier than the *Boy with a Lizard* which Mancini places before it. Pictorial directness, anti-Mannerism, iconographic and compositional innovation, characterize this little work, to which attention was first drawn by Isarlo ('L'Amour de l'art', 1935) in the Hampton Court copy (62 × 49 cm.). In 1943, Longhi ('Proporzioni') published the copy he himself owned (68 × 67.5cm.); a third copy (the poorest; 67 × 51cm) is in a private collection in Berlin. Finally, the fourth copy, perhaps the best, illustrated here, was formerly in London in the Sabin Collection and was published by Hinks (1953) as an original work. No critic has expressed doubts as to the originator of the design. Mahon ('Paragone', 1952) observed that the model was the same as that for one of the youths in *A Musical Scene* (12).

2 ⊞ ◉ 66×52 / 1591* ▤ :
Sick Bacchus Rome, Galleria Borghese
Described in some detail among the paintings seized by the public treasury from the Cavaliere d'Arpino on 4 May 1607 and presented by Pope Paul V to Cardinal Scipione Borghese. Perhaps also listed by Baglione and, as a Caravaggio, in the 1693 and 1790 inventories of the Borghese Gallery. Subsequent confusions in the catalogues and fanciful attributions (Ludovico Carracci, Tiarini, Bonzi) obscured the quality of this painting even from distinguished scholars such as A. Venturi (Borghese Catalogue, 1893) and Cantalamessa (*Note al Catalogo Venturi*, 1912). After a mention by Marangoni ('Dedalo', 1921–2), who contested the attribution to Bonzi, Longhi renamed and definitively identified the canvas in 1927–8 ('Vita artistica'; also in 'Pinacotheca', 1928–9). This attribution was unanimously acknowledged by critics after the publication of the d'Arpino inventory discovered by De Rinaldis and the latter's exhaustive essay ('Archivi', 1936; also in 'Bollettino d'arte', 1935–6), except for Arslan ('Aut Aut', 1951 and 'Arte antica e moderna', 1959), who considered the picture a copy because of the thinness of the paint surface and the colours. The datings proposed range from 1589–90 (Longhi; Friedlaender) and 1591–2 (Jullian) and 1593–7 (L. Venturi). The most reasonable seems to be c.1594. According to Wagner (1958) the figure was borrowed from one in Raphael's *Parnassus*. The painting's critical history is admirably summarized by P Della Pergola (Borghese Catalogue, 1959).

3 ⊞ ◉ 70×67 / 1593-94 ▤ :
Boy with a Basket of Fruit Rome, Galleria Borghese
The early history of this work is similar to that of the *Sick Bacchus* (2). A. Venturi (Borghese Catalogue, 1893) listed it as 'attributed' to Caravaggio; the first to publish it, as an early copy of a Caravaggio, was Marangoni ('Rivista d'arte', 1917; and Dedalo', 1921–2); however, he later changed his mind ('Bollettino d'arte', 1922–3) and opted for authenticity. Arslan (1959) alone has remained doubtful, being undecided between the excellence of the work and the X-ray results, which seemed to him to prove that the canvas dated from the eighteenth-century. L. Venturi (1951) mentioned it among Caravaggio's works, but left the question open and quoted contrary opinions. The belief in the painting's authenticity, resolutely upheld by Longhi ('Vita artistica', 1927–8; and 'Pinacotheca', 1928–9) has received the almost unanimous support of other critics, among them Voss, De Rinaldis, Mahon and, latterly Mariani, Jullian and De logu. But Friedlaender (1955) thought that the figure — though not the still life — might be by another hand, possibly an artist in the workshop of d'Arpino akin to, though different from, Caravaggio, a notion which appears somewhat eccentric. A. Czobor ('Acta historiae artium Academiae scientiarum Hungaricae', 1955) saw it as one of Caravaggio's many idealized youthful self-portraits (see 12). The date is presumably close to that of the *Sick Bacchus*, i.e. about 1594.

4 ⊞ ◉ 65,8×39,5 / 1593* ▤ :
Boy Bitten By a Lizard
Florence, Longhi Collection
'He also painted a youth bitten by a lizard emerging from amongst flowers and fruit; the head seemed indeed to shriek; and the whole was rendered with the utmost care' (Baglione). The authenticity of two versions of this work has to be considered: one published by Borenius ('Apollo', 1925), later in the Korda Collection, the other published by Longhi ('Pinacotheca', 1928–9), which now belongs to him. Among specialists, the two versions have given rise to one of the most abstruse, bitter and hair-splitting guessing-games in Caravaggio studies. Pevsner ('Zeitschrift für bildende Kunst', 1927–8), Zahn (1928), L. Venturi ('Commentari', 1952) and Jullian (1961) — the latter doubtfully — sided with Borenius for the Korda version. Schudt (1942), Baroni (1951), Mahon ('Burlington Magazine', 1951).

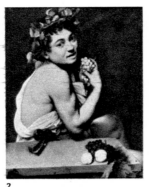

2

1

Joffroy (1959) and De Logu (1962) supported Longhi's claim. It is difficult to express a fresh opinion on the two versions for, if the painting in the Longhi Collection, shown at the 1951 Milan exhibition, impresses by its crystalline perfection, the other is only known to most critics through a photographic reproduction. A direct comparison supported by laboratory analysis would be desirable, since both paintings are of high quality and to view them separately does not solve the question. *Pace* Moir (1967), it is highly unlikely that both are originals and one would prefer not to think that both are copies.

5 ⊞ ◉ 67,3×51,8 / *1592-93 ▤ :
Boy with a Vase of Roses
Atlanta, Ga., Atlanta Art Association
This work was mentioned, though vaguely, by Bellori. It was published as an original by Voss ('Die Kunst', 1951), but was identified as a work by Caravaggio as early as 1909 by L. Venturi (unpublished statement) and was included in Mahon's catalogue ('Burlington Magazine', 1952); it was shown at exhibitions in Houston (1952) and Bordeaux (1955). It was disregarded by Longhi, Hinks and Friedlaender in their respective monographs — with good reason, according to Joffroy (1959); Wagner (1958) also rejected it, because of its metallic sharpness. This did not prevent Jullian (1961) from inclining to accept its authenticity, referring to Bellori's statement and explaining the painting's appearance by suggesting it had been over-cleaned. Paola Della Pergola ('Bollettino d'arte', 1964) also considers it an authentic work. Photographs cannot resolve the problem; the details of leaves, flowers, glass, fabrics, hair, are remarkable but the facial type and idealized pose seem untypical of Caravaggio. The composition is obviously in a sense a variant of the preceding work.

6 ⊞ ◉ 96×73 ▤ :
Boy bitten by a Crayfish
Whereabouts unknown
The existence of such a subject, passed over in silence by the early biographers, is attested by Manilli in his seventeenth-century catalogue of the Villa Borghese (1650, p. 71). Salerno (in his edition of Mancini, 1959), calling attention to Manilli's statement, pointed to this painting, which appeared in a Roman sale in 1955 as a possible copy of the original by Caravaggio. Despite its weakness and obviousness of sentiment, which suggest that it is a work of a follower, it was published by Jullian (1961) as a copy of the lost original.

7 ⊞ ◉ 92,5×128,4 / 1591-92* ▤ :
St Francis in Ecstasy
Hartford, Conn., Wadsworth Atheneum
In 1894 Vincenzo Joppi ('Miscellanea di storia veneta', XII) reported the existence, in the church of S. Francesco at Fragagna, of an oil painting by Caravaggio with documentation going back to the will in 1597 of Ruggiero Tritonio, Abbot of Pinerolo. This will states that the picture was a gift from the Genoese collector Ottavio Costa and that it was to be bequeathed in perpetuity to Tritonio's descendants, who were forbidden to sell or give it away. In 1852 Count Francesco Fistalario, who had inherited the picture, donated it to the church at Fragagna. This information led A. Venturi to identify a version of the painting in the museum at Udine as the picture which had been in the church at Fragagna in 1894 and to publish it as authentic ('L'Arte', 1928). Longhi held this work to be a copy ('Pinacotheca', 1928–9). Subsequently Marangoni ('International Studio', 1929) published the Hartford version, then in Trieste (owned by the

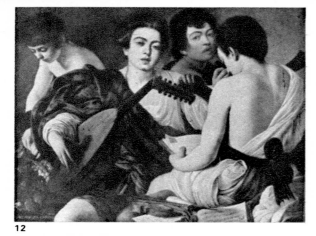

12

[image 7 — St Francis]

7

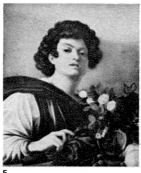

5

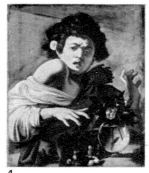

4

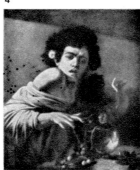

Version of 4, Korda Collection (Great Britain)

Peterzano. Calvesi ('Bolletino d'arte', 1954) pointed to a drawing by Peterzano showing some similarity with the angel.

Grioni family and formerly in a private collection in Malta), as the original; he conjectured that it had been replaced in the Tritonio collection by a copy at some point between 1622, the year of Tritonio's death, and the donation to the Fragagna church in 1852. The attribution of the Hartford canvas was rejected by Longhi ('Proporzioni', 1943) but accepted by Bloch ('Maandblad voor beeldende kunsten', 1948), Berenson (1951), L. Venturi (1951), Mahon (1952), Friedlaender (1955), Jullian (1961) and De Logu (1962). However, Schudt (1942) doubted its authenticity, and Arslan ('Arte antica e moderna', 1959) dismissed the painting as a copy, stressing the primitiveness and lack of unity of the composition, although the model for the angel was clearly the same as that for the *Boy Peeling Fruit* and the youth at the back on the left in the *Musical Scene*. Oertel ('Pantheon', 1938) considered the work as possibly the earliest known Caravaggio; Mahon ('Burlington Magazine', 1952) called it one of the earliest as did Arslan, who did so on the basis of characteristics the composition shares with Savoldo – or, even more with

8 ⊞ ◐ 99 × 131 1594* ▤ :

The Fortune Teller Paris, Louvre
This is no doubt the original of the 'Gipsy telling the fortune of that youth, by the hand of Caravaggio', which in 1620 belonged to Alessandro Vittrice, 'a gentleman of Rome', and which Mancini (c.1620) said had been sold for eight

scudi. But the earliest mention of the work is in a madrigal by Gaspare Murtola (*Rime, cioè Gli occhi d'Argo*, 1603), cited by Heikamp ('Paragone', 1966). The painting is also referred to by Baglione and Bellori: 'Caravaggio called a gipsy who chanced to pass in the street, and having led her to his inn he portrayed her in the act of predicting the future, as these women of the Egyptian race are wont to do. He also represented a young man with his gloved hand resting on his sword and the other bare one proffered to the woman, who holds and examines it' (Bellori, 1672). According to Scannelli (*Microcosmo*, 1657), the work was then in the 'vigna Pamphilia' at Rome; Don Camillo Pamphili presented it to Louis XIV on the occasion of Bernini's visit to France (Chantelou, 1665) and it came to the Louvre with the royal collection. Modern critics, from Kallab to Jullian, are in agreement with the attribution to Caravaggio, except for Benkard (1928), who gave it to Saraceni, together with the version in the Capitoline Museum (9). Mancini mentions it as painted in the house of Monsignor Petrignani; Baglioni seems to link it with the works painted for Cardinal del Monte. In either case it would date from about 1595–6.

9 ⊞ ◐ 115 × 150 ▤ :

The Fortune Teller Rome, Musei Capitolini
This variant of the Louvre canvas (8), formerly attributed to Saraceni, to whom it was re-ascribed by Bocconi (*Musei Capitolini*, 1930), was sold to the Pope as a Caravaggio in 1750, with the collection of Pio di Savoia. It was mentioned without comment, but as authentic, by Kallab (1906). The attribution to Caravaggio was confirmed by Longhi ('L'Arte', 1913), who later described the painting as an original variant, only dimmed by the thick varnish ('Proporzioni' 1943, and 1952). Voss (1923), Pevsner (1927–8), Schudt (1942) and Grassi (1953) took the same view. However, Marangoni (1922), L. Venturi (1925 and 1951) and Benkard (1928) disagreed, the latter ascribing it to Saraceni, as he did the Louvre canvas. Mahon ('Burlington Magazine', 1951), Samek Ludovici (1956), Jullian (1961) and De Logu (1962) also reject it. Arslan ('Arte antica e moderna', 1959), regarded it as an eighteenth-century copy; Wagner (1958) rightly pointed out fundamental differences in painting technique and drawing compared to Caravaggio's manner. It is difficult to be certain but the figure style, by comparison with the Louvre version, does seem to be too slack for Caravaggio. There is no particular reason for attributing it to Saraceni and Moir (1967) calls it – slightly misleadingly – an anonymous copy of the Louvre painting.

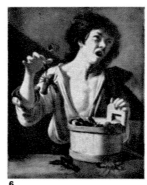

6

10 ⊞ ◐ 130 × 160 1594 - 96 ▤ :

The Rest on the Flight into Egypt Rome, Galleria Doria-Pamphili
Bellori wrote (1672): 'He painted in a larger work the Virgin resting during the Flight into Egypt. There is an angel standing and playing the violin, while St Joseph, seated, holds the musical score before him; and the angel is most fair as, sweetly turning his head in profile, he reveals his winged shoulders and a view of the rest of his nude body, interrupted only by a small cloth. On the other side sits the Virgin and, bowing her head, she seems to sleep with the Child on her lap.' Although it was already mentioned by Mancini (c.1620), and recalled by Bellori himself as being in the Palazzo Doria – Pamphili (in the catalogue of which, drawn up by Tonci in 1794, it still appears with the correct attribution), this painting – like the *Magdalene* (11) – was rejected by Mündler (1869) and ascribed to Saraceni. Mündler was followed by subsequent cataloguers of the Doria – Pamphili Gallery and by Biancale ('Bollettino d'arte', 1920) and Benkard (1928), although the work had been correctly restored to Caravaggio by Kallab in 1906. In recent times there have been no voices raised against this beautiful and fully authenticated canvas, about which there is unanimous agreement on the part of modern critics. Pages of analysis have been written on it, notably by Voss ('Jahrbuch der preussischen Kunstsammlungen', 1923). Hess (1954), followed by Friedlaender (1955), have

pointed out an analogy between the angel and the figure of lust in *Hercules at the Crossroads* by Annibale Carracci (Naples, Capodimonte Gallery), datable 1595–7. Calvesi ('Commentari', 1956) cited as a common source the Juno engraved by Caraglio. Röttgen ('Zeitschrift für Kunstgeschichte', 1964) has pointed to a further partial source for the composition in a drawing by d'Arpino in the British Museum. According to Mancini the picture was painted when Caravaggio was staying in the house of Monsignor Petrignani, i.e. about 1595–6.

11 ⊞ ◐ 106 × 97 1594 - 96 ▤ :

The Magdalene Rome, Galleria Doria-Pamphili
'He depicted a girl seated on a chair, her hands in her lap, in the act of drying her hair; he painted her in a room and, by adding on the ground a small jar of ointment with trinkets and jewels, he would have us believe that she was the Magdalene. Her face is turned somewhat to the side, and the cheek, the neck and bosom are suffused with a pure, smooth and true colour, matched by the simplicity of the whole figure. She wears a blouse and her yellow frock is pulled up to the knees over a white underskirt of flowered damask. We have described this figure in detail to stress his natural manner and his ability to render real colours with but a few tints.' Thus Bellori (1672). Mentioned by Mancini (c.1620) as painted in the house of Monsignor Petrignani and by Bellori as belonging to Prince Pamfili, this picture is listed as a Caravaggio in Tonci's catalogue of the Doria Gallery (1794). It was attributed to Saraceni in Burckhardt's *Cicerone* (Mündler edition, 1869) and in the subsequent catalogues of the gallery; these were followed by Biancale ('Bollettino d'arte', 1920) and Benkard (1928), who repeated the attribution to Saraceni, although the painting had been restored to Caravaggio by Kallab (1906). Most of the best modern authorities (Longhi, L. Venturi, Voss, Mahon, Friedlaender, Jullian, Moir) have accepted the painting without question. Despite this,

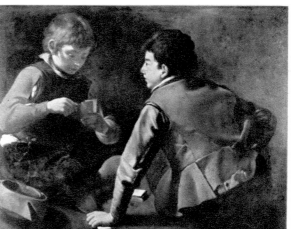

16

however; despite an excellent provenance going back to Bellori's time; and despite the presence of a *pentimento* in the work (Mahon, 'Burlington Magazine', 1952), Arslan ('Aut Aut', 1951 and 'Arte antica e moderna', 1959), followed by implication by Folkker (Doria Catalogue, 1952), chose to regard the picture as an eighteenth-century copy because of an apparently untypical paint structure revealed by X-rays. It is admittedly conceivable that a copy was substituted for the original in the Doria-Pamphili collection at some time in the past. The position is also complicated by the discovery of another good version of the painting (Milan, Boscarelli Collection), which Bossaglia, who published it ('Commentari', 1961), held to be more precise in execution and, because of its larger dimensions (136 × 121 cm), more nearly corresponding to Scannelli's description of the original (1657) as a 'full-length life-size figure', than the Doria version. Bossaglia, however, only believes this to be an earlier copy than the Doria picture of the supposedly 'lost' original, not necessarily the original itself. For the moment there does not seem to be sufficient evidence to upset the almost universally held attribution of the Doria *Magdalene* to Caravaggio. A suggestion by I. Toesca ('Journal of the Warburg and Courtauld Institutes', 1961) that the figure represents not the Magdalene but St Thäis, on the grounds of its resemblance to an etching of this subject by Parmigianino that may have provided a mode for the pose, may be provisionally disregarded as an ingenious but unnecessary hypothesis, in view of the statements by the early biographers that the subject is the Magdalene. If, as Mancini implies, the picture was painted in the house of Monsignor Petrignani, it would date — like *The Rest on the Flight into Egypt* (10), to which it is similar in feeling — from c 1595–6.

12 🔲 ◐ 92×118.5 / 1591-92* 📋 ⋮

A Musical Scene New York, Metropolitan Museum
'He painted very expertly for the

Version of 18 (Florence, Private Collection), which Longhi regards as the original

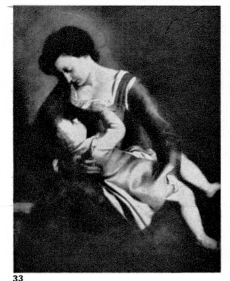

33

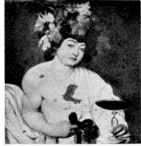

Detail of 14 before restoration

3 Plate I

Cardinal (Del Monte) a musical scene with youths drawn from nature' (Baglione). From the day when it was discovered by D. Carritt in an English private collection and published by Mahon ('Burlington Magazine', and 'Paragone', both 1952), this painting, carrying an old attribution to Caravaggio, has been almost unanimously accepted: by Samek Ludovici in the same year, by Longhi (1952), Baroni (1952 and 1956), Mariani (1958), Arslan (1959), Joffroy (1959) and De Logu (1962). Mahon, referring to Baglione's and Bellori's placing of the painting in the sequence of the early works, dated it 1594–5. Longhi put it at 1590. To separate it from the very early half-lengths of boys (1–6), which it most obviously resembles, and place it after the more sophisticated *Rest on the Flight into Egypt* (10) — as Mahon does and as we do here — is indeed somewhat paradoxical. But if the *Musical Scene* is the first picture commissioned by Cardinal del Monte, as both Baglione and Bellori suggest, it is difficult to see any other solution and the picture may not have been executed until 1596. A. Czobor ('Acta historiae artium Academiae scientiarum

Hungaricae', 1955) regarded the lute player in the centre as an idealized self-portrait.

13 🔲 ◐ 94×119 / 1594* 📋 ⋮

The Lute Player
Leningrad, Hermitage
In listing Caravaggio's works Baglione wrote (1642): 'he painted very expertly for the Cardinal (del Monte) a musical scene with youths drawn from the life (12) and also a youth playing the lute in which everything he depicted looked alive and real; in this work he showed a carafe of flowers full of water, within which could be perfectly seen the reflection of a window with other reflections of a room in the water, and on the flowers was a fresh dew imitated with the most exquisite care'. Ever since the canvas was brought to light by Kallab in 1906 ('Jahrbuch der kunsthistorischen Sammlungen der allerhöchsten Kaiserhauses') and illustrated by L. Venturi ('L'Arte', 1910), no doubts have been expressed either about its authenticity (perhaps because few Western critics have seen it) or about assigning it to Caravaggio's early period. The arguments centre mainly on the figure's sex and on the exact description of the instrument being played. On the solution to these questions depends the decision as to whether or not Baglione's 'a youth playing the lute' and Bellori's, 'a woman in a shirt playing the lute with the score before her' both refer to the same painting. Apart from the visual evidence, which is reasonably decisive, Caravaggio's known homosexual inclinations — as well as those of some of his patrons — make it almost certain that the figure is a boy. It is possible that Bellori did not realize this aspect of the painter's character and, writing about the picture from memory, understandably mistook it for a girl. Painted for Cardinal del Monte — and hence datable about 1596 — it later passed into the Giustiniani Collection from which Baron Denon bought it in 1808 for the Hermitage. The critical history of the painting is among the most straightforward of the early works. A. Czobor (1955) had it as the fifth idealized self-portrait (see 3). One of the few interesting points to have emerged recently

was that made by De Logu (1962), who read as 'Gallus' the inscription on the closed book. If this reading is correct (though it could also be 'Bassus'), the inscription might refer to a text by the Milanese Giuseppe Galli, who published a treatise on music at Milan in 1598. If explored, this might throw some light on the painter's musical knowledge.

14 🔲 ◐ 95×85 / 1593-94 📋 ⋮

Bacchus Florence, Uffizi

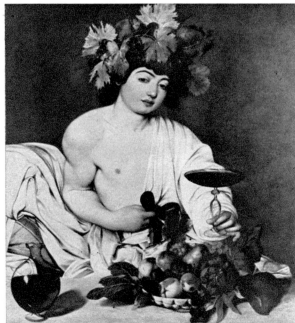

14 Plates II & III

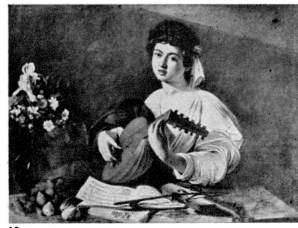

13

According to Baglione (1642), Caravaggio's first work in a series done from himself in a mirror 'was a Bacchus with some bunches of grapes, painted with great skill'. Identified by Longhi (1916) in the depot of the Uffizi, it was then published by Marangoni ('Rivista d'Arte', 1917) as a copy on the basis of Longhi's attribution; Marangoni later, however, described it as an original 'Bollettino d'arte', 1922). Since then, it has been included without opposition among the works of the young Caravaggio. In fact it has generally been used as a touchstone for establishing the authenticity of other debatable paintings. The arguments between critics concern two points: the date of the canvas and its place in the sequence of paintings prior to the Contarelli Chapel (cfr. Joffroy, 1959). Marangoni strikingly if somewhat eccentrically likened the painting to Ingres' portrait of *Madame Rivière*; and indeed the statuesque and cold, albeit ambiguous, purity of the forms tends to suggest a neo-classicist, an unknown Ingres, rather than a supposed pioneer of the Baroque. Nor is the figure reminiscent of the first supposed idealized self-

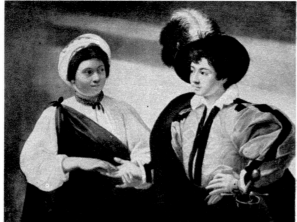

8 Plates IV & V

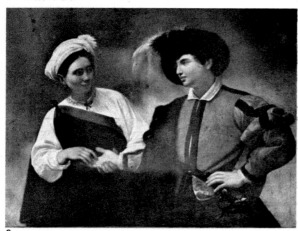

9

portrait – see 3 – (Czobor). (It should perhaps be mentioned that the picture has been damaged and heavily restored.) Voss noted shortcomings typical of a beginner; Mahon regarded it as the last painting of the early period; Hinks placed it after the *Boy Bitten by a Lizard* (4) and the *Lute Player* (13). Whereas Jullian assigns it to 1593–4, Mahon's dating seems to be most nearly right, about 1595–6.

15 99×107 1596*

The Cardsharpers New York, Private Collection
Described in detail by Bellori (1672), who called it Caravaggio's 'first work in the plain (*schietta*) manner of Giorgione': 'These paintings (*The Magdalene* (11) and *The Rest on the Flight into Egypt* (10)) are to be seen in the palace of Prince Pamphili. Another, worthy of the same praise, is in the apartments of Cardinal Antonio Barberini; it consists of three half-length figures intent on a card game. Here Caravaggio depicted an innocent youth in a dark suit with the cards in his hand, his head being well portrayed from life. Facing him is a dishonest youth shown in profile, one of his hands resting on the card-table as with the other behind his back he pulls out a false card from his belt; meanwhile a third man beside the first looks at the values of the boy's cards and with three fingers of his hand indicates them to his companion who, in bending over the table,

exposes his shoulder to the light. This latter figure wears a yellow jerkin with black stripes. There is nothing false in the colouring of this work.' There has been a great deal of argument over the authenticity of this painting, although no one doubts that the composition is by Caravaggio. For a long time the original was believed lost (perhaps it still is). The first candidate was a picture in the Dresden Gallery (Catalogue by Woermann, 1902) but this was not even the right composition and that picture is in fact by Valentin, although it long went under Caravaggio's name. The composition was first correctly identified by Kallab (1906), who traced the progress of the painting from the Barberini Palace (in 1812) to the Sciarra Collection, from which it was sold about 1896 to an unidentified 'Mr Rothschild'. After this it went out of sight. A reference to the Sciarra painting had appeared in A. Venturi's *Gallerie di Roma* (1895), it was illustrated in Vicchi's *Dieci quadri della galleria Sciarra* (n.d.) and it was photographed by Braun after the sale. It was on the evidence of this (good) photograph that Longhi discussed the painting in 'Proporzioni' (1943), calling attention to its importance and convincingly proposing it as the lost original by Caravaggio. Not surprisingly, the hunt for the Sciarra painting has been feverishly pursued since then. After fruitless searches in the collections of the various

branches of the Rothschild family, Baumgart thought he had hit on the solution and published ('Das Werk des Künstlers', 1939–40) what he took to be the original, in which he was supported by Schudt (1942). In fact this was an indifferent copy which Longhi ('Proporzioni', 1943) was easily able to dismiss. What seems to be the best claimant (there have been hosts of others) is the painting illustrated here, and now in a private collection in New York. It was published by L. Venturi ('Commentari', January 1950), who stated that he had identified it as the original in a canvas submitted to him two years previously in New York, bearing on the back a small label with the inscription 'Antonine de Rothschild', a member of the English branch of the family. This canvas, smeared with dirt and badly damaged, turned out after cleaning and restoration to be a work of considerable quality. Its authenticity has been accepted by Pevsner, Friedlaender, De Logu and, with some ambiguity, Jullian. However, it has been rejected by Samek, Mahon, Longhi (by implication, 1956), Valsecchi (1951) – who pointed out discrepancies between the canvas and the documentation relating to the Sciarra painting – and Baumgart (1955). Unfortunately the painting was not shown at the Milan exhibition in 1951, where the problem might have been solved (in fact its whereabouts were then still secret). The datings proposed range from 1591–2 (Longhi), 1593–4 (Baumgart), 1594–5 (Hinks), to 1597–8 (Mahon, Arslan). If Bellori is correct in asserting that it was the painting which brought Caravaggio to the notice of Cardinal del Monte it was presumably executed about 1595–6. However, this is not easy to reconcile with Bellori's other statement that the *Musical Scene* (12) was the first painting commissioned by the Cardinal, when Caravaggio was living in his house, since of the two *The Cardsharpers* is much the more sophisticated work. Perhaps it is this second

17

statement which is false and the first true; alternatively, we may be wrong in identifying 12 with Bellori's remark. It may be relevant that the dimensions of the New York *Cardsharpers* are the same as those of the *Fortune Teller* (8) which is in the Louvre.

16 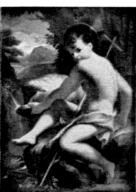 96.5×117 1593*

Card Players Cambridge, Mass., Fogg Art Museum
Berenson (1951) first illustrated this canvas, which has the superficial appearance of a work by Caravaggio following the precedent of the ex-Sciarra *Cardsharpers* (15). On the evidence of the lighting, conception and treatment of detail, the painting shows every sign of being a later plagiarism of two of the figures in 15, not by Caravaggio.

17 66×53

Portrait of a Young Woman Formerly in Berlin, Kaiser Friedrich Museum
This is the only known portrait by Caravaggio, the attribution of which has been universally accepted (no doubt it would

34

have been disputed if it had survived into the last twenty years). It came from the Giustiniani Collection (not the Sciarra, as maintained by Joffroy), which it had entered in about 1600, when Caravaggio was working in S. Luigi dei Francesi. It was purchased in 1815 with *Victorious Love* (46) and with the first version of *St Matthew and the Angel* (41A), together with which it was destroyed in 1945. According to tradition, it portrayed a Roman courtesan, whose name – obviously a *nom de guerre* – was Fillide (Phyllis). It was studied by Rouches (1920), Marangoni (1922) and Voss (1923).

18 121×95 1593–94

Portrait of Maffeo Barberini Florence, Galleria Corsini
The old inventories attribute this work to Scipione Pulzone, to whose circle it was restored by Longhi ('Proporzioni', 1943). L. Venturi ('Bollettino d'arte', 1912), relying on Bellori and on a vague reference by Mancini ascribed it to Caravaggio, followed by Voss ('Jahrbuch der preussischen Kunstsammlungen', 1923), Marangoni (1922), Zahn (1928), Schudt (1942), Mahon ('Burlington Magazine', 1952), Hinks (1953), Friedlaender (1955) and, with reservations, Samek (1956). The authors of the catalogue of the 1951 Milan exhibition also accepted it. The attribution was rejected by Baroni, Berenson and De Logu (1962). Against Pulzone's authorship – who died in 1588 – must be weighed the fact that in this portrait Maffeo Barberini – born in 1568, made a cardinal in 1606 and Pope Urban VIII in 1623 – looks around thirty. Bellori's statement that Caravaggio portrayed Maffeo Barberini might refer to the canvas published by Longhi mentioned below or to another, still unknown; or, if the portrait were by Pulzone, the sitter's age might appear to be increased by his bearing, his appearance, or his desire as an already eminent churchman to appear older and

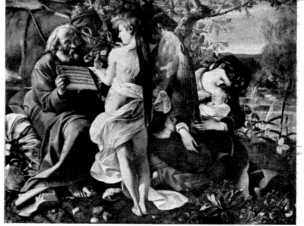

10 Plates VI–IX

more austere than he was. Assuming that the portrait is by Caravaggio, the difficulty of blending likeness and creative imagination would explain in a painter still only twenty-five and unused to portraiture what is hard, stilted and static in the picture. But the set of the shoulders, the sleeves, the hands bathed in light, the carafe with the jasmine and the small carnations, the chair and the table, all leave – according to Samek – reason for doubting the attribution.

Longhi ('Paragone', 1963), firmly removing the painting from Caravaggio's oeuvre, published a portrait of Maffeo Barberini which appeared in Rome without provenance (but possibly from the Barberini Collection when it was

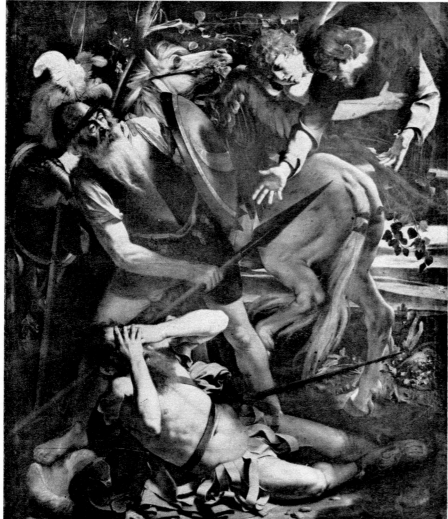

42

29 Plates X & XI

Friedlaender, Voss), some strongly doubting it (Bottari, De Logu) and others explicitly rejecting it (Wagner, Jullian). It is indeed hard to believe that this relatively cluttered and — even though rather beautiful — atmospheric still life, the motive of which extends behind and beyond the frame, can be by Caravaggio. No alternative attribution has, however, been produced and for the time being the painting must remain an anonymous work of the Caravaggio school.

held by Joffroy, who considered it a violation of Mancini's text to interpret 'racano' (tree frog) as 'ramarro' (green lizard) or 'lucertola' (lizard), and thus incorrect to identify this canvas with the *Boy Bitten by a Lizard* described by Baglione (4). A number of points support this. One, 'putto' (child, little boy) (Mancini) is not the same as 'fanciullo' (young boy, youth) (Baglione). Two, the 'racano' (frog) held in the hand is not identical with the 'ramarro' or 'lucertola' (green lizard or lizard) emerging from the flowers and fruit of Baglione's description. Three, it should be noted that, in the chronological sequence, Mancini's *Boy Bitten by a Frog,*

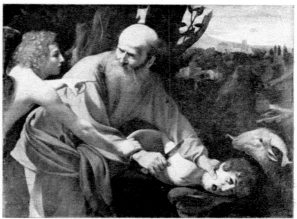

dispersed in 1930–5), proposing it as the 'real' work mentioned by the sources.

19 ▦ ◉ 46×64,5 ▤ ⋮
1596
Basket of Fruit Milan, Pinacoteca Ambrosiana. This is documented through an appendix dated 1607 to the inventory of the works of art, books, manuscripts etc., given by Cardinal Federico Borromeo to the Accademia Ambrosiana in Milan, which he had created that year, that is, during Caravaggio's lifetime. The painting is also mentioned with the artist's name in a work written by the Cardinal, the *Museum*, published in 1618. It

works by L. Venturi, Marangoni and Voss; however, Longhi (1928–9) convincingly dated it slightly later, both for reasons of style and because of a letter written in 1596 from Cardinal del Monte to Cardinal Borromeo, in which the painting may be mentioned by implication. It is the only pure still life by Caravaggio, apart from the doubtful painting (20) in Washington, with which Longhi has coupled it. Nevertheless, Borgese ('Corriere della sera', 16 September 1950) has suggested that it may be a fragment, a hypothesis that must remain in abeyance for the time being until the results of the most recent X-rays, which apparently show something underneath the present neutral background, are published. And while it is not, as was once wrongly maintained, the first still life in Italian art, it is undoubtedly the first in which a humble object becomes a positive 'feature', the first in which a mere basket with a few common fruits appears to be raised to and recreated on an intellectual and moral level. It is thus in a sense the aesthetic ancestor of a line of still lifes in European painting in which the object is not merely 'object' but 'subject'.

Rome and entitled by him *Postpasto* (Dessert), this still life then bore on the reverse an old label, undoubtedly of the seventeenth century, with the inscription : 'Quadro di frutta con caraffa. MIL. Caravaggio'. The painting was bought by Samuel H. Kress of New York and later given by him to the National Gallery in Washington. Longhi has always tenaciously upheld the attribution to Caravaggio ('Proporzioni', 1943, and 1952), dating the painting contemporaneously with the London *Supper at Emmaus* (47). However, hardly anyone else has accepted this, some omitting the work altogether (L. Venturi,

We list at this point a group of documented works, now lost or destroyed, which were presumably painted by Caravaggio in his first period of activity and for which it is impossible to establish a chronology, however conjectural.

21 Boy Bitten by a Frog
This is the title under which Jullian lists the painting among the lost works referable to the first Roman period, relying on a passage by Mancini (c.1620) and interpreting 'racano' (or 'ragano', according to Mancini's various manuscripts) as 'ranocchia' (frog). The same opinion was

assigned to the period when the artist lived in Pandolfo Pucci's house and thus contemporary with the *Boy Peeling Fruit* (1), is earlier than the *Boy Bitten by a Lizard*, as was already noted by Clark ('Paragone', 1951). While no dictionary records the word 'racano' or 'ragano' (green frog) as a synonym for 'lucertola' (lizard), 'raganella' for a frog is still in use. Joffroy translates it with the French 'rainette', an obsolete word once used to designate a frog living in the woods near water.

22 Portrait of an Innkeeper
'For the market he painted ... the portrait of an innkeeper with whom he found shelter' : thus

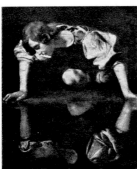

31 Plate XII

is therefore obvious that it is among the few paintings by Caravaggio, other than altarpieces, whose authenticity cannot be disputed. The date, however, has given rise to argument. It was grouped with the very first

20 ▦ ◉ 51×72 ▤ ⋮
1596
Still Life Washington, National Gallery of Art (Kress Collection).
Discovered by Longhi about 1928 in a private collection in

11 Plates XIII & XIV

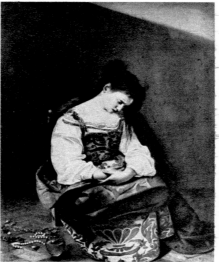

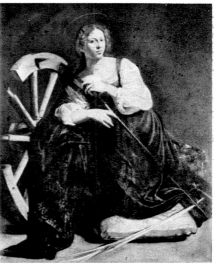

25 Plate XV

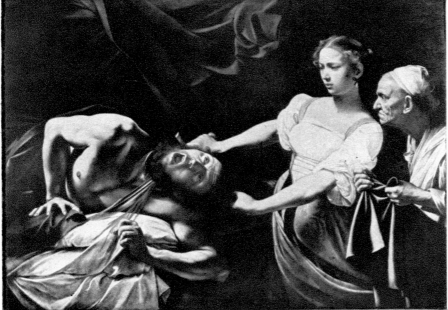

26

26
Judith Beheading Holofernes Rome, Coppi Collection

'For the Costi family he painted a Judith in the act of beheading Holofernes' (Baglione, 1642). The present canvas was first published and linked to Baglione's statement by Longhi ('Paragone', 1951), whose attention had been drawn to the painting by the restorer P. Cellini. Baglione's words, suggesting the immediacy of the action, seem to apply perfectly to this painting, in that the subject is treated in it with extreme, unsparing violence – a violence that foreshadows rather the macabre canvas by Artemisia Gentileschi than the painting by Valentin, which was more directly modelled on it. Because of the literal representation of the sword half-way through the throat, the attribution was, in fact,

27
Sts Martha and Mary Magdalene Oxford, Christ Church Library

This is the best surviving copy of a lost Caravaggio and was first brought to light by Longhi ('Proporzioni', 1943). In the same article, Longhi mentioned two other copies in Rome, a fourth, with variations, in the Musée des Beaux-Arts in Nantes, attributed to Saraceni and a fifth and a sixth, belonging to private collectors in Savigny and New York. Although this subject is not recorded by the sources and although the surviving versions are copies, and not even very good ones, the hypothesis that they depend on a lost original, datable about 1597–9, seems convincing. This is not only because of the similarity of the Magdalene to the *St Catherine* in Lugano (25). Wagner (1958) and Vos (1924–5) alone have

Mancini (c.1620) after mentioning the *Boy Bitten by a Frog* (21) and the *Boy Peeling Fruit* (1), and before referring to the young Caravaggio's admission to the Roman hospital of the Consolazione. No work remotely corresponding to this portrait has been found.

23 Portrait of a Peasant (?)
Mentioned by Mancini together with the above-mentioned *Innkeeper*; but the reading of the word 'villico' (peasant) in Mancini's manuscript is doubtful.

24 Carafe with Flowers
Bellori (1672) states that Caravaggio 'painted a carafe of flowers with the transparencies of the water and of the glass and with the reflections of the window of a room, the flowers sprinkled with the freshest of dewdrops'. An attempt was made (Samek Ludovici; etc.) to apply this passage to the *Lute Player* (13), almost as though that painting were the only one where the play of reflections is stressed, whereas, from the *Boy Bitten by a Lizard* (4) to the *Boy with a Vase of Roses* in Atlanta (5), there is no lack of other instances of such virtuosity of which, in any case, Caravaggio was not the inventor. It is, however, quite probable that the description refers to an isolated still life of a carafe, that is to say a painting that, in a certain sense, preceded the *Basket of Fruit* in the Ambrosiana (19). Bellori, in his descriptions, displays considerable iconographic precision and he would not have confined himself to mentioning a secondary detail in a canvas, omitting the principal subject.

In addition to the above, Mancini recalled as works by Caravaggio 'some copies of devotional (paintings) which are in Recanati', as having been made during the period when the painter was a guest of Pandolfo Pucci, who lived in Recanati. These were copies, not original works.

25
St Catherine of Alexandria Lugano, Thyssen Collection

Owned by the Barberini family until 1927. Bellori (1672) recalls it as having been executed for Cardinal del Monte: 'for this prelate Caravaggio painted ... a St Catherine on her knees leaning against her wheel'. Bellori also suggests – correctly – that it is not one of the painter's earliest works since he is

'already beginning to strengthen his shadows'. It was first published by Longhi who ascribed it to Gentileschi in 1916 ('L'Arte') but since 1943 ('Proporzioni') he has followed Marangoni ('Bollettino d'Arte', 1922), Voss ('Jahrbuch der preussischen Kunstsammlungen', 1923) and Zahn (1928) in giving the painting to Caravaggio. This has also been the opinion of Baroni, L. Venturi, Mahon, Samek, Friedlaender and Jullian. Schudt (1942) alone held it to be a copy, although Arslan ('Aut Aut', 1951) considered the mantle thrown over the hub of the wheel to be a later addition – not altogether unreasonably in view of the

decorative and 'baroque' fullness of this piece of drapery. Despite some preciocity in the pose and the *mise-en-scène* – cushion, crossed sword and palm – and the slightly affected gesture of the hands, this stands out as an undoubtedly authentic work, the powerful wheel in which is like a signature. The same model is in *Judith Beheading Holofernes* (26) and *Sts Martha and Mary Magdalene* (27).

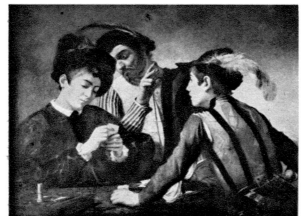

15

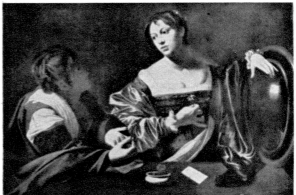

27

rejected by L. Venturi, Wagner, De Logu and Bottari, although Mahon (1952), Friedlaender, Samek and Jullian have accepted the painting. That it is a genuine work is surely true, not so much because of the similarity of Judith to *St Catherine* (25) and *Mary Magdalene* (27) – since neither of these two paintings is absolutely beyond doubt – as because of the rapid rhythm and vigour of the composition, the clearly Caravaggesque treatment of the nude, the expressions on the faces and the blood-red curtain, which seems to look forward to that in the *Death of the Virgin* (63).

rejected it, the latter attributing it to Vouet. The attribution of the composition to Caravaggio has most recently been affirmed by Jullian (1961), De Logu (1962) and Moir (1967).

28
Head of the Medusa Florence, Uffizi

The picture is painted on canvas stretched over a convex shield of poplar wood and is mentioned by Baglione (1642) as having been executed on commission for Cardinal del Monte, who presented it to Ferdinand, Grand Duke of Tuscany. The first documentary reference to it occurs in the oldest inventory of the Medici armoury (1631), where it is described as being held in the hand of a manikin wearing a precious iron and gold armour. It was praised by two rivals in poetry: Murtola, in a madrigal in the *Rime* (1603), and Marino in a fable in the *Galleria* (1620). As it has never been moved from the Grand Duke's palace, controversy turns only on the dating. To insert it after the *Boy Bitten by a Lizard* (4), as did Longhi, noting that the model reappears in the Isaac of *The Sacrifice of Isaac* (29) and in the boy on the right of *The Martyrdom of St Matthew* (40), is reasonable whether or not the Medusa is to be regarded as the last but one of the adapted youthful

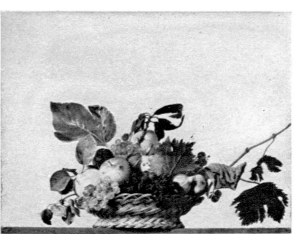

19 Plates XVI & XVII

self-portraits as maintained by A. Czobor ('Acta historiae artium Academiae scientiarum Hungaricae', 1955). However, Longhi's date must certainly be moved forward : these last experiments by the young Caravaggio belong to the eve of the Contarelli Chapel (1599–1602). C. Ricci ('Vita d'arte', 1908), Voss, Schudt and, above all, Marangoni were the first modern students of the painting, already very famous in its time and reputedly a commissioned work. The rhetorical straining after effect in the expression, typical of Caravaggio's work in the late 1590s, would have helped to ensure the picture's fame as a display of virtuosity. According to D. Heikamp ('Paragone', 1966), this shield was added by Ferdinand to the collection of precious armour presented to him, apparently in 1601, by the Persian ruler

inconsistencies, and established that *The Sacrifice of Isaac* was contemporary with the *Medusa* (28) and the *Boy Bitten by a Lizard* (4) (*sic*) – all three being placed somewhat later than the first works – Voss (1925) considered the painting authentic. Zahn (1928), Longhi (1928–9 and 1952), Mahon (1952), L. Venturi (1952) and Friedlaender (1955) have all also accepted it. The old doubts and objections formerly raised by Marangoni and Schudt and, more recently, Baumgart (1955), surfaced again, however with Jullian (1961). The work may be dated about 1592 according to Longhi, about 1595 according to Friedlaender and 1597–9 according to Mahon, which seems the most plausible. There is some similarity in the landscape to that of the Odescalchi-Balbi *Conversion of St Paul* (42).

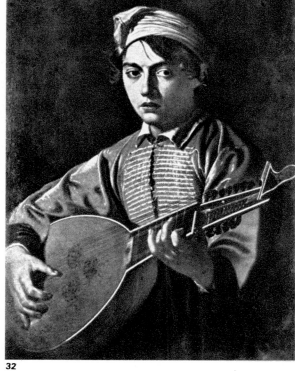
32

undramatic treatment of the subject seem more typical of a follower of Caravaggio, possibly Caracciolo, than of Caravaggio himself. If this is the case, the question of whether the painting is an original or a copy hardly arises. If by any chance the composition is by Caravaggio its date must certainly be later than that of the Uffizi painting of the subject, perhaps about the time of *The Death of the Virgin* (63, c. 1605)

31 110×92 1594-96
Narcissus Rome, Galleria Nazionale d'Arte Antica
Formerly (1913) in a Milanese private collection, this painting was then for the first time attributed to Caravaggio by Longhi, despite the lack of historical and documentary evidence. Purchased as a Caravaggio by B. Kwhoshinsky and presented to the National Gallery in Rome (then in the Corsini Palace), it has since been the focus of much argument. Longhi himself has only briefly alluded to it in print, once in 1916 ('L'Arte') and then again, confirming the attribution, in 1943 ('Proporzioni'). He was supported by Biancale ('Bollettino d'arte', 1920), Marangoni (*ibid.*, 1922–3, though he expressed some reservations thirty years later in the catalogue of the 1951 Milan exhibition), Baroni (*Introduzione al Barocco*, 1947 and 1951), Grassi (1953), Hinks (1953), Nolfo di Carpegna (Catalogue of the Exhibition of Caravaggio and the Caravaggesques, Rome, 1955), Wagner (1958), Mariani (1958) and De Logu (1962). But the attribution, much debated, was refuted or doubted by L. Venturi, Mahon ('Burlington Magazine'; 1952), (who in 1953, however, reverted to considering it authentic), Friedlaender, Voss, Baumgart, Jullian, Schudt and Joffroy. Few of those who have rejected its authenticity could propose an alternative attribution ; Arslan (1959)

called it a free seventeenth-century copy after a lost original. Baumgart, followed by Panofsky – according to De Logu – suggested Gentileschi. It is hard to believe that the daring and beautiful pictorial invention is not due to Caravaggio himself ; the Savoldesque colouring and the subtle play of the shadow that at once veils and enhances the forms is also typical of Caravaggio, as are the defects in the drawing. Yet the handling is coarse in places (which may be due to damage and old restoration) and the forms somewhat loose. If it is by Caravaggio the painting must date from c.1597–9. There are some similarities in feeling with the figures round the table in *The Calling of St Matthew* (39).

32 110×81 1597*
The Lute Player Munich, Alte Pinakothek
This painting derives from the collection of the Electors of Bavaria, in the old inventories of which it is attributed to a

follower of Caravaggio. It was later exhibited in the subsidiary gallery at Augsburg as by a German artist of the end of the seventeenth century. It was first discussed as a possible original of Caravaggio by Longhi (who had considered it autograph ever since 1920) at the art-historical congress in London in 1939. Longhi confirmed his attribution in 1943 ('Proporzioni') and again in 1952 ('Paragone'), describing the painting as a 'marvellous work' from the period of the first version of *St Matthew and the Angel* (41A) and the Thyssen *St Catherine* (25), i.e. of the early 1590s. Grassi alone (1953) has agreed with Longhi. Venturi, Argan (1943), Mahon (1952), Jullian (1961) and De Logu (1962) reject the painting. It is indeed hard to see how such an anecdotal, almost pedantically descriptive work, can be by Caravaggio.

33 131×91
The Madonna and Child
Rome, Galleria Nazionale d'Arte Antica
Regarded as a work by Caravaggio up to the mid-nineteenth century (Burckhardt, 1855), it was attributed to Gentileschi by Longhi in his famous essay of 1916 ('L'Arte') and exhibited as such at Florence in the 1922 exhibition of Italian seventeenth- and eighteenth-century painting. Marangoni ('Bollettino d'arte', 1922–3) suggested that it might be a copy after an original by Caravaggio, and this opinion was later shared by Longhi ('Paragone', 1951 and 1954), who firmly reassigned the painting to Caravaggio's immediate ambience, possibly as an authentic work whose quality had suffered from poor restorations and cleanings. However, Longhi was opposed by L. Venturi (1951), Baumgart (1955) and Wagner (1958). Friedlaender does not mention

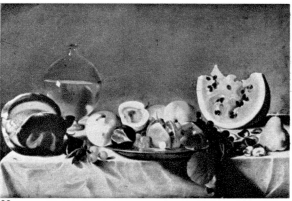
20
Abbas the Great. This might suggest a later date for the painting, towards 1600.

29 104×135 1594-96
The Sacrifice of Isaac
Florence, Uffizi
Formerly in the Sciarra Gallery and presented to the Uffizi in 1917 by John Murray. Cited by Bellori as having been executed for Cardinal Barberini : 'For Cardinal Maffeo Barberini . . . he painted the Sacrifice of Abraham, the latter holding the blade to the throat of his son who cries out and falls'. Marangoni ('Dedalo', 1921–2) was the first to publish the painting as a good early copy of the composition described by Bellori, but not a work by Caravaggio himself for the following reasons : the presence of a landscape, alien to Caravaggio and different from the landscape of *The Rest on the Flight into Egypt* (10) ; the presence in the canvas of an Isaac similar to the *Medusa* (28), an Abraham resembling the Matthew in *The Calling of St Matthew* in S. Luigi dei Francesi (39), and an angel that is a beautified version of the Doria *Baptist* (37) – three analogues, according to Marangoni, which belonged to different periods of the artist's career. This opinion was echoed by Schudt (1942). Having 'overcome' the apparent

30 *160×110*
The Sacrifice of Isaac
Formerly in Como, Di Bona Collection
This second composition of *The Sacrifice of Isaac* (see 29), known through various copies (two in Italy – of which this is one but the better known of which is in the cathedral of Castellammare di Stabia – and three in Spain), was published by Ainaud ('Anales . . . de los Museos . . . de Barcelona', 1947) and subsequently by Longhi ('Paragone', 1951), who referred to a print by Le Vasseur and to the peregrinations of the supposed original by Caravaggio from the collection of Queen Christina of Sweden (catalogue by Campori, 1879) to the Odescalchi, the Duke of Orléans and finally England in 1800. Joffroy (1959) maintained that this painting, known from the engraving when it was in the Orléans collection, does not tally with the existing copies. Baumgart (1955) and Wagner (1958) maintained that even the composition was not by Caravaggio. Friedlaender (1955) briefly cited Ainaud's article but gave no opinion. Jullian (1961) was also doubtful. To judge from the photograph, the rather slack, linear figure style, scattered pools of light and totally

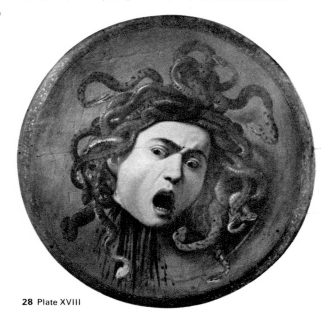
28 Plate XVIII

the work, while Moir (1967) wavers between Gentileschi and an unknown close follower of Caravaggio. Jullian (1961) again put forward Gentileschi's name and, in fact, this charming painting could well be ascribed to that highly refined artist, whose name was first suggested by Longhi in 1916.

34 ▦ ⊘ $\frac{76 \times 105}{}$ ▤ ⦂

The Infant St John with the Lamb
Rome, Private Collection
The long and persuasive advocacy of this painting as a comparatively early work by Caravaggio is due to Grassi ('Arte Lombarda', 1959). The conception looks strange for Caravaggio and the face is remarkably Correggesque but, to judge from the detailed photographic comparison, the attribution seems convincing. There are some close similarities

30

with Caravaggio's other versions of the same subject (35 and 36) and with *The Sacrifice of Isaac* (29).

35 ▦ ⊘ $\frac{102,5 \times 83}{1596-98}$ ▤ ⦂

St John the Baptist
Basle, Oeffentliche Kunstsammlung
Bought for the public gallery, Basle, with the Bohny Collection in 1864, this painting was first attributed to Caravaggio by A. Venturi ('L'Arte', 1920). Marangoni ('Bollettino d'arte', 1922) disagreed while Longhi suggested ('Proporzioni', 1943) that judgement be suspended on this 'very beautiful canvas', which had in the meanwhile been attributed by Von Loga to Gonzales. If not by Caravaggio, it would thus be by one of the artist's Spanish followers. The painting was described as attributed to Caravaggio in the catalogue of the Milan exhibition in 1951 (45). Arslan ('Arte antica e moderna', 1959) favoured its authenticity, pointing to supposed resemblances in the compositional rhythms to other works of the late 1590s. Jullian (1961) alone seems now to regard it as a work of the Spanish school under Caravaggio's influence, mainly because of the figure's character and the rendering of the grey mantle; he lists it among the uncertain or doubtful works of Caravaggio.

36 ▦ ⊘ $\frac{132 \times 97}{1597-98}$ ▤ ⦂

St John the Baptist
Rome, Musei Capitolini
A painting of this subject was first mentioned by Baglione (1642): 'S. Giov. Battista, made for Signor Ciriaco Mattei'. It was described by Bellori (1672) – 'He painted Saint John in the wilderness as a seated nude youth who, leaning forward with his head, embraces a lamb; and this is to be seen in the palace of Cardinal Pio'. It was also mentioned by Scannelli (*Microcosmo*, 1657). There are two almost identical versions, one in the Capitoline Museum, the other in the Doria-Pamphili Gallery (37). The painting was first published in the latter version (which for a long time was the only one studied) by L. Venturi ('L'Arte', 1910), who linked it with Bellori's description and conjectured that it had passed at

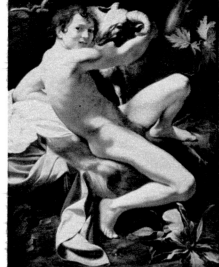

36 Plate XXIII

37

some stage from the Pio to the Doria-Pamphili. However, in 1953 ('The Burlington Magazine') Mahon disclosed that the *Baptist* from the Pio collection must be that which, removed from public view in the Capitoline Museum about the end of the nineteenth century, was at the time of writing in the office of the mayor of Rome. (In fact the rearrangement of the museum took place in 1903 and 1918–21, according to Bocconi's catalogue (1955), in which the work in question is not listed as being among those displayed.) The bulk of the Pio Collection,

together with that of the Sacchetti, had been purchased by Pope Benedict XIV in 1750 (125 'pieces' for 16,000 scudi) to form the nucleus of the Capitoline galleries. *St John the Baptist* was included, always as a Caravaggio, in: Scannelli's *Microcosmo della Pittura* (1657) – as in the Pio Collection – in the old inventories of the Pio Collection drawn up by Trevisani (1740) and G. P. Pannini (1749), and in Roisecco's *Roma antica e moderna* (1745); it is similarly listed in the catalogue of the Capitoline galleries published in 1765. There can be no doubt that the Capitoline version of the painting is the original, although the possibility remains that the Doria version is an autograph replica.

37 ▦ ⊘ $\frac{132 \times 95}{1598^*}$ ▤ ⦂

St John the Baptist
Rome, Doria-Pamphili Gallery
See 36.

38 ▦ ⊘ $\frac{116 \times 91}{}$ ▤ ⦂

David and Goliath
Madrid, Prado
In the royal collections at Madrid since 1700 and listed as 'school of Caravaggio', in Madrazo's old but reliable

catalogue (1913), this painting was attributed to Caravaggio himself by A. Venturi (*Studi dal vero*, 1927) though as a late work. Subsequently considered an old copy after a lost original, by J. Ainaud ('Anales ... de los Museos ... de Barcelona', 1947), followed by Zahn, Voss and Berenson, it was restored to Caravaggio by Longhi ('Paragone', 1951), followed by Mahon ('The Burlington Magazine', 1952) and Hinks (1953), in contrast to L. Venturi (1951) and Arslan (1959) who rejected it. while Jullian (1961)

remained undecided. Wagner (1958) also doubted that the painting could be a copy after an original by Caravaggio. Even without taking into account the resemblance between the head of Goliath and the Holofernes of the Coppi *Judith* (26) and the possible identity of the model used for the figure of David with that of *Victorious Love* (46), it seems reasonable to consider this work as, at least, an old and skilful copy of a lost painting by Caravaggio.

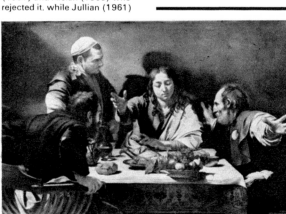

47 Plates XIX–XXII

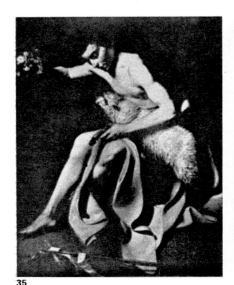

35

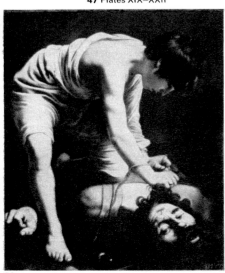

38

The Paintings for the Church of S. Luigi Dei Francesi

Although Mancini (c. 1620) alludes only briefly to these paintings (Van Mander mentions no work by Caravaggio by name except an apocryphal one) and although later seventeenth-century critics did not greatly care for them, it was already evident to Baglione (1642), and has become increasingly clear in the present century, that Caravaggio's *Scenes from the*

Life of St Matthew in the Contarelli Chapel of S. Luigi dei Francesi marked the turning point of his career. They were his first public commission. For over forty years, beginning with the difference of opinion in the 1920s between Chéramy ('Rassegna d'arte', 1922) and Pevsner (1928) on the one hand and Longhi ('Pinacotheca', 1928) on the other, a critical battle has been fought over the exact dating of the series. Were the paintings executed in the early 1590s (Longhi, followed by most other writers of the 1930s and 1940s) ? or just before 1600 (Chéramy and Pevsner) ? The debate flared up again after the Caravaggio exhibition in Milan in 1951, beginning with an important series of articles by Hess (1951) and Mahon (1951, 1952) in the Burlington Magazine, in which strong evidence was produced in

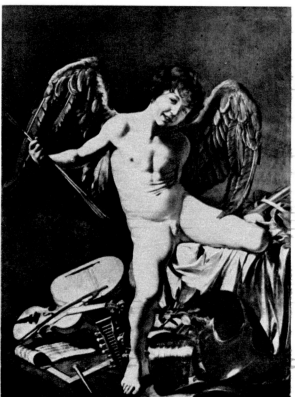

46

favour of the later date. Since then, while Longhi has fought a rearguard action on behalf of the early 1590s (though recently giving ground), J. Bousquet ('La Revue des arts', 1953) and H. Röttgen ('Zeitschrift für Kunstgeschichte', 1964, 1965) have proved 1599–1602 to be correct. Other writers, including all the authors of monographs, have entered the field but chiefly with opinions rather than facts. It is above all Röttgen who has clarified the problem, recounting the Cavaliere d'Arpino's part in the decoration of the chapel and publishing the contracts with, and payments to, Caravaggio for the paintings. The documents relating to both d'Arpino's and Caravaggio's work were found, largely by Michèle Schwager, in the State Archives in Rome among the papers of the

Capitoline notary Agostino Amatucci (Mahon had already suspected the existence of these documents but had been told they were lost).
The chief dates to bear in mind are 23 July 1599 and 4 July 1600, when the paintings on the side walls of the chapel representing *The Calling* and *The Martyrdom of St Matthew* were commissioned and paid for, and 7 February and 22 September 1602, which are the corresponding dates for the altarpiece. Besides publishing this information, Röttgen was able to show that Caravaggio made use of the dimensions and iconographical programme originally prescribed to d'Arpino who had been commissioned to decorate the chapel (in fresco) on 27 May 1541 but who only completed three fields on the vault.
As has already been mentioned, the articulate critical reception of Caravaggio's paintings in the chapel was not particularly enthusiastic, although they clearly created a sensation. Baglione (1642), the first to discuss them at any length, acknowledged that they greatly increased Caravaggio's fame. He briefly describes the paintings and mentions the purchase of the first version of the altarpiece ('which no-one had liked, simply because it was the work of Caravaggio') by Marchese Giustiniani. Baglione's chief contribution was to record that when Federico Zuccaro, the director of the Academy of St Luke, came to view the chapel, 'he said in my presence "What is all the fuss about" ? and as he carefully examined the entire work he added "I don't see anything here but the thought

(*pensiero*) of Giorgione in the picture of the saint called to the apostolate by Christ".' Several modern critics have been puzzled by the meaning of this phrase, if it means anything at all. It might refer either to the costumes, which are vaguely Giorgionesque, or to the warm colour scheme with accentuated shadows, which are also reminiscent of Giorgione and very unusual in Roman painting of the late sixteenth-century, or to the basically simple and straightforward composition. Bellori (1672) concentrated on the 'drama' of the rejection of the first altarpiece, alleging that Caravaggio had felt it as a near-fatal threat to his fame and that he had taken great pains with the second version as a result. Bellori mentioned the realism of *The Calling of St Matthew* with mild approval but considered the composition and movements of the *Martyrdom* inadequate to the story, 'even though Caravaggio painted it twice' (it is not clear whether Bellori knew about the repainting of the *Martyrdom* as now revealed by the X-rays or whether he was confusing this commission with the paintings in Sta Maria del Popolo, of which two distinct versions probably were painted). He further complained that the chapel was dark and the paintings difficult to see. Perhaps the warmest of seventeenth-century critics was Sandrart (1675), who greatly admired the vividness and narrative realism of the *Calling*. However, his memory of the others in the series was slight. He describes briefly and approvingly the first version of the altarpiece, though not indicating that it was in the Giustiniani collection, which he knew well. He seems to have forgotten that there was a second version of the altarpiece by Caravaggio in the chapel and he mistakes the subject of *The Martyrdom of St Matthew* for *Christ Driving the Money Changers from the Temple.*

39 ⊞ ◔ 322×340 1598-1601 ▤ ⋮

The Calling of St Matthew
Rome, S. Luigi dei Francesi
Commissioned 23 July 1599 and finally paid for (and hence completed) 4 July 1600, together with its pendant, *The Martyrdom of St Matthew. The Calling* is on the left (west) wall of the Contarelli Chapel and was last cleaned and restored in 1966. X-rays, first published in 1952 by Venturi and Urbani (the latter in 'Atti dell'accademia nazionale dei Lincei', II) and re-analysed by Urbani after the restoration in 1966, show that the composition was originally planned without the figure of St Peter who now stands in front of Christ. Comparison of the painting with d'Arpino's drawing of the same subject in the Albertina, Vienna (reproduced by Röttgen, 1964) which is basically the same in iconography, demonstrates the

immense gain in clarity, economy and dramatic force made by Caravaggio. D'Arpino's would have been a decorative, somewhat confused and anecdotal treatment of the subject ; Caravaggio's is as if yoked into vivid, shattering existence by the blinding power of genius. As Sandrart pointed out, the figure clutching the money on the left of the table was taken from a woodcut by Holbein for a series illustrating the *Dance of Death* (reproduced by Friedlaender, 1955).

40 ⊞ ◔ 323×343 1598-1600 ▤ ⋮

The Martyrdom of St Matthew Rome, S. Luigi dei Francesi
The dates of commissioning and completion are the same as those for *The Calling of St Matthew.* The *Martyrdom* was also cleaned and restored in 1966 and is on the right (east) wall of the Contarelli Chapel. The X-rays show that much more extensive alterations were made to this composition than was the case with *The Calling.* At least two previous versions (probably not complete) seem to lie beneath the present paint-surface. Originally the saint, still on his feet, appears to have been backing away on the right with his arms raised to ward off the blows of three executioners attacking him from the left. One of them is conspicuously striding forward in profile in a pose reminiscent of a figure in Raphael's *Battle of Ostia* in the Vatican. Another, possibly not from the same version as he is much larger, is standing with his back to the spectator in the centre of the composition, dividing it like the angel in *The Rest on the Flight into Egypt* (10). A nude angel holding a book stands on the right. In the background there is a fairly elaborate architecture consisting of pilasters, an entablature and a niche visible above the altar. The whole effect would have been similar in composition to, though much more dramatic than, the design that d'Arpino might have made (though no trace of this exists). There are also some reminiscences of a fresco by Muziano of the same subject in Sta Maria in Aracoeli (reproduced by Friedlaender, 1955). These echoes of earlier, 'Mannerist' solutions, together with the fact that all the figures are lower in the canvas than in the final version, suggest that *The Martyrdom of St Matthew* was painted, or at least begun, by Caravaggio before *The Calling.* There are still some 'Mannerist' traces in the final version, especially in the two gigantic nudes in the bottom corners. For the poses of the saint lying on the altar steps and the acolyte fleeing to the right, Caravaggio used an engraving of Titian's (now lost) *St Peter Martyr*, as many critics have pointed out. The subject is taken from the legend of St

Matthew in *The Golden Legend* of Jacques de Voragine, according to which the saint, while saying Mass, was martyred on the altar steps on the orders of the King of Ethiopia, whom he had converted to Christianity but whose divorce from his queen he had opposed. Caravaggio represented himself among the horrified witnesses in the background on the left. This (see p. 84) is the only unquestionably authentic self-portrait in his work, on account of its resemblance to a drawing known to be of him by Ottavio Leoni.

41 ⊞ ◔ 232×183 1597-98 ▤ °°

A. St Matthew and The Angel
Formerly Berlin, Kaiser-Friedrich Museum
This is the first version of the altarpiece for the Contarelli Chapel, commissioned from Caravaggio on 7 February 1602.
There is no reference in the documents to its rejection and substitution by the present version. Nevertheless, it is reliably reported by Baglione and Bellori that it was disliked by the clergy of S. Luigi and was bought by the Marchese Giustiniani for his private collection. It was sold by Giustiniani's descendants to the Kaiser-Friedrich Museum, Berlin, in 1815 and was destroyed in Germany at the end of World War II. Exactly why it was rejected still remains a mystery. According to Bellori, the clergy complained that 'the figure had no decorum and did not look like a saint, sitting with crossed legs and with his feet crudely exposed to the people'. Perhaps this explanation is basically correct, provided we interpret 'no decorum' as including the erotic physical proximity of the svelte angel to the rough-hewn saint – even though it was stipulated in the contract that the saint should be seated with the angel standing beside him. In the final version the saint is removed to a 'safe' distance, in the air.

41 ⊞ ◔ 296,5×189 1600-01 ▤ ⋮

B. St Matthew and The Angel
Rome, S. Luigi dei Francesi
This is the second and final version of the altarpiece painted by Caravaggio for the Contarelli Chapel. It was paid for (and hence was complete) on 22 September 1602 and was framed by February 1603. Like the other paintings, it was cleaned and restored in 1966. Almost all modern critics have considered it to be a much more inhibited and less exciting version than the first. Bellori, who liked it, indicates that Caravaggio took great care with it not to give further offence.

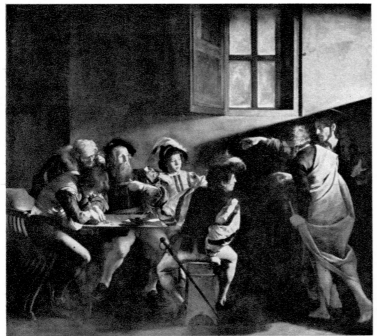

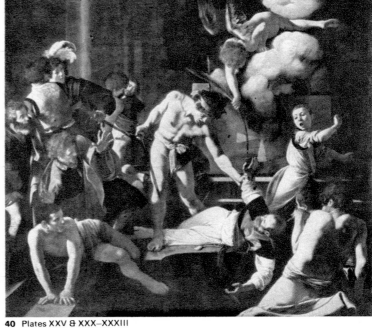

39 Plates XXIV & XXVI–XXIX

40 Plates XXV & XXX–XXXIII

42 🔲 ⊗ 237×189 1594-96 📋 ⁝

The Conversion of St Paul

Rome, Odescalchi Balbi di Piovera Collection

This painting was described as a work by Caravaggio in the will of Francesco Maria Balbi (1701), in Ratti's (1766) and Alizieri's (1847) guides to Genoa, then by Bode (in Burckhardt, *Der Cicerone*, 1884) and finally by Suida (*Genoa*, 1906). It was briefly mentioned by Longhi ('L'Arte', 1916), who suggested it was reminiscent of Orazio Gentileschi, and was re-introduced into the context of Caravaggio's work by Argan ('Parallelo', 1943, and 'Arts plastiques', 1948). It was discussed at length and with considerable insight on the occasion of the exhibition of seventeenth- and eighteenth-century painting in Liguria by Morassi ('Emporium', 1947), who formulated two alternative hypotheses : one, that this painting should be identified as the supposed first version of *The Conversion of St Paul* intended for the Cerasi Chapel (45), which Baglione states was refused by the patron and purchased by Cardinal Sannesio (the dimensions correspond to those of the Cerasi picture, 225 × 180 cm, and the work is painted on a cypress-wood panel, as stipulated in the contract dated 24 September for that chapel) ; two, that it could be a work which had left no trace in the seventeenth-century literature on the artist. The latter hypothesis was favoured by Longhi, who at first denied Caravaggio's authorship of it ('Proporzioni', 1943) on the basis of a photograph ; he later accepted it but considered it a very youthful work. This was also the opinion of Baroni (1951) and Clark ('Paragone', 1951), the latter adding that he did not feel able to identify this painting as the hypothetical work purchased by Cardinal Sannesio. No opinion was expressed by Samek (1956) ; L. Venturi (1952) placed the painting among the 'attributed works' and it was

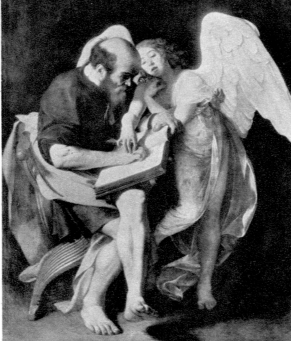

41 A

excluded from Caravaggio's oeuvre by Mahon, Hinks, Friedlaender and Baumgart (1955). Joffroy, favouring its authenticity and its contemporaneity with the Cerasi Chapel and taking up a suggestion by Berenson, put forward the hypothesis that this panel might be the expression of a satirical, ironic state of mind : a tongue-in-cheek treatment of the patron, the subject and the painter himself. Despite an apocryphal story first put into circulation by Van Mander (1604) – who later withdrew it – and repeated by Sandrart (1675) that Caravaggio executed a picture containing a figure mocking a painting by d'Arpino next to it, it is not very likely that a whole altarpiece would have been painted as a joke. Besides, the Odescalchi-Balbi *Conversion of St Paul* is a serious work. Despite the Mannerist extravagance and a sixteenth-century palette, the

details are not unworthy of Caravaggio, from the landscape and the Lombard sky to the shrubs, Christ, the angel, the horse's rump and the bearded St Paul ; in addition, the old soldier with his legs apart and a spear in his hand is a powerful piece of painting. What is out of keeping is the 'machinery', the composition, the abhorrence of a vacuum, the tangle of shields, spears, helmets, plumes, branches, rumpled garments and harness. The result is precisely what Caravaggio's followers were to produce in the years around 1605, especially Gentileschi. In view of its late Mannerist look it is difficult to accept this work even as an early Caravaggio, let alone as the first version of a mature work, the Cerasi Chapel *Conversion of St Paul*. Yet the dimensions of the panel and the unusual wood, corresponding to the contract, are a powerful argument in favour of this painting's

authenticity – assuming that there was a first version, for which we have only Baglione's word, not documentary evidence. Perhaps if we could see the first version of *The Martyrdom of St Matthew* more clearly, later buried under the final version (see the X-rays), we might have a better idea of what Caravaggio was capable of when starting on a complicated composition at this stage (1600–1). As it is, we have to acknowledge that the Odescalchi-Balbi *Conversion of St Paul* is perhaps the most difficult crux in Caravaggio studies. It is the one painting which seems almost wholly out of character but for which there is strong external evidence.

43 🔲 ⊗ 232×201 📋 ⁝

The Crucifixion of St Peter

Leningrad, Hermitage

This painting was acquired by the Hermitage in 1808, indirectly from the Giustiniani collection, as a genuine Caravaggio. It was identified by Friedlaender ('Journal of the Warburg and Courtauld Institutes', 1945) as the supposed first version of the picture in the Cerasi Chapel in Sta Maria del Popolo ; such a version, according to Baglione, had been rejected by the patron and bought by Cardinal Sannesio. However, after the discussion by Morassi in 1947 of the Odescalchi-Balbi *Conversion of St Paul*, Friedlaender realized (1955)

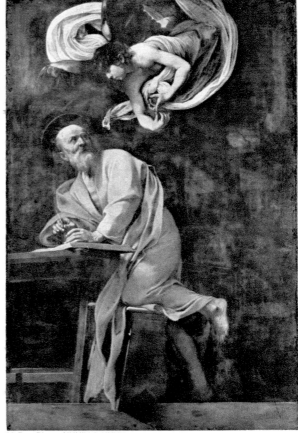

41 B Plates XXXIV & XXXV

94

(Above and at left, from the top) Details of the X-rays showing the initial lay-out of The Martyrdom of St Matthew : area at centre left (behind the arm in the foreground and the saint's robe); central area; area to the right, as far as the edge of the canvas. (Below, a reconstruction of the lay-out revealed by X-rays)

that the two paintings could not be by the same hand, although he still maintained that the Hermitage painting was 'at least a reflection' of Caravaggio's first version of The Crucifixion of St Peter. This has been the opinion of most other modern critics. Longhi ('Proporzioni', 1943), Jullian (1961) and De Logu (1962) regard it as a copy of a lost original; Salerno (in his edition of Mancini, 1956–7) describes it as a doubtful copy. In the most recent catalogue of the Hermitage (1958) it is given to the school of Caravaggio, an attribution

picture could just as well be an echo of Reni's Crucifixion of St Peter as a prototype for it and the slight resemblance to the painting by Rubens might be coincidence. The best solution seems to be to suggest, as Moir does, that the composition as well as the execution is by an anonymous comparatively late follower of Caravaggio.

The paintings in the Church of Sta Maria Del Popolo

(Above) reconstruction of the right side of The Calling of St Matthew showing the first lay-out without St Peter

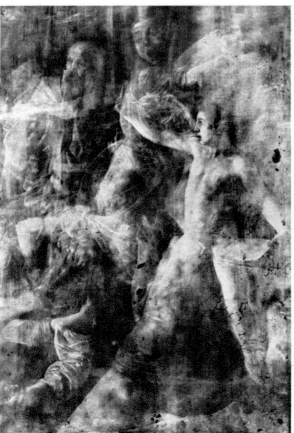

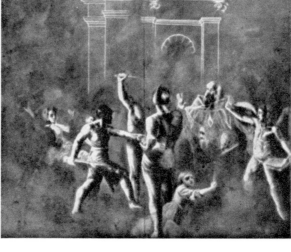

followed by Moir (1967). Since it is on canvas, not cypress wood, and since its dimensions are very different from those of the painting in the Cerasi Chapel, the two strongest arguments in favour of the Odescalchi-Balbi Conversion of St Paul do not apply. There is some relationship to Reni's painting of the same subject in the Vatican (1603) and to a late work by Rubens in Cologne, as Friedlaender pointed out. Nevertheless, the Hermitage

44 ⊞ ◯ 230 × 175 / 1600-01 ▤ ⦂

The Crucifixion of St Peter

Rome, Sta Maria del Popolo
This canvas and the following one (45) are among the best authenticated of Caravaggio's works, not only because they are mentioned by all the early biographers but also because, as with the Scenes from the Life of St Matthew, the documents recording the commission and payments to the

artist survive (published by Mahon, 'Burlington Magazine', July 1951). The chapel was bought in July 1600 by Monsignor Tiberio Cerasi and the contract for the paintings between him and Caravaggio – described as egregius in Urbe pictor – was drawn up on 24 September 1600 (i.e. two and a half months after The Calling and The Martyrdom of St Matthew had been finished). The paintings were to represent 'the Mystery of the Conversion of St Paul' and 'the Martyrdom of St Peter', and they were to be executed on cypress wood, 10 palmi high by 8 palmi wide. Caravaggio was given a free hand in the interpretation of the subject but he was to submit 'specimens and drawings of the figures and other objects' to the patron in

advance. The paintings were to be finished within eight months and the price was to be 400 scudi, 50 scudi being payable on account to the Marchese Giustiniani as guarantor. On 5 May 1601 Monsignor Cerasi died, having left his property to the Hospital of the Consolazione. In the notice of his death (Mahon, 1951) it was stated that he was to be buried 'in the beautiful chapel which he had had made (in Sta Maria del Popolo) by the hand of the most famous painter Michel Angelo da Caravaggio'. This might mean that the paintings were already finished or nearly finished by then. Caravaggio received the final payment of 50 scudi from the administrators of the hospital on 10 November 1601. The altarpiece representing The Assumption of the Virgin was painted during the same period by Annibale Carracci. No mention is made in any of the documents discovered so far that Caravaggio's first attempts at the paintings were rejected and that they were later replaced by the versions now in the chapel. The only positive evidence that this occurred is found in Baglione (1642), who stated that 'the two subjects were first painted by him in another manner but because they did not please the patron they were taken by Cardinal Sannesio. Caravaggio then painted the

two versions one sees now'. Nevertheless, bearing in mind the history of the altarpiece for the Contarelli Chapel, of which two versions were painted without this fact being mentioned in the documents, it is not impossible that Baglione's account is correct. Evidence in its favour is the stipulation in the contract that the paintings were to be on cypress wood whereas the present versions are on canvas (a painting of *The Conversion of St Paul* on cypress wood exists in the Odescalchi-Balbi collection – see above, 42). It is also perhaps unlikely that Caravaggio would have fulfilled the requirement to submit projects and drawings in advance, which would have been a good reason for rejecting his first versions. It is conceivable that these versions, if they ever existed, were completed and in the chapel by May 1601, when Monsignor Cerasi died (cf the notice of his death which implies that the paintings were then finished), and that the present versions were executed between May and November at the instigation of Marchese Giustiniani.

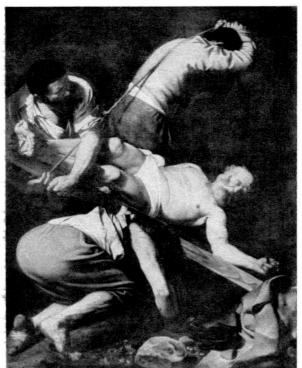

44 Plates XXXVI & XXXVIII

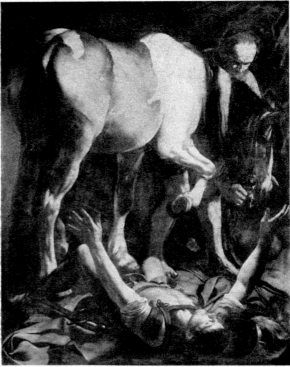

45 Plates XXXVII & XXXIX

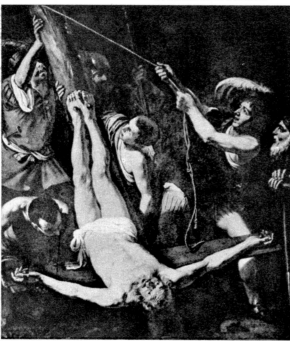

43

However, if Cerasi had approved the paintings it is unlikely, in view of the fuss over the Contarelli Chapel, that his heirs would have allowed anyone to contradict the terms of his will. L. Steinberg ('Art Bulletin', 1959) has produced an ingenious, perhaps over-ingenious, theory that the two paintings were designed by Caravaggio to be seen at an angle, from a point just on the threshold of the chapel. If the spectator stands at this point, Steinberg argues, he will see the bodies of the two saints in steeper foreshortening, which makes them appear to jut out into real space. Although Caravaggio was capable of contriving this optical effect, it is less likely that he would have

96

adopted such an illusionistic, and hence 'baroque', approach.

45 🔲 ⊘ 230×175 1600-01 📋 ⋮

The Conversion of St Paul
Rome, Church of Sta Maria del Popolo
See 44.

46 🔲 ⊘ 154×110 1598-99 📋 ⋮

Victorious Love Berlin (West) Staatliche Museen
Murtola included a madrigal on this work in his *Rime* (1603). It is mentioned in the same year in the records of Baglione's action for slander against Caravaggio (evidence by Gentileschi). It was later referred to by Baglione himself (1642) – 'A seated

Cupid, taken from life' – and was described by Bellori (1672) as having been executed for Marchese Ginstiniani: 'He depicted a Victorious Love with his arrows raised in his right hand and arms, books and other objects lying as trophies at his feet'. Sandrart (1675) also mentions the painting. Giustiniani's descendants sold it in 1815 to the Kaiser Friedrich Museum in Berlin. The attribution has never been in doubt. It is at once a painting of enormous vitality and charm – highly finished, beautifully painted in the wings and other still-life details – and of outrageously erotic appeal. Sandrart, who knew the Giustiniani collection well, suggested that it should be kept covered by a curtain. Most critics have dated it in the late 1590s, just about the time of *The Martyrdom of St Matthew*, but Röttgen ('Zeitschrift für Kunstgeschichte', 1965) now sees it as contemporary with the first altarpiece for the Contarelli Chapel, i.e. 1602. The fact that it was publicly mentioned twice in 1603 suggests that it was a recent work.

47 🔲 ⊘ 139×195 1596-98 📋 ⋮

The Supper at Emmaus
London, National Gallery
This is probably the work recalled by Baglione as executed for Ciriaco Mattei: 'for him Caravaggio had painted a St John the Baptist, Our Lord at Emmaus (*e quando N. Signore andò in Emaus*) and a St Thomas touching the Saviour's side with his finger; he charged that gentleman several hundred scudi'. Bellori (1672) mentioned two versions of the subject: one for Marchese Patrizi (cf 65), the other as 'painted for' Cardinal Scipione Borghese. It is the latter which is now in London, having remained in the

Borghese collection until 1798, when it passed to that of Robert Vernon, who gave it with his collection to the National Gallery in 1839. Since Baglione describes the subject with the words 'and when Our Lord went to Emmaus', this might refer to a *Journey to Emmaus* (a picture

of which may survive in a copy – cf 48) rather than a *Supper at Emmaus*. However, that the London picture belonged to someone else before Cardinal Scipione Borghese is evident, since he only arrived in Rome in 1605 and the painting must be earlier than that on stylistic grounds; it may therefore have

76

48

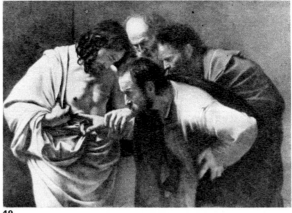

49

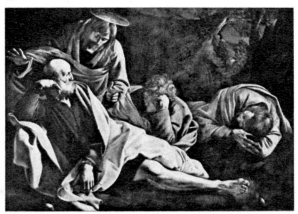

66

been executed first for Ciriaco Mattei, as Baglione says. (That Bellori knew the London version is also certain, since he refers later in his biography to the very unusual feature of the beardless Christ, a feature not shared by the Patrizi version.) The authenticity of the painting has never been doubted and most modern authorites have agreed in dating it in the late 1590s (e.g. Hinks, c.1598; Mahon, 1599–1600), Longhi seeing it as belonging with a small group of other easel pictures to a 'classical interval' between the paintings in the Contarelli and Cerasi Chapels. Hinks and others have rightly associated the painting stylistically with the first altarpiece for the Contarelli Chapel (41 A). Now, however, Röttgen ('Zeitschrift für Kunstgeschichte', 1965) has discovered documents virtually proving that this altarpiece was painted in 1602. He thus proposes a date of about 1602 for the London *Supper at Emmaus* also.

48 ⊞ ⦿ 132×163 ☰ ⦂

The Journey to Emmaus or **The Calling of Peter and Andrew** Hampton Court, H.M. The Queen
As a *Journey to Emmaus* this painting might perhaps be connected with an ambiguous reference by Baglione (1642) — see 47 above — to a canvas which Caravaggio painted for Ciriaco Mattei, representing the episode 'when our Lord went to Emmaus' (Friedlaender, 1955). As a *Calling of Peter and Andrew* (the title suggested by Longhi and accepted by Hinks) it would lack references in the early biographies. It was acquired by Charles I in 1637 and is mentioned in Van der Doort's catalogue (c.1639) as representing 'Three Disciples'

by an imitator of Caravaggio, although it was sold to De Critz by the Commonwealth in 1651 as a genuine Caravaggio. First mentioned by Voss (*Die Malerei des Barock in Rom*, 1925), it has been accepted as a copy (never as an original) by most modern scholars, e.g. Longhi ('Proporzioni', 1943, and 'Paragone', 1951), Friedlaender (1955) and Jullian (1961), although Mahon (1952) ignored it and Wagner (1958) alleged it was not derived from an original by Caravaggio. There are several other copies in English and Italian collections. The date seems to be around 1600–02, although any precise dating is obviously impossible.

49 ⊞ ⦿ 107×146 ☰ ⦂

The Incredulity of St Thomas Formerly at Potsdam, Neues Palais
The painting is clearly referred to by Baglione (1642) as having been painted for Ciriaco Mattei and by Bellori (1672), who says it was executed for Vincenzo Giustiniani: 'Saint Thomas placing his finger in the wound in the side of the Lord, who draws his hand near and reveals his breast under a sheet which he draws away from his chest'. Either there were two paintings of the subject by

Caravaggio, or Baglione was wrong in saying it was executed for Ciriaco Mattei, or — perhaps the most likely — the picture passed from one collection to the other. The composition immediately became famous, as the many copies show; the most important are that in the Uffizi, published by Marangoni ('Dedalo', 1922) and the present one, regarded as an original by Voss ('Jahrbuch der preussischen Kunstsammlungen', 1923), Zahn (1928) and Schudt (1942), but described as a copy by Venturi (1952) and Jullian (1961), despite its provenance from the Giustiniani Collection, in which it is documented throughout the seventeenth and eighteenth centuries until the transfer of the collection to the Berlin Gallery (1815). It was apparently destroyed in 1945; the best extant copy is therefore that in the Uffizi, identical in size. Note should be taken of the resemblance of the figures to the pilgrims in the London *Supper at Emmaus* (47).

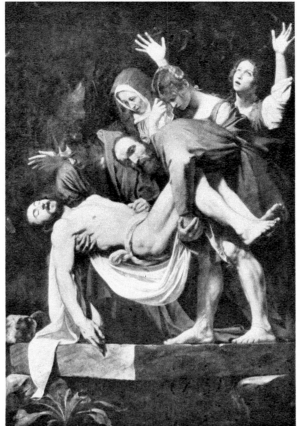

51 Plates XL–XLII

Peter Paul Rubens, variant of 51 (Ottawa, National Gallery of Canada): the absence of Mary Cleophas led some critics to suppose, wrongly, that this figure was added by a later hand in the original

Paul Cézanne, watercolour copy of 51 (or of the variant by Rubens?)

50 ⊞ ⦿ 116×94 ☰ ⦂

The Holy Family with St John New York, Acquavella Collection
The early sources make no mention of this subject, known in four different versions: in the Berlin Staatliche Museen, in the Musée des Beaux-Arts at Tours, in a private collection at Montevideo, and in the Acquavella collection, New

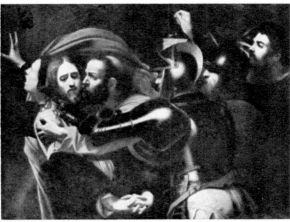

52

Copy (canvas, 165×245 cm.) of 52 (Florence, Ladis Sannini Collection)

York. The composition was first published by Voss (1923), who considered the Berlin painting to be the original, with the assent of L. Venturi (1925). Longhi disagreed ('Pinacotheca', 1928 and 'Proporzioni', 1943) but later upheld the authenticity of the Acquavella version, which he published in 1951 ('Paragone'). This attribution was tentatively accepted by Jullian (1961).

Arslan, who had already dismissed the Berlin canvas as a poor eighteenth-century copy, did not regard the New York version as authentic either (1959). The composition was listed among the attributed works by De Logu (1962), citing the Berlin version. There is an engraving by F. Daret (1604–78) describing the painting as an original. That all the extant

50

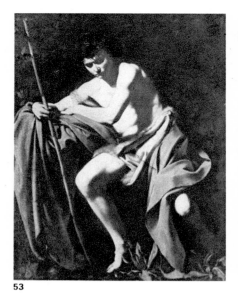

53

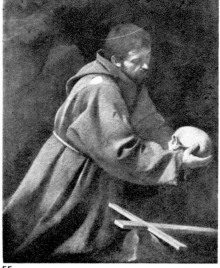

55

versions are copies seems clear but whether the composition derives from Caravaggio or not must remain an open question.

51 ⊞ ◉ 300×203 1602-04 ⊟ ⦂

The Entombment of Christ Rome, Pinacoteca Vaticana

Mentioned by Mancini (c.1620), Baglione (1642) and Scannelli (1657) and described in detail by Bellori (1672). The painting was commissioned by Francesco Vittrice for the chapel which his uncle Pietro Vittrice (who died on 26 March 1600) had

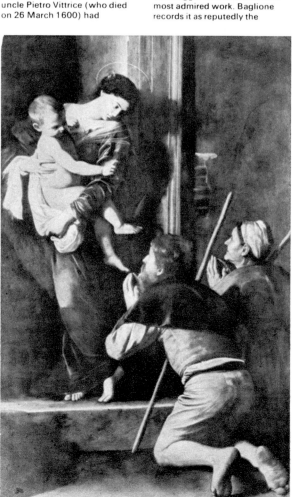

58 Plates XLIII & XLIV

bought in 1571 in the Chiesa Nova (Sta Maria in Vallicella). It was executed sometime between 9 January 1602 and 6 September 1604, as revealed by excerpts from the *Libro dei decreti* (register of decrees) published by L. Lopresti ('L'Arte', 1922). The painting was moved to Paris by Napoleon in 1797 but was returned to Rome in 1815, when it was placed in the Vatican Gallery. There is no doubt that from the seventeenth to the nineteenth centuries this was Caravaggio's most famous and most admired work. Baglione records it as reputedly the

artist's 'best work', Scannelli (1657) refers to it as being 'of extraordinary excellence' and the enthusiasm with which Bellori describes it is in marked contrast to his – and others' – coolness towards the *Scenes from the Life of St Matthew* and even the paintings in Sta Maria del Popolo. (Sandrart alone ignores it, perhaps characteristically in view of his relatively unclassical tastes.) The popularity of *The Entombment* is further attested by numerous copies, engravings and variants of it. Free copies or adaptations were made by Rubens, Baburen, Valentin, Fragonard, Géricault and Cézanne, to mention only the most important. All this is a reflection of something which several modern critics have consciously or unconsciously felt, namely that *The Entombment* is Caravaggio's most classical and in a sense 'conventional' painting. Longhi has treated it as the centre-piece of a 'classical interlude' in Caravaggio's development and has grouped round it such other clear, compact, heavily modelled and relatively restrained compositions as *The Incredulity of St Thomas* (49) and the London *Supper at Emmaus* (47).

It should be added that Mary Ann Graeve ('Art Bulletin', 1958) has ingeniously but perhaps wrongly questioned the description of the iconography as that of a simple *Entombment*. She suggested that the projecting stone slab is the 'stone of unction' on which Christ's body was laid for anointing before burial and that the subject should be interpreted as a sort of conflation of *The Entombment* and *The Pieta*.

52 ⊞ ◉ 133×171 ⊟ ⦂

The Taking of Christ Odessa, State Museum of Western and Eastern Art

'Other Roman gentlemen concurred in the appreciation of his work and among them was the Marchese Asdrubale Mattei who had him depict the Capture of Christ in the Garden, likewise in half-length figures. Judas lays his hand on the Master's shoulder after the kiss; meanwhile, a soldier in full armour holds out his iron-clad arm and hand to the breast of the Lord who stops, patient and humble, with his hands joined before him, while behind him Saint John flees with outstretched arms. Caravaggio painted even the rust on the armour of the

York (Longhi, 'Paragone', 1960) and, finally, Odessa, the version which is here illustrated and which Malickaya ('Iskusztvo', 1956) held to be possibly the original. This view was upheld by Bialostocki ('The Burlington Magazine', 1957) and Jullian (1961), despite Longhi's strong criticism and firm opinion that it was a copy. This appears to be the most likely judgement. It is possible that the hatless figure in profile on the extreme right is a self-portrait, confirming Bellori's statement that the lost original was by Caravaggio.

53 ⊞ ◉ 172,5×104,5 1603-04 ⊟ ⦂

St John the Baptist Kansas City, William Rockhill Nelson Gallery of Art

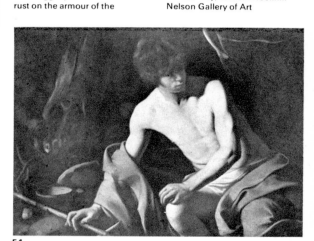

54

67

soldier whose head is covered by a helmet, so that only part of his profile is visible; behind him a lantern is raised and one can distinguish two more heads of armed men'. Thus Bellori (1672). On the evidence of this detailed description, Longhi ('Proporzioni', 1943) brilliantly discovered a little-known copy of a lost original in the Ladis Sannini Collection at Florence, which corresponds to the description at every point. Although perhaps the most inferior, this copy is undoubtedly the most complete (see also L. Venturi (1951) and Friedlaender (1955)) and it paved the way for other discoveries: at Berlin (Lossow, 'Zeitschrift für Kunstgeschichte', 1956), Budapest (Czobor, 'Bulletin du Musée hongrois des Beaux-Arts', 1957), Antwerp, New

Referring to a painting in the Museo Nazionale di Capodimonte, Naples, previously ascribed to Manfredi or Riminaldi, Longhi deduced as early as 1927 that it must be a copy of an original by Caravaggio. This view was confirmed by his discovery ('Proporzioni', 1943) of the present canvas – formerly in the Aston and Chichester-Constable collections – which he claimed to be authentic; it was displayed as such in the 1951 exhibition in Milan. Longhi's attribution was rejected by Venturi (1951), who also rules out the idea that it might be a copy after Caravaggio; the painting was, however, accepted by Berenson (1951), Mahon (1952), Friedlaender (1955) and Jullian (1961).

54 ⊞ ⊗ 99×134 1603-04 ▤ ⦂

St John The Baptist
Rome, Galleria Nazionale
d'Arte Antica
Exhibited from an early period
as the work of a follower of
Caravaggio, this painting was
attributed to Caravaggio
himself and dated about
1597-8 by Longhi ('Vita
artistica', 1927-8 'Proporzioni',
1943, and 'Paragone', 1952),
followed by Berenson (1951),
Mahon (1952) and Jullian
(1961). Its authenticity was
denied by Schudt (1942) and L.
Venturi (1951) ; Friedlaender
(1955) referred it to the circle of
Caravaggio. Arslan, who in
1951 ('Aut Aut') had
conjectured it to be an
eighteenth-century copy, later
recognized it as belonging to the
period of Caravaggio ('Arte
antica e moderna', 1959) on the
basis of X-rays.

55 ⊞ ⊗ 128×94 1603* ▤ ⦂

St Francis in Prayer
Rome, Church of the
Capuchins
First described as a Caravaggio
by Cantalamessa in 1908
('Bollettino d'arte'), followed by
Posse (Thieme-Becker, 1911)
and Pevsner (Barockmalerei,
1928), this painting was
thought by the latter to be
related to the loan of a
Capuchin habit by
Gentileschi to Caravaggio in
1603 (records of the Baglione
slander action, published by

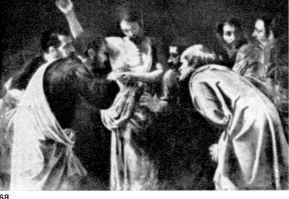

68
Bertolotti [1881]). The work
was shown as a genuine
Caravaggio at the 1951
exhibition in Milan and was still
regarded as authentic by
Longhi (1952) and Hinks
(1953). Arslan ('Aut Aut',
1951), L. Venturi (1951) and
Baumgart (1955) reject it as
having nothing to do with
Caravaggio. Mahon (1951)
regards it as a copy, Jullian
(1961) is also inclined to reject
it because of its weak and
theatrical modelling. The lack of
documentation, contemporary
references and copies of a
painting supposedly by
Caravaggio displayed in a
church, even though
comparatively small in size, is
more perplexing than the
points Jullian emphasizes.
Something in this canvas does
not persuade ; at the same time

the theory that a copy was
placed over an altar even after
the lifetime of the painter is
hardly satisfactory given the
silence of the sources. There
seems no alternative but to
relegate the work to the
Caravaggio School.

56 ⊞ ⊗ 112×157 1605-06 ▤ ⦂

St Jerome Writing
Rome, Galleria Borghese
'For the same Cardinal
(Scipione Borghese) he painted
a Saint Jerome concentratedly
writing ; he extends his
hand and the pen towards the
inkwell' (Bellori, 1672). The
work is also mentioned as a
genuine Caravaggio by
Manilli (Villa Borghese
descritta, 1650) and in the
1693 inventory of the Borghese
collection. However, in the
1790 inventory it was attributed
to Lo Spagnoletto and this
attribution was retained in
subsequent lists and catalogues
until 1893 (Catalogue of the
Borghese Gallery by A. Venturi)
and beyond. The painting was
first restored to Caravaggio by
Modigliani ('Nuova antologia',
16 December 1909), who was
followed by Longi (1928), De
Rinaldis (1948), Mahon (1951),
Hinks (1953), Friedlaender
(1955), Jullian (1961) and De
Logu (1962). The attribution to
Caravaggio was also accepted
after some hesitation by P.
della Pergola in her catalogue
of the gallery (1959). So far as is
known the painting has never
left the Borghese collection and,
if Manilli (1650) and Bellori are
right in saying that it was
executed for Cardinal
Scipione Borghese, it is
difficult to find reasons for
doubting it. Nevertheless it
shows a certain dryness and
insensitivity in the execution
which makes it much inferior
as a work of art to the David
with the Head of Goliath (60)
in the same collection, which
is presumably of about the
same date. It is this fact which
has led Marangoni (1922),
Pevsner (1927-8), Schudt
(1942), Nicco Fasola (1951),
Wagner (1958) and others to
reject it, some calling it a copy
others not a composition by
Caravaggio at all. The dates
proposed have varied from
1602-4 (Mahon, 1952) to
about 1605-6 (Friedlaender,
1955, and others). If it was

59 Plate XLVI

painted for Scipione Borghese,
as Bellori states, rather than
acquired by him from a previous
collector like the Sick Bacchus
(2) or the Boy with a Basket of
Fruit (3), it cannot have been
commissioned before 1605. On
stylistic grounds Mahon's
dating (1602-4) seems the
most plausible.

57 ⊞ ⊗ 110×81 1605-06 ▤ ⦂

St Jerome Monastery of
Montserrat, Barcelona
Until 1911 or 1914 this painting
was in a private collection in
Rome ; it then passed to Spain.
Associable by its pictorial
technique and identity of
model with the Borghese
Gallery St Jerome Writing (56),
its authenticity has been
similarly debated. Longhi
('Proporzioni' 1943), followed
by Ainaud ('Anales ...', 1947)
and Venturi (1951),
attributed it to Caravaggio,
dating it at the end of the
Roman period (1605-6).
Wagner (1958) called it a
copy, Friedlaender (1955) a
good imitation and Arslan
('Aut Aut', 1951) a variation by
Spagnoletto. To judge from a
photograph, the whole work
looks too clean and the
lighting too clear for
Caravaggio, and, unlike the St
Jerome Writing, it lacks the
support of evidence in the early
sources and an old provenance.

58 ⊞ ⊗ 260×150 1603-05 ▤ ⦂

Madonna Dei Pellegrini
(Madonna di Loreto) Rome,
S. Agostino
'In the first chapel on the left
(Cavalletti chapel) in the
church of S. Agostino, he
painted a Madonna of Loreto,
drawn from life with two
pilgrims, a man with muddy
feet and a woman with a torn
and dirty bonnet ; because of
this misuse of the talents which
a great painter ought to display,
the people raised a great clamour

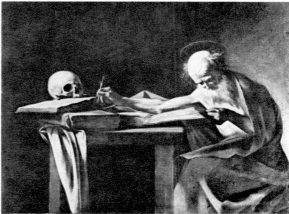

56 Plate XLV

('L'Arte', 1922) show that the
chapel where the work is still
preserved was bought by
Cavalletti on 4 September 1603
and that the Pietà which stood
above the old altar was
presented to Cardinal Borghese

over it', (Baglione, 1642). Even
though it was so unmistakably
described, mentioned in the
subsequent sources and by
Titi (Studio di pittura delle
chiese di Roma, 1674),
Passeri (1670-9) and others,
Biancale maintained the work
was by Saraceni ('Bollettino
d'arte', 1920). But he is the
only one to doubt the painting,
which is otherwise universally
accepted. Documents
published by L. Lopresti

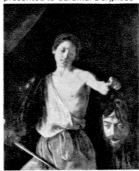

60 Plate XLVII

on 2 March 1606. This proves
that Caravaggio's altarpiece
was, at that time, already in
place. But the terminal date can
be shifted back slightly, if we
bear in mind Caravaggio's
clash with Mariano
Pasqualone, which occurred
on 29 July 1605 (p. 84) and
accept the truth of Passeri's
story (Hess edition, 1934)
concerning a 'poor but
honourable' neighbour of
Caravaggio who, in exchange
for a very high reward, permitted
her daughter to pose for the
figure of the Virgin ; she had
many times refused her
daughter's hand to 'a young
man, a notary by profession',
who, observing the young
girl's frequent visits to the
painter and suspecting an
affair between them, insulted the
mother for having handed over
her daughter 'to an
excommunicate and cursed
man'. This was reported to
Caravaggio, who was so
incensed that he wounded the
notary with an
'uncontrolled' blow with a
hatchet and then had to repair
to the church of S. Luigi dei
Francesi where he remained
'for a long time'. (See also
Hess, 'Bollettino d'arte',
1932-3, and 'Commentari',
1954.) Passeri's account
reads like a fabrication and
there is no positive evidence to
connect it, since he does not
name the notary, with
Caravaggio's attack on
Pasqualone on 29 July 1605, in
which a woman named Lena
of no fixed address was
involved. In any case the

Madonna dei Pellegrini was
probably painted in 1604 or
early in 1605 on stylistic
grounds. Longhi at one time
('Pinacotheca', 1928) dated it
about 1597 because of its
connections with other
paintings which he then
thought were earlier, but he has
since ('Documento sul
Caravaggio', Universalia, 1947)
accepted the evidence of the
documents. The alternative
title, Madonna di Loreto, is
taken from the miraculous
statue of the Madonna at
Loreto which is supposed to
come alive and which the
pilgrims are worshipping.
Caravaggio alludes to this by
giving the Madonna a
statuesque and slightly wooden
look, especially in the lower half
of the figure.

99

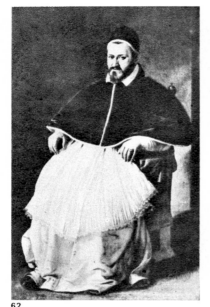

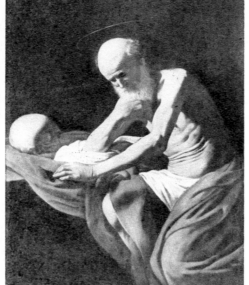

62

59 ⊞ ◉ 292×211 1605 🗐 ⋮

The Madonna of the Serpent (Madonna dei Palafrenieri) Rome, Galleria Borghese

This altarpiece was painted in 1605 for the Confraternity of the Grooms (Palafrenieri) of the Vatican Palace. There is evidence that it was being painted during October of that year, although it certainly took more than a month to finish and the final payment to the artist was not made by the dean of the Confraternity until 8 April 1606. There seems to have been some difficulty over finding a location for the painting. The Palafrenieri had long had their own chapel or altar near the entrance of the Old St Peter's, dedicated to their patroness St Anne. When the altars in this part of the church were de-consecrated in October 1605 to make way for the new nave designed by Maderno, the grooms hoped to obtain a corresponding place in the new church but were disappointed in this and were assigned an altar in the Old Sacristy of St Peter's. This altar was far too small to take the huge painting by Caravaggio and so, probably for this reason, the Confraternity was permitted to place the painting in the much larger chapel of St John Chrysostom (Friedlaender, 1955). According to Friedlaender, this must have been a temporary arrangement until a permanent home for the altarpiece could be found. Then, at some unknown date, possibly around 1620 (Hess, 'Commentari', 1954), it seems that Cardinal Scipione Borghese persuaded the Palafrenieri to give him the painting. Baglione implies and Bellori states that there were objections to the work on grounds of propriety, although neither suggests that the Palafrenieri themselves were dissatisfied (in fact they paid Caravaggio in full — see above). It is difficult to see what the objection could have been unless, as Bellori suggests, it was to the lack of dignity of the figures and the blatant nudity of the Christ Child, who is no longer an infant but a small boy. Iconographically the painting is impeccably orthodox. The stamping on the serpent's head as a symbol of the extirpation of heresy was derived from a slightly ambiguous text in the Vulgate, and the old theological argument as to whose foot, Christ's or the Virgin's, performed this act had recently been settled by a bull of Pius V sanctioning the representation of the two superimposed feet (Longhi, 'Pinacotheca', 1928, and 'Paragone', 1954). This solution had already been adopted in a painting of the subject by Figino in Milan, which may have influenced Caravaggio. The presence of St Anne in Caravaggio's altarpiece is to be explained not only by her role as patron saint of the Palafrenieri but also as an affirmation of the dogma of the Immaculate Conception; it was because the Virgin was conceived without sin that she had power to expel heresy. In paintings of the Immaculate Conception St Anne is normally shown with the Virgin seated on her lap but Caravaggio places her to one side, in a strange, haunting pose of detached yet anxious watchfulness.

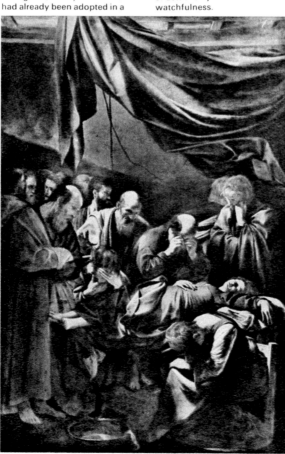

63 Plates IL & L

60 ⊞ ◉ 125×100 1605-06 🗐 ⋮

David With The Head of Goliath Rome, Galleria Borghese

Like the *St Jerome Writing*, this is said by Bellori to have been painted for Cardinal Scipione Borghese and thus not before 1605; 'for him he also painted a half-length figure of David, holding by the hair the head of Goliath, which is his own (Caravaggio's) portrait. David, who is shown gripping the hilt of his sword, is depicted as a bareheaded youth with one shoulder out of his shirt. The picture has the bold shadows which Caravaggio liked to use to give force to his figures and compositions'. The painting is also described by Francucci in his short poem, written in 1613, on the Borghese Gallery and by Manilli (*Villa Borghese descritta*) in 1650. It is listed as a genuine work in all the inventories and catalogues of the gallery and is accepted by virtually all modern critics. Manilli identified the David as a likeness of Caravaggio's 'boy' Mao Salini and the Goliath (as did Bellori) as a self-portrait of the artist. The latter suggestion at least seems probable. Most modern authorities have dated the painting at the end of Caravaggio's Roman period (1605–6), except Longhi who believes ('Paragone', 1959) that it was executed in Naples or Sicily (c.1607–9).

61 ⊞ ◉ 159×124 1609 🗐 ⋮

St John the Baptist Rome, Galleria Borghese

Probably a direct purchase by Scipione Borghese (i.e. after 1605), this painting is mentioned first by Francucci (1613) and then by Scannelli (*Microcosmo*, 1657). It appears in the inventories of the gallery from 1693 onwards with the correct attribution; in the 1790 inventory it was attributed to Valentin. Restored to Caravaggio by L. Venturi ('L'Arte', 1909) it was rejected by Schudt and Zahn, but accepted by Marangoni, Pevsner, Voss, Longhi, Mahon, Friedlaender (with some reservations), Jullian and De Logu. This is no doubt the latest of Caravaggio's paintings of the subject, since its sombre style looks forward to that of the Neapolitan period, but there seems to be no reason for accepting Longhi's view ('Paragone', 1959) that it was executed in Palermo in 1609.

62 ⊞ ◉ 203×119 1605-06 🗐 ⋮

Portrait of Pope Paul V Rome, Palazzo Borghese

Formerly in the Borghese gallery, this portrait was returned to the family palace as it was not included in the inventory of Cardinal Scipione Borghese's bequest to the Gallery (Pope Paul V was his uncle); for this reason it has always remained in the custody of the sitter's descendants. On Bellori's evidence ('The Cardinal, pleased with these and other works that Caravaggio did for him, introduced him to Pope Paul V, of whom he made a seated portrait for which he was well rewarded'), the painting was published as a genuine Caravaggio by L. Venturi ('L'Arte', 1910). Others who have accepted it include Zahn (1928), Schudt (1942), Berenson (1951), Hinks (1953) and Jullian (1961). Marangoni (1922), Longhi ('Proporzioni', 1943), Grassi (1953), Baumgart (1955) and, by implication, Mahon (1952) reject it. Friedlaender (1955) remained undecided. Longhi, discounting Bellori's evidence, proposed Ottavio Leoni as an alternative attribution. Once again, as with the *St Jerome Writing* (56), we are faced with an apparently reliable statement by Bellori and a good provenance yet with a work that seems stylistically and aesthetically 'wrong' for Caravaggio. At the same time it must be remembered that all portraits, from *Maffeo Barberini* (18) to *Alof de Wignacourt* (83) are among the most controversial items in Caravaggio's *oeuvre*. Perhaps portraiture was inherently uncongenial to Caravaggio. Alternatively there are those of the period – not a great age of portraiture in Rome – and the wishes of the patron may have inhibited him, deadening his creative inspiration. Speaking of portraits, Mancini (c.1620) states somewhat obscurely: 'there have been others who were good painters who have not succeeded in creating a likeness, like Caravaggio, without colouring similar to

Detail of 64 before restoration

nature'. Because of the quality of the painting, which seems reasonably good and yet to be untypical of Caravaggio, it is perhaps best to leave the question of attribution open.

63 ⊞ ◉ 369×245 1605-06 🗐 ⋮

The Death of The Virgin Paris, Louvre

This much-discussed and complex work, one of the last completed by Caravaggio in Rome, i.e. in 1605–6, was painted for the altar of the second chapel on the left in the church of Sta Maria della Scala in Trastevere. Accepted by the patron, the jurist Laerzio Cherubini, and probably placed above the altar, it was removed

by the clergy of the church, the Discalced Carmelites, (Bellori, 1672). It was replaced by an altarpiece of the same subject by Saraceni (repr. Moir, 1967, fig. 96). Mancini wrote that Caravaggio's painting was rejected because the artist had used a prostitute as a model for the Virgin; Baglione, followed by Bellori, says it was because he had represented the Virgin indecorously, 'swollen up and with bare legs'. None of the early critics, and few recent ones, have spotted a significant innovation – apart from the realism of the slumped corpse – which Caravaggio made in the iconography of the subject. This was to represent the Virgin not dying, as was traditional, but already dead. Although few had yet had a chance to see it, the painting was bought in 1607 (i.e. after Caravaggio had left Rome) on the advice of Rubens by the Duke of Mantua. The negotiations were handled by the Duke's agent in Rome, Giovanni Magno, who reported that the owner (presumably the original patron, Cherubini) was asking the high price of 280 scudi plus brokerage charges and packing of 20 scudi and that 'he would not be done out of a single giulio'. This was in Febuary 1607. At the urgent request of the artistic community in Rome, Giovanni Magno consented to allow the painting to be publicly exhibited for a week (1–7 April 1607); it left for Mantua on 28 April. (See the correspondence of Giovanni Magno in Rome with Annibale Chieppo in Mantua, February to April 1607, published by A. Bertolotti, *Artisti in relazione coi Gonzaga*, 1885; also Rubens *Correspondance de Rubens ...* 1887 *et seq.*) In 1627–8, like the greater part of the Gonzaga collection at Mantua, the painting entered the collection of Charles I of England and in 1649 passed into that of the French banker, Jabach, who sold it to Louis XIV in 1671, when it was hung at Versailles; in 1793 it was handed over to the Musée Central des Arts and finally to the Louvre. The painting has been particularly studied by Hinks.

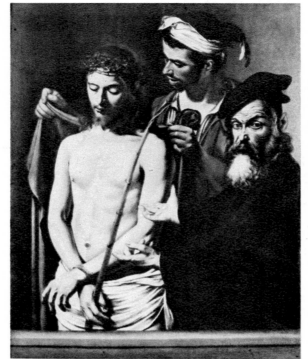

64

now in the Uffizi. A version of Caravaggio's composition in the museum at Messina (formerly in the church of S. Andrea Avellino in Messina) was first brought to light by Sacca (*Archivio storico messinese*, 1906–7), who considered it a genuine work and identified the figure of Pilate as a self-portrait of the artist, a suggestion which is obviously wrong. Downgraded to a work by one of Caravaggio's Sicilian followers by Mauceri (Catalogue of the Museum, 1928, and 'Bollettino d'arte', 1924–5), the painting was later proposed again by Longhi ('Proporzioni', 1943) as a crude but faithful copy of a lost prototype by Caravaggio. In 1954 ('Paragone') Longhi triumphantly produced and published as the original the painting here illustrated, which had just been discovered by chance in the Naval Academy in Genoa (until 1925 it had

According to Bellori (1672), commissioned from Caravaggio by the Marchese Patrizi: 'For the Marchese Patrizi he did the *Supper at Emmaus*, in which Christ is shown in the centre blessing the bread, and one of the seated apostles opens his arms in recognition of Him, while the other grips the table and gazes at Him in wonder; behind them are an innkeeper with a cap on his head and an old woman bringing in the victuals'. The work is mentioned in an inventory dated 1624 of the Patrizi possessions (*Archivio storico capitolino*, No. 592). In 1939 the painting was transferred to the Brera Gallery by the family. First acknowledged as a Caravaggio by L. Venturi ('Bollettino d'arte', 1912), it has been accepted by all subsequent critics with the single exception of Marangoni (*ibid.*, 1922–3) who later withdrew his objections.

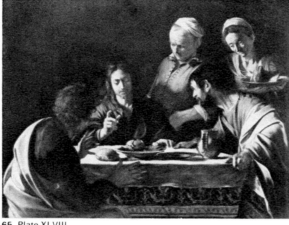

65 Plate XLVIII

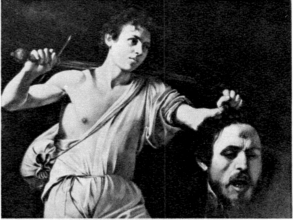

69

64 ▦ ◉ 128×103 / 1605-06 ▤ :
Ecce Homo Genoa, Palazzo Rosso
The authority for attributing this composition to Caravaggio lies in a brief reference by Bellori ('he painted for the Signori Massimi an *Ecce Homo*, which was taken to Spain') and in the biographies of the painter Cigoli by his nephew, G. B. Cardi (1628), and by Baldinucci (1702). According to the last two sources,

Monsignor Massimi commissioned a painting of the *Ecce Homo* (Christ Presented to the People) from each of three artists – Caravaggio, Passignano and Cigoli – with the intention of retaining the one he liked best and getting rid of the others. The winner of this undeclared competition was Cigoli, who was in Rome from 1604–13 and whose painting later passed to Severi in Florence and from him to the Grand Dukes of Tuscany; it is

been in the Palazzo Bianco where it was catalogued in 1921 as a copy after Caravaggio by Lionello Spada; from 1925–9 it was in the Palazzo Rosso and from 1929 onwards in the Naval Academy; it is now back in the Palazzo Rosso). Longhi believed that this canvas must have come from Sicily, where at least three copies and several variants exist, rather than Spain, as Bellori said (possibly because the island was then under Spanish rule), there being no copies in Spain. After cleaning and restoration the Genoa version was accepted by Samek (1956) and Joffroy (1959), although Jullian (1961) doubted it and De Logu (1962) called it a copy, admittedly much superior to the one in Messina. The head of Pilate, which must be a portrait, though not a self-portrait, seems out of keeping with the other two figures but there is some similarity with the heads, also portraits, in *The Madonna of the Rosary* (72). If Bellori is right in stating that the *Ecce Homo* was painted for Signor Massimi, it must have been executed before the artist left Rome in May 1606.

65 ▦ ◉ 141×175 / 1606 ▤ :
The Supper at Emmaus
Milan, Galleria Brera

Longhi has suggested that Caravaggio painted this *Supper at Emmaus* in 1606, when he took refuge at Zagarolo or Palestrina, and sent it for sale to Rome, where it was bought by the dealer, Costa. This would relate it to Mancini's statement (c.1620) that 'he stopped first at Zagarolo, where he was secretly sheltered by the Prince (of Palestrina) and there he painted a Magdalene and a Christ going to Emmaus, which was bought in Rome by Costa, and with this money he moved on to Naples'. It should be noted that Bellori also mentions a *Supper at Emmaus* as having been painted by Caravaggio at Zagarolo, in addition to the one for Marchese Patrizi in Rome. However, the canvas mentioned by Mancini would not appear to have been a *Supper* and Bellori's reference to the Patrizi version, taken in conjunction with the 1624 inventory, would appear to leave no room for doubt. This painting differs considerably both in conception and technique from the London *Supper at Emmaus*, (47) executed some four years earlier. In the Brera version the treatment is much quieter and less rhetorical, the feelings are subtler and the lighting more atmospheric and subdued.

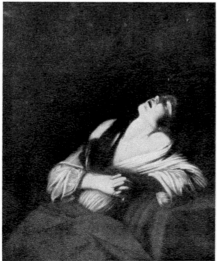

70

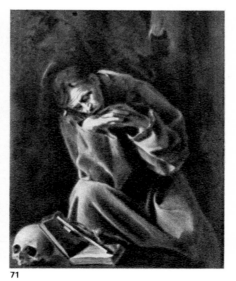

71

101

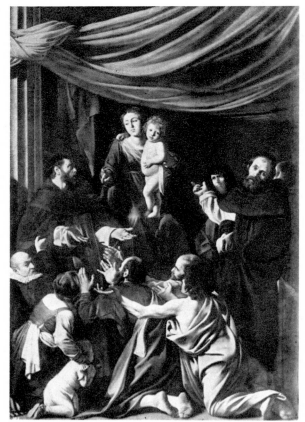

72 Plates LI–LIII

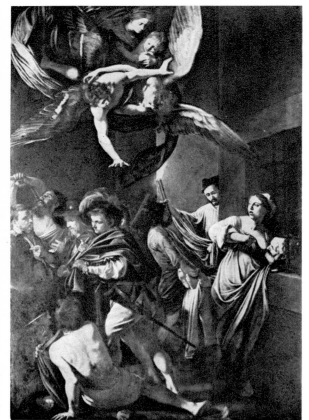

73 Plates LIV & LV

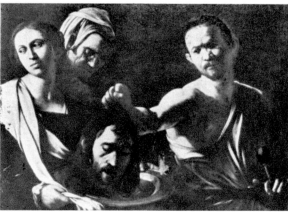

92

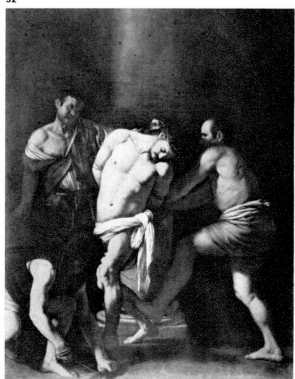

74

'key works' – and noting their derivation from Caravaggio's London *Supper at Emmaus* (47) and the ex-Berlin *Incredulity of St Thomas* (49). This would suggest that they were painted in Sicily shortly after Alonzo's visit to Rome (1606 – before 1614). At all events it is certain that the two paintings, both clearly by the same hand or hands, are not by Caravaggio.

68 142×200

The Incredulity of St Thomas Messina, Museo Nazionale
See 67.

69 90,5×116,5 / 1605-06

David With the Head of Goliath Vienna, Kunsthistorisches Museum
This painting was listed by Prayer in the inventory of the Kunsthistorisches Museum (1718) as a work of Caravaggio's school; Kallab ('Jahrbuch der Kunsthistorischen Sammlungen in Wien', 1906–7) introduced it to modern critics as authentic. L. Venturi ('L'Arte', 1910) identified it provisionally with the 'half-length figure of David' purchased by the Count of Villa Mediana at Naples (Bellori, 1672), who resided in that city from 1611 to 1617. Voss (*Die Malerei des Barock in Rom*, 1925) regarded it as earlier than the Borghese *David* (60); so did Schudt (1942) (dating it c.1595), Baumgart (1955) and Znamerovskaia (1955). It was disregarded by Hinks, rejected by Marangoni (1922), Mahon (1951), Friedlaender (1955, with some inclination to consider it a copy) and Wagner (1958); Berenson (1951) appeared undecided between

66 154×222

Christ on The Mount of Olives Formerly Berlin, Kaiser-Friedrich Museum Destroyed in 1945. It is not mentioned in the sources but there is evidence that it came from the Giustiniani Collection in Rome (1815). Nevertheless, it was not attributed to Caravaggio in either Bode's (1904) or Posse's (1909) catalogue of the Berlin Gallery. An attribution to Caravaggio, as an authentic work, was first proposed by Voss ('Jahrbuch der preussischen Kunstsammlungen', 1923) and accepted by Longhi (1952), tentatively by Mahon (1952: 'judging from a photograph … could have been an original of the end of the master's Roman period'), Grassi (1953) and Hinks (1953), quoting Mahon. Marangoni ('Bollettino d'arte', 1922), however, regarded it as a copy and this opinion was recently shared by Jullian (1961). The confused mass of draperies and the elegant modelling of the limbs appear to be untypical of Caravaggio and there remain to be explained both the lack of references in the sources and the absence of copies, or of other copies, of a work by a painter so famous and so widely imitated.

67 148×200

The Supper at Emmaus Messina, Museo Nazionale
This painting, together with its pendant, *The Incredulity of St Thomas* (68), was first attributed to Caravaggio in 1915 by Longhi ('L'Arte'), who has ever since ('Pinacotheca', 1928, and 'Proporzioni', 1943) maintained the attribution, dating the work to the end of the artist's Roman period. Most other critics – e.g. Argan (1943), Venturi (1952),

Arslan (1951 and 1959) – have rejected it or passed over it in silence. Mauceri ('Bollettino d'arte', 1925, and Catalogue of the Messina Museum, 1928) gave both paintings, which had then been recently cleaned and restored, to Rodriguez. Voss ('Jahrbuch der preussischen Kunstsammlungen', 1927) suggested Caracciolo and De Logu (1962) a Spanish follower of Caravaggio close to Stomer. Moir (1967) has revived the attribution to Rodriguez, describing both paintings as due to a collaboration between the brothers Alonzo and Antonio Rodriguez – indeed as their

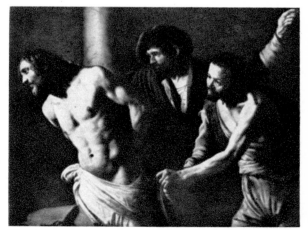

75

(*From the left*) *The head of Christ in 75, respectively in the versions at Rouen, in a Swiss private collection, and formerly at Lucca*

Caravaggio and Gentileschi. Longhi placed it, as authentic, in the Neapolitan period; and he was tentatively followed by Jullian (1961). F. Klauner ('Jahrbuch der kunsthistorischen Sammlungen in Wien', 1953) reported that it was painted, without priming, over a *Venus, Mars and Cupid* by a Roman-Dutch painter about 1550–75; Samek (1952) maintained that Count Villa Mediana's *David* had been lost. In view of its decorative elegance and over-inflated forms, which lack the savage concentration of Caravaggio's, this is surely not genuine.

Rome, Florence, and in the Marseilles Museum. This last is the copy signed and dated 1612 by Finsonius. It was therefore executed in Naples, where Finsonius was then living (and where other copies of the painting survive, as they do in Milan and elsewhere). Another copy, dated 1620, was executed by the Dutchman Wybrand de Geest, Rembrandt's brother-in-law, who painted it as an imitation of Caravaggio; this copy is at Barcelona in the Santiago Alorda Collection and was published by Ainaud in 1947. The success enjoyed by the

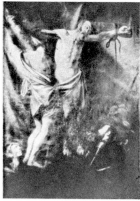

Mantua, who had recently bought Caravaggio's *Death of the Virgin* (63), of the possibility of purchasing two further works by the artist, one of which 'is a Rosary and was made as an altarpiece; it is 18 palmi high and they want for it not less than 400 ducats' (Luzio, *La Galleria dei Gonzaga*, 1913). The painting is also mentioned in a letter of the same year by Ottavio Gentili, published by Baschet ('Gazette des Beaux-Arts', 1868). Pourbus's statement, precise as to both subject and dimensions, leaves no doubt that the painting in question is

Nativity of the Virgin (18 September) because Caravaggio is a fugitive from justice . . . and I hear is now in Genoa' (L. Venturi, 'L'Arte', 1910). Masetti continued to pursue the matter and on 16 November 1605 reported that Caravaggio, by now back in Rome, had come to see him the previous night asking for 20 scudi on account and promising that the picture would be finished within the current week. Still the painting was not ready and Masetti went on chasing Caravaggio, to whom he had given a further 12 scudi, after the painter had left Rome on

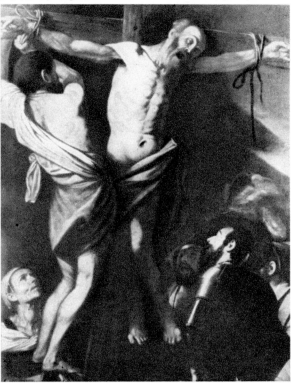

77

Copies of 75, in a Swiss private collection (left) and formerly in a private collection at Lucca (right)

70 126 × 100

The Sleeping Magdalene Marseilles, Musée des Beaux-Arts
Among the first works painted after Caravaggio's flight from Rome, at the end of May 1606. Mancini (c.1620) and Bellori (1672) mention a Magdalene, the latter specifying 'a half-length figure', as having been executed at Palestrina or Zagarolo or, more probably, in the castle of Paliano, where Caravaggio's presence is established in September 1606 by a letter from the Modenese Ambassador in Rome. Longhi ('Proporzioni', 1943) drew attention to several copies of the lost original: at Velletri,

composition still persisted in the eighteenth century, when Giuseppe Angeli modelled a painting of a *Peasant Girl* on it (Kress Collection, Houston Museum; Camesasca, 1966). Longhi is certain that all these canvases derive from an invention by Caravaggio. Yet another version, mentioned by Longhi who owns a photograph of it but does not know its whereabouts ('Paragone', 1951), might be the original. This could be the same as that which Jullian (1961) published as in a 'private collection'. A copy close to the version published by Longhi is in a private collection at Naples and it was shown there in the *Caravaggio e i Caravaggeschi* exhibition (Catalogue, 1963).

Copy of 77 (Toledo, Museo Parroquial de S. Vicente)

71 130 × 90

St Francis Cremona, Pinacoteca
This was brought to light by Longhi ('Proporzioni', 1943, and 1952) as a 'badly worn original or a faithful copy', possibly an idealized self-portrait, which Caravaggio painted in 1606 at Palestrina, Zagarolo or Paliano, before the artist moved to Naples. Unlike the *Magdalene* (70), this *St Francis* lacks documentation, nor are any other versions known. Its affinity to the same subject in the church of the Capuchins at Rome (55) has perplexed several historians, such as Friedlaender (1955) and De Logu (1962). Venturi (1951) excluded it from Caravaggio's *oeuvre*. Jullian (1961) agreed with Longhi's opinion, as did Wagner (1958), though dating it in the Sicilian period; Mahon ('The Burlington Magazine', 1952) and Hinks (1953) also accept it. Puerari (*Pinacoteca di Cremona*, 1951) calls it a work 'after Caravaggio'.

72 364 × 249 / 1606–07

The Madonna of the Rosary Vienna, Kunsthistorisches Museum
The earliest mention of this great painting occurs in a letter from Frans Pourbus, court painter at Mantua, written from Naples on 25 September 1607, informing the Duke of

the one now in Vienna. On account of the subject—the Virgin presenting the rosary to St Dominic—there is also no doubt that the work was painted for a Dominican church or chapel. The question is, which Dominican church or chapel was it made for, and when? Several modern critics, notably Friedlaender (1955), have wanted to identify the painting with one ordered by the Duke of Modena in 1605 but never delivered. The first reference to this commission appears in a letter written by the Duke of Modena's agent in Rome, Fabio Masetti, on 6 August 1605. Masetti there states that 'it will be impossible to get the pictures (*sic*—there was evidently to be another by Annibale Carracci) for the chapel by the day of the

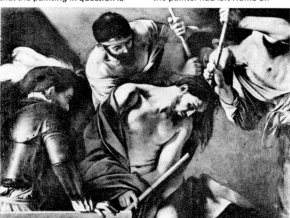

78

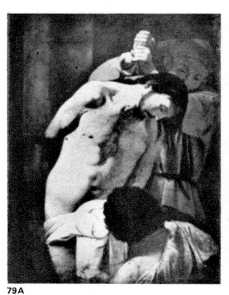

79 A

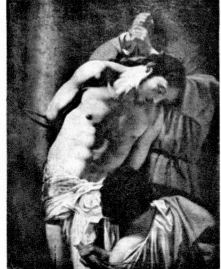

79 B

31 May 1606, first for the country and then for Naples. The last letter from Masetti to Modena was written on 20 August 1607, when Caravaggio was in Naples or perhaps had already left for Malta. The Duke of Modena was apparently still hoping to receive the picture although by this time Masetti was chiefly interested in recovering the 32 scudi. Unfortunately Masetti never mentions the subject of the painting nor the chapel for which it was destined (there is a church of St Dominic in Modena). The chief reason for relating *The Madonna of the Rosary* with this Modenese commission is a negative one, namely that if the painting had been executed in Naples—and it must have been commissioned, not painted by

Caravaggio as a speculation—it should still be in the church of S. Domenico Maggiore in that city. There is no trace in any of the sources of such a painting having been executed and then refused, and it is hard to see why it should have been refused, since it is, for Caravaggio, eminently 'respectable'; it is almost hieratic in its presentation of the people worshipping the Madonna through the mediation of the saints. Alternatively, critics have argued that Caravaggio would have had no time to execute such a large altarpiece in Naples, given the other work that he produced there, since he stayed in the city barely more than a year, if that. The

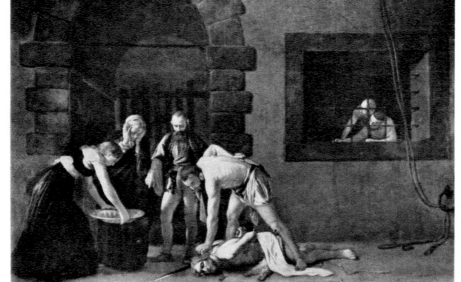

82 Plates LVI & LVII

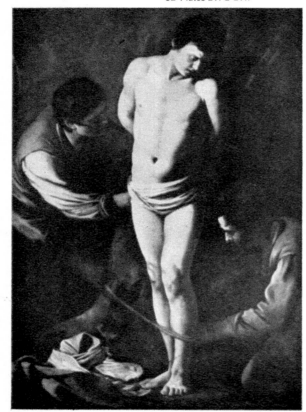

80

chief objections to identifying the Vienna painting with the commission for the Duke of Modena are, one, that in a letter of 12 October 1605 Masetti reports that Caravaggio proposes to charge only 50 or 60 scudi for his painting for the Duke, i.e. far too little for an altarpiece as large as *The Madonna of the Rosary*, for which the later owners wanted to charge the Duke of Mantua 400 ducats (the ducat was worth only slightly less than the scudo); two, that both Pourbus and Gentili state explicitly in their letters of 1607 that *The Madonna of the Rosary* was 'painted here', i.e. in Naples. The problem remains extremely difficult to solve. Nor is stylistic evidence much help, although those critics who have favoured the 'Modenese' solution have tended to see the work, which is rather brightly coloured and smoothly treated, as belonging more to the late Roman than to the darker, more

104

expressionist Neapolitan period. In addition, Friedlaender and some others have somewhat dubiously suggested that the upper part of the composition, including the red curtain, the Madonna and Child and the portrait of the unidentified donor, are not by Caravaggio but by another hand. At all events the painting was not bought by the Duke of Mantua. It is said to have been acquired (or partly acquired) in Naples by the painter Louis Finsonius, who took it via Aix-en-Provence to Antwerp, where he died in 1617. After passing to another painter, Abraham Vinck, who died in Amsterdam about 1620, it was presented by a group of artists and art lovers, including Rubens and Jan Breughel, to the Dominican church in Antwerp (document dated 1651 in the Dominican archives). It was acquired from this church in 1786 by the Austrian Emperor Joseph II, who took it to Vienna.

73 🔲 ⊗ 390×260 1607 ▤ ⋮

The Seven Works of Mercy Naples, Church of the Pio Monte della Misericordia
Bellori (1672) mentions this work, describing it in some detail, as having been painted by Caravaggio in Naples (i.e. in 1607) for the charitable foundation of the Pio Monte della Misericordia, from which it has never been moved except for exhibition. Documents discovered by Ruggero (*Napoli nobilissima*, 1902) confirm the date and the fact that the painting was executed for the high altar of the church at a price of 400 ducats (this was also the price asked for *The Madonna of the Rosary* – see above). Critical comment has been mainly centred on the style and the unusual iconography (see especially Wagner, 1958). The subject is taken from Matthew XXV; 35 ('For I was an hunger'd, and ye gave me meat: I was thirsty, and ye gave me drink:' etc.). Traditionally, the seven acts of mercy mentioned in the Gospel had been represented in art in seven separate scenes. Caravaggio's is the first painting in which they are combined, albeit somewhat confusedly, in the same composition. The other seven altars of the octagonal church are occupied by paintings by other artists (including Caravaggio's follower, Caracciolo), in which each of the seven acts is represented by a scene from sacred history appropriate to it.

74 🔲 ⊗ 286×213 1607 o 1610? ▤ ⋮

The Flagellation of Christ Naples, Church of S. Domenico Maggiore
Bellori (1672) states it was painted in Naples for the altar of the Franco Chapel in S. Domenico Maggiore, where it has always remained. It was first published by De Rinaldis ('Bollettino d'arte', 1928), on the occasion of its restoration, and has been acknowledged without opposition by all critics. As Friedlaender pointed out (1955), the composition, especially the pose of Christ, shows the influence of Sebastiano del Piombo's

Flagellation in the church of S. Pietro in Montorio in Rome Longhi has recently proposed ('Paragone', 1959) that it should be referred to Caravaggio's second (1610) rather than his first stay in Naples. Causa (1966), too, thinks it was executed in 1610

75 🔲 ⊗ 134,5×174,5 ▤ ⋮

Christ Bound to the Column Rouen, Musée des Beaux-Arts
Against considerable opposition, Longhi published ('Paragone', 1951) a *Christ at the Column*, formerly in Lucca, as an 'arid and laboured copy' after a lost original by Caravaggio. A firm stand against any derivation from Caravaggio was taken by Mahon (1952), Baumgart (1955), and, implicitly, Friedlaender (1955). But Mahon himself later thought he had traced the authentic Caravaggio to a Swiss private

collection ('Burlington Magazine', and 'Paragone', 1956) and he pointed out a copy in the Rouen Museum which he inserted between the Swiss original he had discovered and the weaker copy formerly in Lucca. Upon studying the Rouen painting, Longhi reached the conclusion that it was undoubtedly the original ('Paragone', 1960) and the work was displayed, not without adverse criticism, in the exhibitions of *Caravaggio and Italian Painting of the Seventeenth Century* (Paris, 1965), and *Sixteenth-century Paintings from French Public Collections* (Paris, 1966). The head of Christ, conventionally idealized and almost Mannerist in feeling, is undoubtedly very strange and looks as if it might have been added by another hand. Nevertheless there is good reason to believe that the Rouen painting is an original for, as Pierre Rosenberg pointed out to the present writer at the Paris exhibition in 1966, the canvas shows the characteristic scorings with a pointed metal instrument which Caravaggio used as a substitute for a preliminary outline drawing. Whether the painting belongs to the first (1607) or the second (1610) visit to Naples is very difficult to decide.

76 🔲 ⊗ 138×173 1601-02 ▤ ⋮

Christ Carrying the Cross Vienna, Kunsthistorisches Museum
For long kept in the depot of the Kunsthistorisches Museum as a work of the Caravaggio school, this painting was attributed by Voss (1925) to Tiarini and by Longhi ('L'Arte', 1915) to

83

Caracciolo. Later ('Proporzioni', 1943), Longhi regarded it as at least an excellent contemporary copy of an original by Caravaggio dating from the period of the completion of *The Martyrdom of St Matthew* (40). He finally accepted its authenticity (1952), in which he was upheld by Hinks (1953), although the work was rejected by Mahon (1952), Venturi (1952), Friedlaender (1955) and Wagner (1958). In the most recent catalogue of the Kunsthistorisches Museum (1960) it is attributed firmly to Caravaggio and dated 1610. So late a date is perhaps more likely than Longhi's, in view of the loose, undramatic character of the forms, so unlike the densely packed forms of the paintings in the Contarelli and Cerasi Chapels. Still, the most likely solution is surely that the painting is not by Caravaggio and that it might be worth reconsidering Longhi's original attribution to Caracciolo.

77 ▦ ◐ 200×150 ▤ :

The Crucifixion of St Andrew Vienna, Back Vega Collection

At the end of his biography of the artist, Bellori (1672) states that the Count of Benevento, Viceroy of Naples, took to Spain a *Crucifixion of St Andrew* by Caravaggio. A battered copy of a painting of this subject was found in 1920 by Longhi in the Museum of Toledo and illustrated by him ('Proporzioni', 1943). Nearly all critics, from L. Venturi to Friedlaender, have accepted Longhi's hypothesis, which places Caravaggio's original *Crucifixion of St Andrew* near to

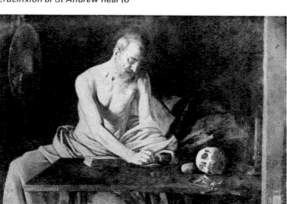

84 Plate LVIII

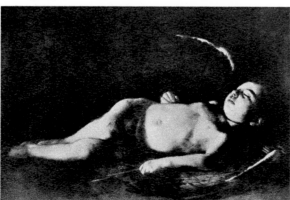

86

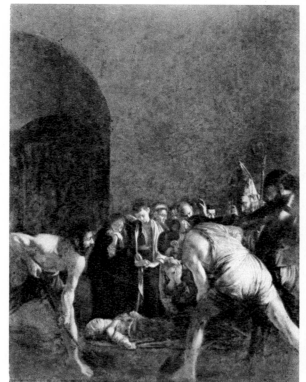

87 Plate LIX

the *Madonna of the Rosary* (72) and the *Flagellation* in the church of S. Domenico at Naples (74). Recently, another version of the composition was discovered in Vienna and, on the basis of its pictorial quality, was published by Jullian (1961) as possibly the authentic work ; it would thus

Copy of 86 (Indianapolis, Private Collection)

be the canvas that remained in the Benavente palace in Valladolid until 1653. If this is the case, *The Crucifixion of St Andrew*, formerly belonging to Finsonius, which was regarded as a Caravaggio by five Amsterdam painters at the Abrahm Vinck sale (c.1620), would most likely be another copy carried out by Finsonius himself when in Naples. At any rate, most critics agree in regarding the Back Vega version in Vienna as at least an excellent copy after a lost original by Caravaggio (Joffroy, 1959 ; Jullian, 1961 ; De Logu, 1962, etc.) Mahon ('Burlington Magazine', 1952) and Hinks (1953) dated the composition to the second Neapolitan period, Hinks adding at that time (before the Back Vega version was discovered) that the Toledo painting might be the much damaged original.

78 ▦ ◐ 165×127 ▤ :

The Crowning with Thorns Vienna, Kunsthistorisches Museum

This was purchased in Rome in 1816 as a work by Caravaggio. Voss ('Zeitschrift für bildende Kunst', 1912) ascribed it to a Roman follower ; Longhi initially attributed it to Caracciolo ('L'Arte', 1915) but later ('Proporzioni', 1943) tended to regard it as a good early copy after a lost original by Caravaggio from the Neapolitan period and as stylistically related to the upright *Flagellation of Christ* known through copies in Macerata and Catania (79A and B.). Under this designation the painting was shown at the Caravaggio exhibition at Milan in 1951 and so appears in the most recent (1960) catalogue of the Kunsthistorisches Museum. While Mahon ('Burlington Magazine', 1951) and Jullian (1961) adhered to Longhi's most recent view, Friedlaender (1955) and Wagner (1958) retained the attribution to

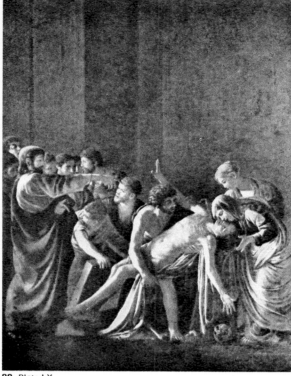

88 Plate LX

Caracciolo.

Whoever the originator of the composition might be, the pose of Christ and some parts of the other figures appear to echo the Naples *Flagellation* (74). Samek (1952), regarding the painting as a copy after Caravaggio, related it to one of the same subject which Bellori (1672) says was executed for the Marchese Giustiniani together with *The Incredulity of St Thomas* (49) ; this would amount to placing the conception of the work in the Roman period, not long after 1600. At first sight there are some attractions in this view, not only the fact that the Giustiniani *Crowning with*

Thorns is otherwise untraced but also the existence of certain compositional parallels with *The Incredulity of St Thomas* and other paintings of the early 1600s such as *The Taking of Christ* (52). However, the undoubted relationship of the Vienna *Crowning with Thorns* to the Macerata/Catania *Flagellation*, which must originate from the Neapolitan period, appears to rule Samek's hypothesis out.

79 ▦ ◐ 150×100 ▤ :

A. The Flagellation of Christ Macerata, Pinacoteca Civica

The present painting and that in Catania (79B) are both copies,

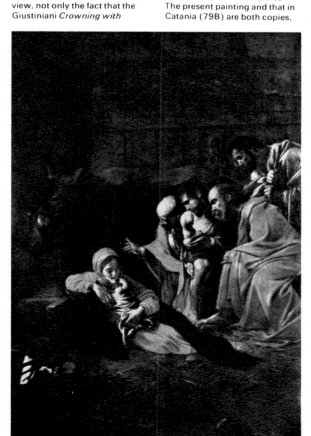

89 Plates LXI & LXII

identical in every respect including size, of a painting of which there is no documentary record or reference in the early sources. The upper part of the body of Christ, down to the shadows on the shoulder, face and chest, closely resembles that in the Vienna *Crowning with Thorns* (78). Longhi ('L'Arte', 1915), on the evidence of the Catania version, called the painting a derivation by Caracciolo from Caravaggio's *Flagellation* (74) in S. Domenico Maggiore, Naples: in 1943 ('Proporzioni') referring to the Macerata version, he thought it a copy of a lost Caravaggio of the late period. Since there is no early record of the composition and since the original, if by Caravaggio, is lost, it would clearly be foolish to dogmatize, but it may be remarked that the cut-off figure with its back turned in the foreground is not very typical of Caravaggio.

81 ▦ ✇ ˙1608˙? ▤ ⁛
The Resurrection of Christ
A painting of this subject by Caravaggio is mentioned by Mancini (c.1620) and Bellori (1672), who states that 'he was commissioned to paint . . . the Resurrection in the church of

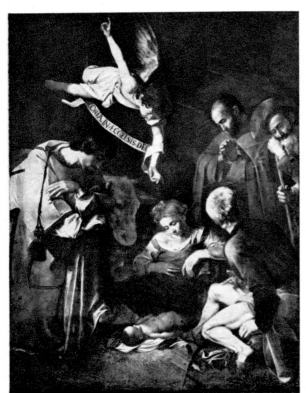

90 Plate LXIII

Perhaps the most likely solution is that both this *Flagellation* and the Vienna *Crowning with Thorns* are by a follower of Caravaggio, probably the same one in each case.

79 ▦ ✇ 150×100 ▤ ⁛
B. The Flagellation of Christ
Catania, Pinacoteca Comunale
See 79A.

80 ▦ ✇ 170×120 ▤ ⁛
St Sebastian Bound to the Tree Rome, Private Collection
This painting was connected by Longhi ('Paragone', 1951) with Bellori's reference at the end of his life of the artist to a *St Sebastian* 'with two executioners tying his hands behind his back' which had by

then (1672) been transferred to Paris. Longhi regarded the picture as a copy of an original dating from the Neapolitan period, executed by a good local painter, such as Vaccaro, about 1620–30. A smaller, weaker copy, found in France, was published by Pariset ('Revue des Arts', 1958) with an attribution to Jean Le Clerc after a presumed original by Saraceni. Jullian (1961) believed the painting to be an imitation or adaptation after Caravaggio. Samek (1952), followed by De Logu (1962), merely classed the work mentioned by Bellori as 'lost'.

Sant' Anna dei Lombardi (at Naples)'. No trace of this work, if it ever existed, has survived.

82 ▦ ✇ 361×520 1608 ▤ ⁝
The Execution of John The Baptist
Valletta (Malta), Cathedral of St John
The incomplete signature (p. 83) on this picture is the only one known in a painting by Caravaggio. According to Bellori (1672), who describes it vividly and in detail. The painting was commissioned by the Grand Master of the Knights of Jerusalem for the church in which it is still preserved. The records of the Order show that Caravaggio was knighted on 14 July 1608, and this canvas, the largest he ever painted, may have been his gift to the Order (Sammut, 'Scientia', 1949). Despite its physical isolation, this masterpiece, described by Longhi as 'the painting of the century', seems to have attracted several artists to Malta just to see it, to judge from the echoes of it which appear in more than one later work. Bellori's lengthy, accurate description suggests that he may have travelled to see it too, since it was not engraved. First discussed perceptively in modern times by Rouchès (1920), the painting, which had been badly damaged and overpainted, was superbly restored by the Istituto Centrale di Restauro in Rome in 1955. The result confirmed Bellori's apt observation concerning Caravaggio's technical spontaneity: 'he used his brush with all its power, working at (the painting) so feverishly that he let the priming of the canvas show through in the half tones'.

83 ▧ ✇ 195×134 1608 ▤ ⁝
Portrait of Alof de Wignacourt
Paris, Louvre
According to Bellori (1672), Caravaggio painted two portraits of the Grand Master of the Knights of Jerusalem, Alof de Wignacourt, 'one standing dressed in armour and the other seated without armour wearing the robes of a Grand Master: the first of these

61 Plate LXIV

91

portraits is in the Armoury at Malta'. Until Longhi ('Proporzioni', 1943) suggested otherwise, almost all critics believed (Maindron in 'Revue de l'Art', 1908, excepted) – and most have continued to believe – that the painting now in the Louvre is the standing portrait mentioned by Bellori. Longhi's chief objection to the Louvre painting was aesthetic and stylistic but there are also other difficulties: (1) the suit of

armour depicted is apparently not that of De Wignacourt but is another suit, plainer and older than his, which is still in the palace at Valletta and which belonged to the Grand Commander, Jean-Jacques de Verdelin, who was only eighteen in 1608 (Sammut, 'Scientia', 1949); (2) two other versions of the portrait of De Wignacourt still exist in Malta; (3) the Louvre painting was already in the French royal

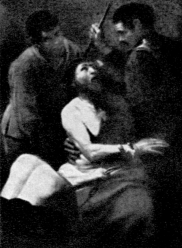

93

94

95

collection in 1670, having previously been in the Hoursel collection, whereas Bellori says that the standing portrait was still in Malta (not too much weight should be attached to this last consideration, as Bellori might have written his life of Caravaggio much earlier than 1672 or his information might have been out of date). Despite these objections, most critics – notably Joffroy (1959) and Jullian (1961) – have accepted the authenticity of the Louvre painting, while admitting its wooden-ness and aesthetic weakness, part of which they explain away by old restoration. It might be suggested that the head is by Caravaggio and the armour and figure of the page by an assistant. No trace survives of the other, seated, portrait mentioned by Bellori.

84 🔳 ⊗ 117×157 / 1608 📋 ⁝

St Jerome Valletta (Malta), Cathedral of St John
'Also for S. Giovanni (Malta) in the Italian chapel he painted two half figures over the doors, the Magdalene and St Jerome writing' (Bellori 1672). This reference establishes the authenticity of the *St Jerome* in St John's Cathedral, which has always been regarded as by Caravaggio (Longhi, Venturi, Mahon, Friedlaender, etc.), even before the restoration of 1955, when it was found to be in much better condition than *The Beheading of the Baptist*. In the bottom right corner appears the coat of arms of the Friar-Commander Ippolito Malaspina, once prior of the Order of the Knights of Jerusalem in Naples, who may have helped Caravaggio to slip into the island. The head of the saint resembles Alof de Wignacourt's in the Louvre painting (83). The *Magdalene*, which Bellori mentions together with the *St Jerome*, also survives in the cathedral but it is an earlier work, not by Caravaggio; it may be by a distant follower of Correggio.

85 🔳 ⊗ — 📋 ⁝

St Jerome Formerly Valletta (Malta), Palace of Alof de Wignacourt (?)
'He painted another St Jerome, meditating on death with a skull before him, which is still in the palace (of Alof de Wignacourt) (Bellori, 1672). Sammut ('Scientia', 1949) tried to identify this with a painting in the palace of Sant' Antonio; however, if it ever existed, it should probably be considered lost.

86 🔳 ⊗ 71×105 / 1608 📋 ⁝

Sleeping Cupid
Florence, Pitti Palace
The attribution is based on a manuscript inventory dated 1675 (Florence, State Archives) and on an old, probably

seventeenth-century, inscription on the back of the canvas: *Opera di Michelangelo Maresi da Caravaggio i* (*n*) *Malta* 1608. Although acknowledging it to be a minor work, modern critics continue to regard it as authentic.

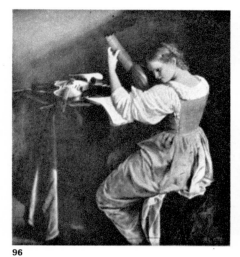

96

Friedlaender (1955), while accepting its genuineness, also published another version, now in a private collection in Indianapolis, as an autograph replica. The Indianapolis canvas, which is unusually smooth, reveals and softens some details and passages; Joffroy (1959) called it a copy. In the absence of the documentation it is unlikely that the *Sleeping Cupid* would seriously have been ascribed to Caravaggio but the stylistic evidence does not contradict the attribution.

98

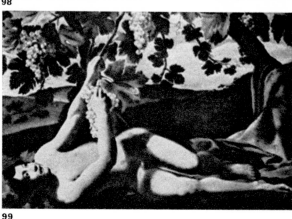

99

87 🔳 ⊗ 408×300 / 1608 📋 ⁝

The Burial of St Lucy
Syracuse, Church of Sta Lucia
'After landing in Syracuse, (Caravaggio) painted a picture for the church of Saint Lucy which stands on the sea-

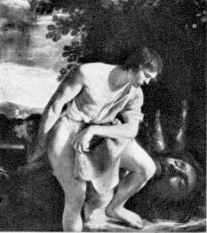

97

shore: he depicted the dead saint with the bishop blessing her, and there are two men digging the earth with shovels to bury her' (Bellori, 1672). Like the other three undoubted works by Caravaggio which have remained in Sicily, this was forgotten for centuries until Rouchès discussed it in his monograph (1920). It was subsequently studied by Mauceri ('Bollettino d'arte', 1921–2 and 1924–5; 'Sicilia illustrata', VI, Nos. 10–12), by Marangoni (1922) and in turn by all later critics without serious disagreement.

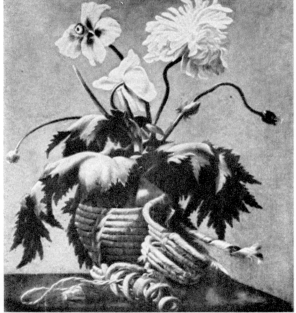

100

least made it decipherable. Note the new spatial relationships and the contrasts in size between the figures; also the obsessive gravediggers in the foreground, the saint's frail body lying on the ground, and the minute mourners at the back, lost, crushed by the huge wall. Old copies of the painting survive in the Jesuit College and in the church of S. Pietro di Palestrina, both in Syracuse, as is the original.

88 🔳 ⊗ 380×275 / 1609 📋 ⁝

The Raising of Lazarus
Messina, Museo Nazionale
This painting was described by Bellori (1672) as follows: 'Having later moved on to Messina . . . he painted in the chapel of the Lazzari family in the Chiesa de' Ministri degli Infermi, the Raising of Lazarus who, held up out of the grave, spreads out his arms in response

Badly damaged during an attempted restoration in 1821 and salvaged as effectively as possible a hundred years later the painting was fully cleaned and restored again in 1947–8 at the Istituto Centrale del Restauro in Rome, which at

calls and reaches out His hand towards him. Martha weeps and the Magdalene looks awed and there is one who holds his hand to his nose to protect himself from the stench of the corpse. The painting is large and the figures are set in a cave with the most light falling on the naked body of Lazarus and those who support him; it is most highly thought of for the realism of the imitation'. Despite this, the picture was not referred to by critics until Saccà ('Archivio storico messinese', 1906–7) discussed it and published two documents of 6 December 1608 and 10 June 1609. These gave the date of the picture's execution and showed that it was commissioned by the Genoese Giovanni Battista de' Lazzari for his chapel in the church of the Crociferi. It was recorded by Samperi in *Messana* (published 1742, though written a century earlier) and by Hackert (*Pittori messinesi*, 1792), the latter stating that the canvas was restored by the Messinese painter Andrea Suppa in 1671.

to the voice of Christ who It underwent a further restoration by Letterio Subba in 1820, following a fire; and it was cleaned and restored again as far as possible in 1951 at the Istituto Centrale di Restauro in Rome. Its authenticity has not been accepted without debate. It was doubted or rejected by L. Venturi (1921, 1925), Pevsner (1927), and particularly by Mauceri, the first curator of the Messina Museum (catalogue of the museum, 1929, and 'Bollettino d'arte', 1924). A firm attribution to Caravaggio has, however, been upheld by Posse, Voss, Zahn, Schudt, Longhi (1943) and others, up to L. Venturi (1952) and beyond. Bottari ('L'Arte', 1935 and *Cultura figurativa in Sicilia*, 1954) finally established the painting's authenticity on the evidence of the documents. R. E. Spear ('Gazette des Beaux-Arts', 1965) related the

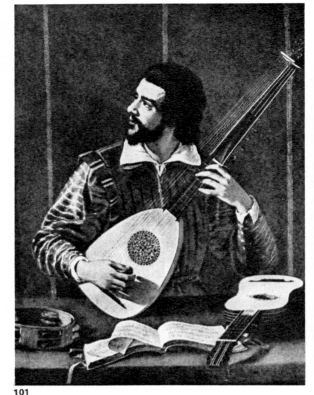

101

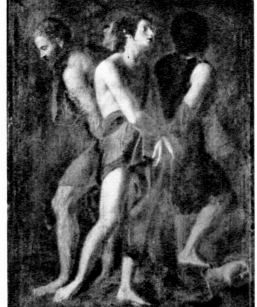

102

103

painting to the traditional Mannerist treatment of the theme, originated by Federico Zuccaro and taken up by the Cavaliere d'Arpino in the Palazzo Barberini at Rome.

89 ▦ ◔ 314×211 / 1609 ▤ ⁝

The Adoration of the Shepherds Messina, Museo Nazionale

Bellori (1672) states that Caravaggio 'painted for the Capuchins at Messina a picture of the Nativity, representing the Virgin with the Child outside the dilapidated shed with its crumbling planks and beams; and Saint Joseph is shown leaning on his staff with some shepherds in adoration'. The work is also mentioned by Sampieri in *Iconologia* (1644). Hackert (*Pittori messinesi*, 1792) said it had been commissioned by the Senate of the city, who paid one thousand scudi for it. Better preserved than *The Raising of Lazarus* (88), the painting has given rise to no opposition or doubt since Saccà's excellent initial discussion of it (1906). Samek Ludovici (1952) emphasized the perfect adaptation of the composition to the sacred theme. The thin light diffused among the shadows of the humble interior, which seems to suggest a local peasant stable, low and closed up against the cold, emphasizes the uniquely painful mood of this *Adoration*.

90 ▦ ◔ 268×197 / 1609 ▤ ⁝

The Nativity with St Francis and St Lawrence Palermo, Church of S. Lorenzo

Bellori (1672) records that Caravaggio 'moved from Messina to Palermo where, for the Oratory of the Society of San Lorenzo, he painted another Nativity; the Virgin gazes upon the new-born Child, with Saint Francis and

Saint Lawrence; there is a sitting Saint Joseph and an angel in the air, the darkness being rent by the light diffused among the shadows'. It was first studied by Saccà (1906) and then, thoroughly, by Meli ('Dedalo', 1925). It must have been painted before October 1609, when Caravaggio is known to have returned to Naples (Orbaan, *Documenti sul Barocco in Roma*, 1920); Arslan (1959) produced the extraordinary view that it was executed in Rome about 1600.

91 ▦ ◔ 116×140 / 1609 ▤ ⁝

Salome with the Head of John the Baptist El Escorial (Spain), Casita del Principe

This painting was first discovered and published by Longhi in 1927 ('Vita artistica'; also studied by him in 'Proporzioni', 1943, and 'Paragone', 1951) and has since been accepted as genuine by all critics. Battisti ('Commentari', 1955) showed that it entered the Spanish royal

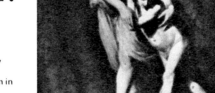

104

105

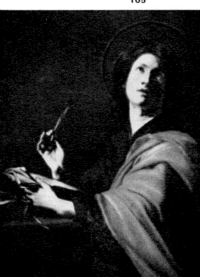

106

107

collections some time between 1637 and 1686. Until 1959 Longhi connected the canvas with Bellori's statement (1672) that Caravaggio painted a 'half-length figure of Herodias with the head of Saint John on a charger' in Naples after his flight from Malta and that he sent it to Malta to appease the Grand Master. (Interpreting this literally, Wagner, in 1958, identified the younger woman as Herodias and not as her daughter Salome, although the older woman in the picture is clearly Herodias.) The question is, whether this painting was executed during Caravaggio's first (1607) or second (October 1609–July 1610) visit to Naples. The problem is complicated by a second autograph version of the subject, now in London, discovered by Longhi in 1959.

Even before the appearance of the London painting, Mahon

('Burlington Magazine', 1952), Hinks (1953) and Wagner (1958) dated the Escorial version during the first Neapolitan period on stylistic grounds. Since 1959, Longhi has favoured relating Bellori's statement to the London version. As the latter has no provenance and as the Escorial version presumably went to Spain from Naples, there is something to be said for identifying the London painting with the picture said by Bellori to have been sent to Malta. Unfortunately for the solution to this problem, there appear to be no significant stylistic differences between the two paintings, which are compositionally related though by no means identical; the figures of Salome and Herodias in each case are basically the same. Both paintings might have been executed during the first visit to Naples or both during the second; or – perhaps less likely – they might have been executed during different visits. But if both paintings are similar in style they are nevertheless different in mood, the Escorial version being the more sombre and tragic, the other being the more aggressive, of the two. Longhi has drawn attention to the influence of the Escorial *Salome with the Head of John the Baptist* on Caracciolo and on the Neapolitan works of Finsonius.

92 ⊞ ◷ 90,5 × 167 / 1610 ▤ ⋮
Salome with the Head of John the Baptist
London, National Gallery (loan)
This painting was also first published by Longhi ('Paragone', 1959), when it was in a Swiss private collection. As has been mentioned in the previous entry, it is difficult to decide whether this picture or the Escorial version (91) should be identified with the one mentioned by Bellori (1672) as having been painted by Caravaggio in Naples after his flight from Malta and sent to Malta to appease the Grand Master. There are stylistic

reasons for dating the London picture in either the first or the second Neapolitan periods. The head of Salome is strongly reminiscent of the Virgin in *The Madonna of the Rosary* (72), of 1607 or even perhaps earlier, whereas the executioner seems closer to some of the figures in *The Raising of Lazarus* (88) or the Messina *Adoration of the Shepherds* (89), both painted in Sicily in 1609. The closest analogy seems to be with the Rouen *Christ at the Column* (75), but whether this was executed during the first or the second Neapolitan periods is itself in doubt. Inconsistencies in style, giving rise to these uncertainties, seem to be a feature of the London painting – which is not to say that it was executed at two different times or that it is not authentic. There has long been a copy of the painting in the Abbey of Montevergine, indicating by its

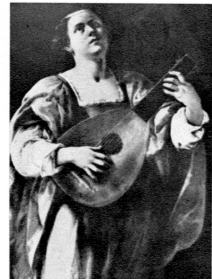

108

109

presence there that the original was executed in Naples.

93 ⊞ ◷ 178 × 125 ▤ ⋮
The Crowning with Thorns
Florence, Cecconi Collection
Bellori's statement (1672), recording a painting of this subject executed for Marchese Giustiniani, might theoretically refer to the original of this picture or to another preserved in a copy in Vienna (78), both of which illustrate the same theme in widely differing compositions. The canvas in the Cecconi Collection was

identified by Longhi in 1916 as a copy or imitation of a lost original by Caravaggio. Later illustrated by Marangoni (1922) and by Longhi himself ('Pinacotheca', 1928, and 'Proporzioni', 1943), it was accepted by Mahon (1951) and Hinks (1953) as a work derived from a very late original (1609–10). It was also accepted as a copy by Jullian (1961), who moved the dating back to 1600–1. Baumgart and Wagner rejected it. So intense and dramatic a composition, if it is by Caravaggio, can surely only be from the late, possibly second Neapolitan period.

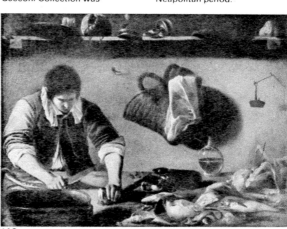

112

110

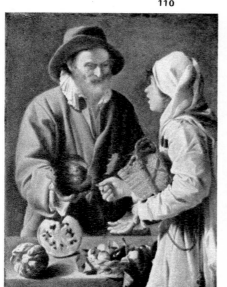

111

113

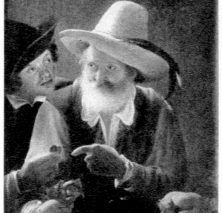

114

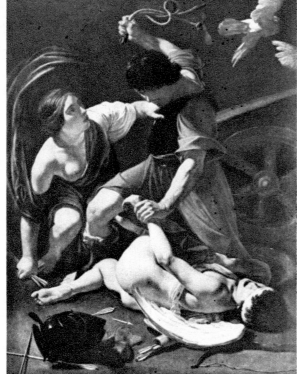

115

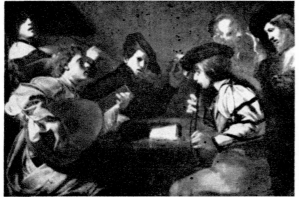

117

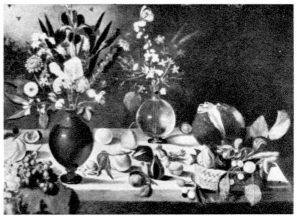

116

(97) David with the Head of Goliath Rome, Galleria Spada
An intriguing canvas (172 × 142 cm.) often illustrated. The 1759 inventory of the Spada Gallery ascribed it to Poussin; in 1765, Roisecco rightly attributed it to Orazio Gentileschi. Caravaggio's name was first put forward by Barbier de Montault (1870), supported by L. Venturi ('L'Arte', 1910), who assigned it to the early period and by Rouchès (1920), despite Longhi's correct attribution to Gentileschi in 1916. Hermanin proposed its classification as 'school of Caravaggio', while most critics retain Gentileschi's name. Moir (1967) describes it as by Gentileschi but in collaboration with Agostino Tassi. An attribution to Saraceni, suggested by some writers, has been discarded and this remains, therefore, one of Orazio Gentileschi's master-pieces. It is datable 1610–12. There are copies at Brunswick, in the archbishop's palace at

guide (1765); in Canova's diary (*Diario degli anni 1799–80*, edited by E. Bassi in 1959); in Ramdohr (1787, III, though tentatively); in Lanzi (1789); in the bequest catalogue of 1820; in Barbier de Montault (*Musée et Galeries de Rome*, 1870); and, finally, in

the canvas with a view to its purchase by the State at 50,000 lire. Only in 1931 did Porcella (*Le Pitture della Galleria Spada*) say it was a free copy after a lost original; two years later, in the guide to the Spada Gallery, Lavagnino assigned it to Caravaggio's

school. Longhi ('Proporzioni', 1943) followed by Moir (1967), ascribed the painting to Giacomo Galli, called Lo Spadarino, adding the canvas to others attributable to that painter. Zeri (*Galleria Spada*, 1954) has held to the view that it is a seventeenth-century copy of a lost original by Caravaggio.

(99) Bacchus Frankfurt, Staedelsches Kunstinstitut
Recently disregarded, rather than positively deleted from Caravaggio's *oeuvre*, this painting (95 × 125 cm.) was published as a Caravaggio by J. Breck (1910). An attempt was made to relate it to Baglione's reference to the *Bacchus* in the Uffizi (14), a reference which admittedly also fits the present subject (it also fits a number of others not by Caravaggio). The canvas, long famous, was even regarded as a genuine Caravaggio by Longhi in 1917 ('L'Arte'). Voss (1927) downgraded it to a 'work of the 'Neapolitan school' and gave it to Caracciolo, with which Longhi was then inclined to agree, although he also put forward the name of Finoglio, a 'more

Old copy of 117 published by Berenson (1951)

Milan and – on copper and possibly a second original – in Berlin (Moir).

(98) St Anne and the Virgin Rome, Galleria Spada
This canvas (101 × 131 cm.) was for long regarded as one of Caravaggio's masterpieces. It appears under his name in the 1759 inventory of the Spada-Veralla estate in Roisecco's

Burckhardt's *Cicerone* (Bode edition, 1904). L. Venturi ('L'Arte', 1910) listed the painting among the works of Caravaggio's last Roman period, describing it as the artist's most sincere and perfect example of realism. He was followed by Witching (1916), Biancale ('Bollettino d'arte', 1920), Rouchès (1920) and Hermanin (1925), who valued

117

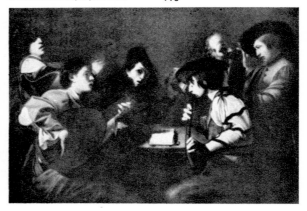

94 🁣 ⊘ 285×205 / 1610* 📖 ⦂

The Annunciation
Nancy, Musée des Beaux-Arts
At first (1921) attributed by Longhi to Caracciolo, this much darkened canvas was later ('Paragone', 1959) published by him as a genuine Caravaggio dating from the second Neapolitan period, i.e. from the last months of the artist's life. According to Longhi, there is evidence that it was painted by a 'Michelangelo of Rome' for a church consecrated in 1609. Pending the restoration now being carried out it is necessary to withold judgement.

95 🁣 ⊘ 73×100 / 1610 📖 ⦂

St John The Baptist at the Spring Malta, Bonello Collection
Longhi ('Paragone', 1951) identified this painting as the last work executed by Caravaggio at Naples in the spring of 1610, on the evidence of documents concerning the artist's death published by Green and Mahon ('Burlington Magazine', 1951), in which mention is made of a 'Saint John' as being among the sparse luggage loaded on to the felucca which disappeared at Porto Ercole. The painting's authenticity was acknowledged by Mahon ('Burlington

Magazine', 1951), Grassi (1953) – who dated it in the Maltese period – and Joffroy (1959). It was rejected by Jullian (1961).

Works formerly attributed to Caravaggio

There follows a list of the most important paintings which, formerly thought to be by Caravaggio, either in the original or as copies, have been discarded by the majority of modern critics.

(96) Woman Playing a Lute Washington, D.C., National Gallery of Art
Until recently in the Liechtenstein Collection and generally regarded, from Kallab (1906) to Marangoni (1922), as a genuine Caravaggio, this work (149 × 130 cm.) was first attributed to Orazio Gentileschi by Gamba ('Dedalo', 1922), followed by all subsequent critics, including Moir (1967).

118

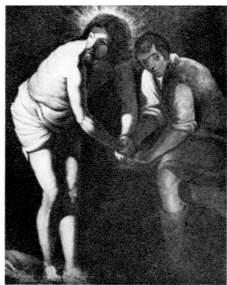

119

brutally realistic painter' ('Proporzioni', 1943). Moir (1967) does not mention it.

(100) Poppies in a Broken Bottle Boston, Museum of Fine Arts

A canvas (66 × 57 cm.) of some charm, this was published by Swarzenski as a Caravaggio ('Boston Museum Bulletin', 1954), with historical precedents, pictorial comparisons and a parade of argument. It bears an old but mis-spelt signature, undoubtedly spurious. This work is the twin of another canvas representing lilies, now in the gallery at Forli, which Swarzenski suggested was a copy of a lost pendant to the Boston painting. This hypothesis was reversed by Arcangeli who attributed the painting at Forli to Giulio Cagnacci and suggested that the Boston painting was a copy after and suggested that the Boston painting was a copy after Cagnacci. The attribution to Cagnacci of the *Still Life* at Forli has been accepted by Sterling (*Nature morte*, 1959), Bottari and Volpe in the entry to 42 in the catalogue of the exhibition of Italian still life (Naples, 1964) and tentatively by Moir (1967), who attributes the Boston *Still Life* to an unidentified follower of Caravaggio. De Logu (*Natura morta italiana*, 1962) created a 'Master of the Bottle of Flowers', to whom he assigned a third still life. Jullian (1961), rejected the painting from Caravaggio's *oeuvre*, though listing it among the doubtful works, as did Baumgart (1955), but he did this mainly in view of the difficulty of placing it in Caravaggio's career. Whether the *Still Life* at Forli is an original or a copy, neither painting is by Caravaggio.

(101) The Lute Player Turin, Galleria Sabauda

Attributed to Caravaggio by Burckhardt (Bode edition, 1906), Jacobsen ('Archivio storico dell'arte', 1897) and Baudi di Vesme in the catalogue of the Sabauda Gallery (1899), this painting (canvas, 119 × 85) was adopted as a touchstone of Caravaggio by Kallab (1906), together with the Washington *Woman playing a Lute* (96) and the Hermitage *Lute Player* (13) and it was famous among scholars such as Posse and L. Venturi until the 1922 exhibition of Italian seventeenth-century painting at the Pitti Palace. It was deleted from Caravaggio's *oeuvre* by Marangoni ('Bollettino d'arte', 1922–3) and Voss (1923), who thought it was a fragment of a *Concert*, a copy of which appeared in a sale at Frankfurt in 1922 (Baugel sale, No. 1030). Longhi ('Pinacotheca', 1928–9) first gave the painting to Antiveduto Gramatica, to whom it is also attributed by Moir (1967).

(102) The Four Martyred Saints (I Quattro Santi Coronati) Rome, Palazzo Braschi

This painting, executed as a banner and formerly in the church of the Quattro Santi Coronati in Rome, was attributed to Caravaggio by L. Venturi ('Bollettino d'arte', 1912, and 1921), on the evidence of a false inscription at the bottom left ('Michel Angelo da Caravaggio dip.') and a print dated 1793. The attribution was challenged by Marangoni (1922) and the next year by Voss ('Jahrbuch der preussischen Kunstsammlungen', 1923), who suggested Mao Salini. Longhi proposed a painter 'close to Rustici' or 'Fiasella or Cavarozzi'. The attribution to Mao has been upheld by Salerno ('Commentari', 1952) and tentatively by Moir (1967). Berenson (1951) revived the attribution to Caravaggio.

(103) St Thomas of Villanova or St Nicholas of Tolentino giving Alms Ancona, Pinacoteca Francesco Podesti

Formerly in the church of S. Agostino at Ancona, this canvas (180 × 105 cm.) was once attributed to Caravaggio by Longhi ('L'Arte', 1913). In the catalogue of the exhibition of seventeenth- and eighteenth-century Italian art at the Pitti Palace, Florence, in 1922, the attribution was changed to 'school of Caravaggio', and this was followed by Serra (Catalogue of the Gallery of the Marches, 1925). In 'Proporzioni', 1943) Longhi gave the painting to Lo Spadarino, an opinion which has been adopted by Marchini (Catalogue of the Ancona Gallery, 1960) and tentatively by Moir (1967).

(104) Tobias and the Angel Rieti, S. Ruffo

This painting (200 × 150 cm.) was assigned to Caravaggio by L. Venturi ('Bollettino d'arte', 1912) who later abandoned the attribution. Longhi first proposed Orazio Gentileschi ('L'Arte', 1916), but later gave the painting to Lo Spadarino ('Proporzioni', 1943), together with *St Thomas of Villanova giving Alms* (103) and *St Anthony and the Child Jesus* (105); echoed by Moir (1967).

(105) St Anthony and the Child Jesus Rome, Church of Sts Cosmas and Damian

Once attributed by Longhi to Caravaggio (1913) but later given by him to Lo Spadarino ('Proporzioni', 1943). like 103 and 104. Moir (1967) wavers between Spadarino and an unidentified follower.

(106) Woman with Compasses Rome, Galleria Spada

This canvas (77 × 62.3 cm.), which is probably a personification of Architecture, is a similar case to that of *St Anne and the Virgin*, also in the Spada Gallery (98). The traditional attribution to Caravaggio followed the same course, from Vasi (*Itinerario di Roma*, 1792) to Hermanin (1925), who valued the canvas, as a

Caravaggio, at 30,000 lire. Porcella (1931), rightly downgrading it, attributed it to Caroselli; Lavagnino, to the school of Caravaggio; Longhi favoured Francesco Mola; Zeri (Catalogue of the Spada Gallery, 1954) proposed Giacinto Brandi. Moir (1967) does not mention the painting.

(107) St John the Evangelist Rome, Galleria Spada

A painting of this subject was mentioned by Mancini (c.1620) as among Caravaggio's works, and the reference is repeated in the various manuscript copies of his treatise, thus throwing doubt on the possibility that it might have been a slip of the pen for St John the Baptist. L. Venturi ('L'Arte', 1910), followed by Rouchès (1920), thought he had identified the work in question in the present canvas (115 × 83 cm.). At various times attributed to Valentin, Guercino and Monrealese, this painting – certainly not by Caravaggio – is now tentatively ascribed to Tournier (Catalogue of the Spada Gallery, 1954; Zeri; Longhi).

(108) St Cecilia Rome, Galleria Spada

The attribution to Caravaggio as an early work, contemporary with the Capitoline *Fortune Teller* (9), put forward by L. Venturi ('L'Arte', 1910) was accepted by Rouchès (1920) and Hermanin (1925). The painting (108 × 478 cm.) was included in the exhibition of Italian seventeenth-century and eighteenth-century painting at Florence in 1922 as 'attributed' to Caravaggio, even though Voss (1911) had already ascribed it to Artemisia Gentileschi, followed by Porcella and by Lavagnino. Longhi suggested Caroselli; according to Zeri (Catalogue of the Spada Gallery, 1954), it is by an imitator of Orazio Gentileschi.

(109) Portrait of a Lady San Diego, Fine Arts Gallery

This painting (85 × 80 cm.) has been in its present location since 1942; it previously belonged to the Schefer Gallery in Berlin, where it was attributed to Sofonisba Anguissola. Voss ('Burlington Magazine', 1927) thought it to be a very early work by Caravaggio, showing strong Lombard influences. Except for the catalogue of the San Diego Art Gallery (1960), in which the attribution to Caravaggio is accepted, Voss's hypothesis has found no support. Joffroy ignores it, while Jullian (1961) reproduces it among the doubtful works.

(110) St Francis in Ecstasy and Two Angels Private Collection

This canvas (134 × 112 cm.) was first published and attributed to Caravaggio by De Benedetti ('Emporium', 1949); it is dated 1601 and the letters

MC can be seen on one of the book's half-open pages. It belonged at one time to the Borghese Gallery and was engraved in 1700 by Basan as a Caravaggio. It returned to Italy after various peregrinations and was included in the Caravaggio exhibition at Milan in 1951 as a work 'attributed' to the artist. However, as early as 1930, well before the rediscovery of the canvas by De Benedetti, Longhi had thought it was by Baglione on the evidence of Basan's engraving and Montelatici's precise description and reference (*Villa Borghese*, 1700, p. 216). Since the painting reappeared, this opinion has been confirmed and generally shared. (See also Longhi in 'Paragone', 1963).

(111) Fruit Seller and Young Maid Servant Detroit, Institute of Art

This painting was bought as a genuine Caravaggio by the Detroit Institute of Art. Like the three following works, it has been attributed by Longhi ('Proporzioni', 1943) to an anonymous painter, probably French, active from about 1610, whom he called the 'Pensionante del Saraceni'.

(112) The Cook Florence, Corsini Collection

A traditional attribution to Caravaggio was definitely rejected by Marangoni ('Bollettino d'arte', 1922) and then replaced by Longhi ('Proporzioni', 1943) with one to the 'Pensionante del Saraceni' because of its resemblance to the preceding and following two works.

(113) Man Selling Poultry Madrid, Prado

At one time attributed in the Prado to Bernat, it was given by Longhi ('Proporzioni', 1943) to the 'Pensionante del Saraceni', in the light of the stylistic analogies with the two preceding works (q.v.) and with the following one.

(114) The Denial of St Peter Rome, Pinacoteca Vaticana

Rouchès (1920) attributed this painting to Caravaggio but he was not followed by other critics. Longhi ('Proporzioni', 1943) assigned the picture to the 'Pensionante del Saraceni' because of its analogies with the three preceding works (q.v.).

(115) Venus with Mars Punishing Cupid Chicago, Art Institute

This canvas (175 × 130 cm.) – in 1937 in the Brasini Collection, Rome – was attributed to Caravaggio by Sestieri ('L'Arte', 1937), followed by Voss ('Apollo', 1938) and Isarlov (1941). But Longhi ('Proporzioni', 1943) rejected it as a Caravaggio, and showed it to be the work of Bartolomeo Manfredi. Moir (1967) and Nicolson (in *Studies … presented to Anthony Blunt*, 1967) have accepted this view.

(116) Still Life with a Glass Bottle Hartford, Wadsworth Atheneum

Thought by Sterling, in the first edition of his *Nature Morte* (1952), to be a copy of a lost painting by Caravaggio and moved out to the artist's circle in the second edition (1959), this canvas (71 × 96 cm.) lacks the compositional rhythms and the colours typical of Caravaggio. Sterling's original attribution was not successful and was explicitly rejected by Jullian (1961). Indeed, the painting is so un-Caravaggesque that it can be hardly classed as by a follower.

(117) The Concert Florence, Uffizi

On the evidence of a reference in Baglione, now thought to apply to the Metropolitan Museum *Musical Scene* (12), Marangoni (1922) published as a possible genuine work by Caravaggio a badly damaged copy of this subject. The original of this (130 × 189 cm.) in the Uffizi Gallery was published, also as a Caravaggio, by Berenson (1951). Longhi ('Proporzioni', 1943) had already convincingly attributed this painting to Manfredi. Moir (1967) and Nicolson (in *Studies … presented to Anthony Blunt*, 1967) concur.

(118) St Isidoro as a Farmer Ascoli Piceno, Pinacoteca Civica

This painting (220 × 150 cm.) is a poor copy of a work formerly in the church of S. Isidoro at Ascoli Piceno, where it was described by Lazzari (*Ascoli in prospettiva*, Ascoli 1724); removed by the French in 1811, all further traces of it have been lost. The copy reproduced here was first published by Cantalemessa ('Bollettino d'arte', 1914). Despite Longhi's opinion ('Proporzioni', 1943) that it is derived from a lost original by Caravaggio, this does not seem to be the case. Subsequent critics have ignored the work.

(119) Christ at the Column Perugia, S. Pietro

Longhi's reference to this work (oils on copper, 45 × 35 cm.) in 'Proporzioni' (1943) as a possible derivative, on a reduced scale, of an original by Caravaggio of about 1595–1600, has found no support among later critics, despite – or perhaps because of – the fact that it was shown at the Caravaggio exhibition in Milan in 1951 as a copy. In addition to this painting, held to be by Caravaggio according to local eighteenth-century tradition (B. Orsini, *Guida*, 1784, p. 41), there is another copy, which Baumgart excluded, Venturi disregarded, Jullian doubted and De Logu accepted. Although the treatment is obviously Caravaggesque, it seems unlikely that this Christ, who appears to be shivering after stepping out of a cold bath, can ever have been conceived by Caravaggio.

Indexes